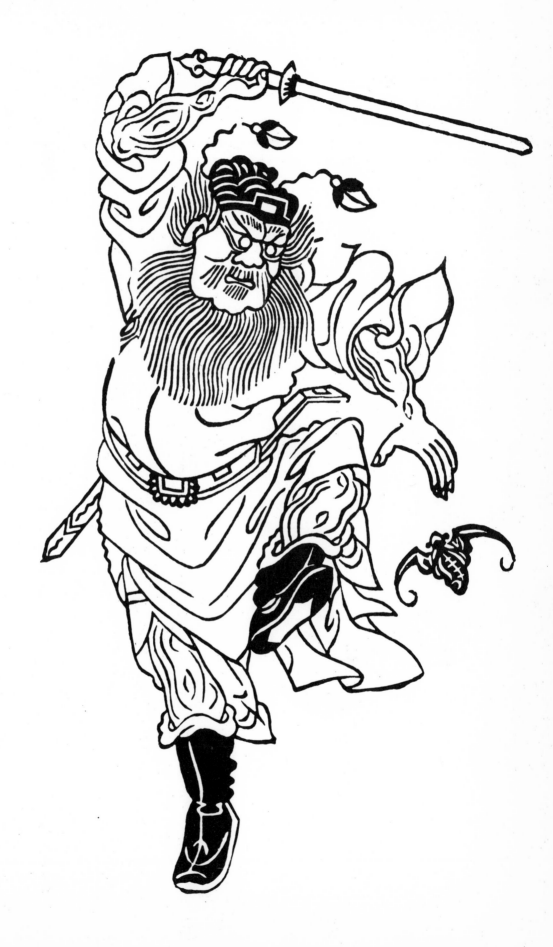

Print-making
Techniques

PRINT-MAKING TECHNIQUES

A Guide to the Processes
and the History of
Original Print-making

Front cover
Andy Warhol (b. 1928)
Marilyn, 1967
silk screen process in colour, 900 × 900

Back cover
Henri de Toulouse-Lautrec (1864—1901)
Frontispiece from the cycle *Elles,* 1896
lithograph in colour, 521 × 405

Endpaper (front)
(1)
Unknown 17th century Chinese artist
Shoky — the demon fighter
woodcut, 256 × 148, new impression from
original block opposite: original block

Endpaper (back)
(95)
Rembrandt van Rijn (1606—1669)
Self-portrait with supported arm, 1639
line etching, 207 × 163

Halftitle
(2)
Jost Amman (1539—1591)
Woodcutter
woodcut, 85 × 65

Designed and produced by Artia
First published in 1982 by
Octopus Books Limited
59 Grosvenor Street, London W 1.
© Copyright Artia, Prague 1982
Text, sketches and graphic design by Aleš Krejča
Illustrations Nos. XV, XVII, XX, XXII, XXVIII,
32, 49, 51, 73, 82, 83, 90, 91
© Copyright ADAGP, Paris & COSMOPRESS, Genf 1982;
Nos. VII, 4, 7, 10, 74, 81, 85—87, 92 © SPADEM, Paris 1982;
No. 78 © Spangenberverlag, München 1982
Translated by Jan Eisler
ISBN 0 7064 1469 1
Edited by A. J. Weelen, Principal Lecturer in Graphic
Reproduction, London College of Print
Printed in Czechoslovakia by Svoboda
2/12/01/51-01

(3)
Unknown 15th century artist
St Christopher, 1423
woodcut, 287 × 207
oldest dated European plate print

CONTENTS

(4)
Pablo Picasso (1881 — 1973)
Woman's torso, 1953
aquatint, 82 × 47

PREFACE

This book is intended for all those who wish to gain a deeper knowledge of the secrets of print-making — a creative art which is becoming more and more popular. The nature of print-making, as opposed to other fields of art, implies the creation of a number of originals, thus enabling their easier circulation and availability. This book explains the genesis of prints and clarifies the complex and precise techniques involved in their creation. For collectors of prints and professional custodians it provides basic criteria for the correct identification, classification and evaluation of individual works, as well as advice on how to handle, treat and store these works. For those who are interested in the history of art, this book provides a brief summary of the history of world print production and outlines the contribution of leading artists in the main phases of development of print-making. But the author had in mind primarily those readers who would like to try out their feeling for art and their manual dexterity by themselves — whether they be self-taught, art students or practising artists. The aim of this book is to help all those who are actively interested in realizing their own designs, starting with the initial sketch and ending with the final print.

This sort of help can only be given by providing the most accurate expert information, practical advice and recipes — in other words the most intelligible and comprehensive know-how. The descriptions of specific working processes include the experience of many generations of print-mak-

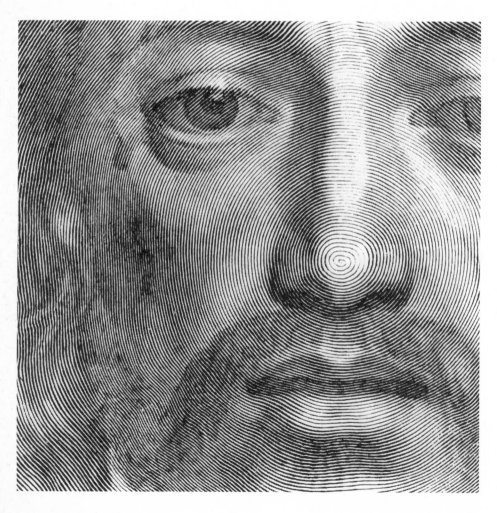

(5)
Claude Mellan (1598—1688)
The veil of St Veronica
copperplate engraving, detail

8

ers — and of course also the author's own experience. Apart from traditional techniques, tested by years of practice, some techniques are explained here, the full importance of which will become clear only in the future. Because the field of printmaking as a whole is very extensive only an explanation necessary for a perfect understanding and mastery of the specific processes can be given. An important role is played by the illustrations, the sizes of which are given in millimetres throughout the book. These comprise works by the most important creative artists and range from palaeotypes to contemporary works. The chosen examples illustrate various artistic approaches to the individual techniques but also manifest the changing aspects of the periods and styles of world print production, giving an idea of artistic creativity through the centuries and in different cultures.

For the person who intends to take up printmaking and wants good results, it is as important to have a perfect knowledge of the subject, as to exercise limitless concentration, stamina and patience during tests and experiments. This the reader will soon understand when studying the book and he will readily accept that lack of craftsmanship or its underestimation is the first enemy of the person who wants to make prints. A true sense of achievement and joy in his own work comes to the print-maker only when he masters these prosaic prerequisities to such an extent that he experiences a need to experiment and to master new possibilities of graphic expression. We hope he will find inspiration in this book.

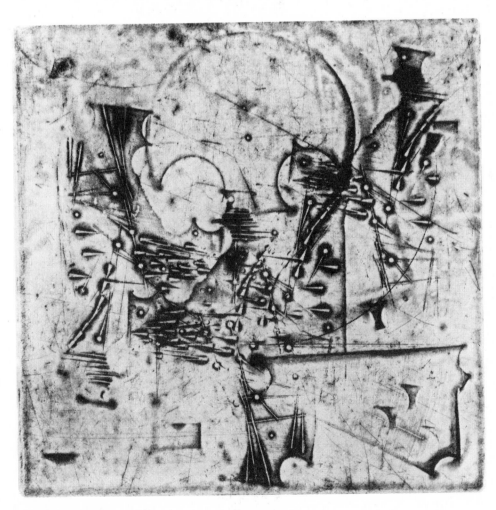

(6)
Vladimír Boudník (1924—1968)
Material traces. 1960
active technique, 148 × 148

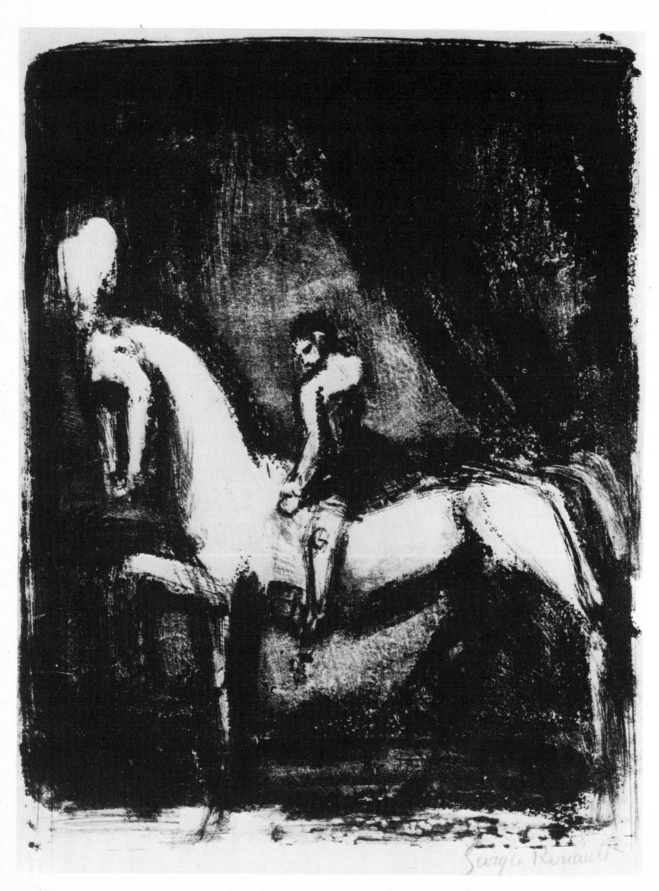

What is graphic art?

Original and reproductive print-making

The term 'graphic art', which is derived from the Greek word *graphein* meaning to write or draw, is used in a broad sense to describe the activity of transposing seen or experienced forms into a system of lines, points or planes. More specifically it describes the creative reassessment of the artist's free drawing, which by utilizing the work of a craftsman making an impression in the appropriate material, enables the work to be reproduced a given number of times. This is called print-making.

Following the development of art as a whole, graphic art has also undergone profound changes. Initially it only diffidently attempted to be separate from the art of painting on which it remained dependent for a long time. Had it not been that some great artists found their most specific expression in print-making, it would probably have remained merely a means of reproducing paintings. Another example of this dependence was the close connection of print-making with books, where it fulfilled the role of decoration and illustration.

These circumstances resulted in the later division of print-making into the fields of original and reproductive prints and into free and applied graphic art. The relentless polarization of these positions marks the whole history of graphic art up to modern times; and only now are they beginning to be separated consistently.

Today a print is considered an original work when it fulfils the following requirements:

1) The drawing of the model or subject must be original.

2) The artist must produce the printing plate or stencil manually by himself (the exception being when the artist cooperates with a printer, for example in the case of lithography).

3) The means of expression must be sensitively chosen and respect for the material is essential.

4) The artist must pull all the copies from the original plate, either by himself or with the assistance of a professional printer using traditional craft processes.

5) All prints must be authorized by the artist and at the same time the total number of prints must be marked. The printing limit must not be exceeded.

From this contemporary point of view a great number of old prints do not fulfil the requirements of originality. In the past artists often found inspiration in the works of other authors, because the criteria for artistic originality were rather different. Very often artists only produced the design, and the actual preparation of the plate or block was left to a specialized engraver or lithographer; the following printing process was then left to another specialist, the printer. The number of prints was not limited.

Today we define all prints based on an original design and made from a hand-made printing plate or stencil, which is used for printing a limited number of hand prints, as *original reproductions*. In contrast to this, *reproductive printing* is the domain of the graphic craftsmen who make a printing plate according to an original by the artist using photomechanical means. Their aim is to reproduce the original as accurately as possible in large numbers using modern printing methods.

Free and applied print-making

The creation of free graphic works with no practical purpose or specific designation i.e. the free transformation of the artist's conception into a graphic form such as a painting or sculpture, is called *free graphic art.* This is the reverse of *applied graphic art,* which is always connected with a specific task, such as the decorating and illustrating of books, posters, bookplates, greetings cards and advertisements.

◁ (7)
Georges Rouault (1871—1958)
White horse
lithograph, 300 × 238

Printing, printing plate or stencil, impression

Printing states

From a technical point of view printing is the reproduction of a graphically formed drawing (or text) achieved by transferring printing ink from a printing plate onto printing paper or other suitable materials.

A *printing plate* is an object in which the artistic concept is realized with the help of graphic processes (cutting, engraving, etching, stencilling, etc.). The *printing elements* of the plate are the places which, when covered with ink, are printed. The printing plate can be made of various materials, for example wood, linoleum, stone, metal, rubber, glass, textiles, plastics, etc. The final product of the printing process is the impression.

Each individual impression made from the same plate is usually slightly different from the others — the application of ink by hand and hand printing cannot quarantee absolutely identical results. With some techniques, for example intaglio, the character of individual impressions, even when using the same printing plate, can be very different. This is one of the reasons why each impression can be called an original.

Apart from this there exist impressions which document various working phases of the same printing plate. These impressions are called *states* and they are signed: 1st state, 2nd state, etc. They are much sought after by collectors, as they disclose a great deal about the procedures the artist has used. Only a small number of these are made. The various stages at which the states are made are as follows:

1) Before the completion of the plate: *text proofs* (signed with the abbreviation E.E. — *épreuve d'état*); *artist's proofs* (signed E.A. — *épreuve d'artiste*); in the past this term was applied to impressions made by the artist before the actual printing by the printer and were identified by Roman numerals.

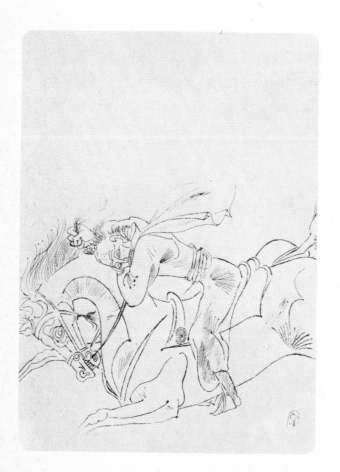

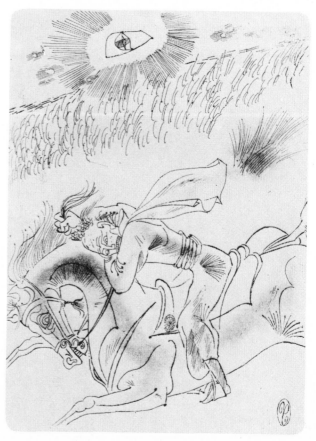

2) *Transfer proofs (contre épreuve),* a copy of an impression onto another paper, which is reversed in the same way as the drawing on the plate. This gave the engraver easier control of the work in progress.

3) *Before the text* was applied, *avant la lettre* (as opposed to *avec la lettre*); an impression made before the text (dedication, address, explanatory text, etc.) was engraved. The text was subsequently placed below the design.

4) *Remarque* proofs: text drawings and small sketches on the edge of the printing plate which are removed before printing.

5) *Early prints* of the edition: the plate already has its final form and is fresh, therefore the prints are of a high quality.

6) *Design variations,* with new lines or tones, in some cases after corrections have been made.

7) *Colour variations:* an impression made with a different colour or on a paper of a different colour.

8) A *late print* of the edition: the plate shows wear and the quality of the impression is poorer.

9) *Additional prints* from the original plate: if the number of prints in the first edition is low and the limit is not reached, the artist may later print further impressions; an additional print must be differentiated from an impression pulled from an old plate without the artist's consent — this is called a *reprint.*

10) *Crossed impression:* after reaching the limit of the edition it is proper to render the printing plate unfit by several cross cuts and to make between one and three impressions as evidence of this; this makes it impossible to use the plate for further unauthorized printing.

As mentioned earlier, one of the major factors which guarantee the originality of a print is the authorization of an impression by the artist. *The signature* is also of great importance for the collector.

The oldest preserved impressions were not signed and the artists remain anonymous. The first signatures began to appear in the middle of the 15th century. These are in the form of monograms incorporated into the design and they were engraved in the wood or metal at the same time as the drawing. Some of them have been deciphered and attributed to known artists, while others remain a mystery, and the artists known as, for example, the monogrammist E.S., or Master E.S. Later on, when the work of the painter as the creator of the design began to be differentiated from the work of the engraver, it became necessary to include both names. These were engraved immediately below the bottom edge of the drawing, the name of the painter on the left, that of the engraver on the right. Their contribution to the work was made known by Latin abbreviations, usually in the following manner: *pinx. — pinxit —* painted; *del., delin. — delineavit —* drew; *comp. — composuit —* composed; *inv. — invenit —* invented; *sc., sculps. — sculpsit —* cut; *inc. — incidit —* engraved; *f., fe., fec. — fecit —* made; *lith. —* lithographed.

Sometimes one also finds the name of the printer with the abbreviation *imp. — impressit —* printed; or the name of the publisher with the abbreviation *e., ex — excudebat, excudit,* or the expression *e formis* (X.T.).

Towards the end of the 19th century it became the practice to sign impressions below the printed design as they are today, using a pencil. In the bottom right-hand corner is written the signature and the date, in the left-hand corner a fraction with the number of the impression in the numerator and the total number of prints in the edition in the denominator. Sometimes the artist adds the title, the technique used, the number of the state, information as to whether the impression is an artist's proof, etc. If the print is part of a graphic cycle it is also necessary to indicate both the name of the cycle and the number of the print in the sequence.

◁ (8, 9)
František Tichý (1896—1961)
Rider, illustration to *The Demon* by Lermontov,
1939—1940
etching, two different states of the same print,
275 × 215

The edition and the printing limit

If every impression made from one plate is to be considered an original the size of the edition must not exceed a certain *limit*. The maximum number of impressions depends on the technique used and the resistance of the printing plate:
— dry point, engraving in the crayon manner and mezzotint — up to 50 impressions,
— those techniques employing steel plating and all types of etchings — up to 100 impressions,
— other engravings in metal or wood, lithographs and silk screen processes — up to 200 impressions.

Not to exceed this limit is a matter of integrity and a mark of a responsible approach by the artist of the graphic design. This applies also to giving the true number of pulled impressions. Usually, especially in the case of artist's proofs, the number of impressions is much lower than the permitted limit. Of course the lower the number of impressions, the rarer they are and this may influence their material value. If the whole edition is handed over to the publisher, then it should include a crossed impression, which guarantees that the printing plate is rendered unfit and cannot be used again.

Print-making in colour

Print-making is often described as a monochrome art. It is true that in this black and white form it has achieved its best results. The black line, tone and half-tone on a white surface of paper are the most appropriate and purest means of graphic expression. Nevertheless the popularity of print-making in colour has been growing recently with both graphic artists and collectors. This is due partly to the fact that prints are more and more frequently replacing paintings in interior decorating. There is no need to be prejudiced against print-making in colour, all that is important is the artistic intention. For a perfect mastery of print-making must first be learnt. A refined sense of colour, harmony and contrast is also necessary. It is as well to employ some theoretical knowledge when using colours in conjunction or when mixing colours.

The basic principle, which makes the understanding of relations between colours possible, is the twelve-part *chromatic circle*. In this the colours are arranged in the same sequence as in the broken down spectrum. It includes three basic, primary colours (1, 5, 9), three complementary, secondary colours (3, 7, 11) and six intermediate colours (2, 4, 6, 8, 10, 12). A pair of colour values placed opposite each other in the circle represent contrasting colours (1:7, 2:8, 3:9, 4:10, 5:11, 6:12).

The sequence of colours and the names of their approximate artist's material equivalents:

1. red	Carmine
2. orange-red	Vermilion Red
3. orange	Cadmium Orange
4. yellow-orange	Cadmium Yellow Deep
5. yellow	Cadmium Yellow Light
6. yellow-green	Cinnabar Green Light
7. green	Brilliant Green Deep
8. blue-green	Emerald Green
9. blue	Cobalt Blue
10. blue-violet	Ultramarine
11. violet	Cobalt Violet
12. violet-red	Purple Red

Mixing physical colours produces what is called the *additive synthesis:* all the colours of the spectrum added together make white. The mixing of real colours gives a reverse effect: the so-called *subtractive synthesis* results in a secondary colour when two primary colours are mixed, and if primary and secondary colours are mixed an intermediate colour is produced. The result of mixing all the colours together is black.

(10)
Pablo Picasso (1881—1973)
In the circus, 1905
dry point, 224 × 140

Mixing two colours can be achieved in two ways: by mutual homogenization, when mixing opaque colours, or by superimposing translucent colours. If one superimposes the colours, using the three primary colours, one can obtain all the other colour values. This is made use of in modern three-colour printing and also in four-colour printing (with an added neutral black or grey); to a certain extent this can be applied in print-making. The colour tone scale printed with primary colours is most helpful when the resulting colour scheme requires an accurate approximation of the equivalent grey tone (colour aquatints, colour lithographs, etc.).

A *coloured print,* i.e. a graphic work printed with bright colours (as opposed to a monochrome print coloured with watercolours), can be pulled from one or more printing forms. There are several different methods of doing this.

From one plate:

a) different coloured inks are applied to individual partial printing elements (for example in etching and Japanese-style woodcuts);

b) the plate is prepared for printing the first (lightest) colour and the whole edition is printed; then the second colour is applied and printed and so on until the darkest part of the design is printed.

From several plates, prepared for each colour separately:

a) the black linear or tone drawing is usually printed from one plate, and the second plate can then be used for printing a single-colour flat background, a background with left-out lights, a lighter colour contour drawing, or for bright surfaces with one or more colours (with a local application of colour);

b) chiaroscuro woodcut or lithograph;

c) three-colour or four-colour soft ground (zieglerography), chalk lithography (a technique of tone drawing, which employs the principle of mixing colours by superimposition);

d) colour woodcut and linocut — techniques of flat drawing, using overprinting of colour surfaces;

e) printing with light opaque colours on a darker tone base or on coloured paper;

f) iris printing — applying two or more colours to merge smoothly together with the drawing or background surface to achieve a special effect. (The colours are applied to the printing plate simultaneously from the same roller.)

Coloured inks for printing are manufactured by homogenization — the mechanical mixing of pigments or dyes with suitable ingredients (e.g. linseed varnish). The powder is then mixed to a smooth consistency.

For practical purposes the colours usually used in printing are:

1. bluish red or magenta
2. medium red
3. yellowish red
4. orange
5. reddish yellow
6. medium yellow
7. gold yellow
8. green
9. greenish blue or cyan
10. medium blue
11. dark blue
12. reddish blue
13. violet

To weaken any tone of colour a transparent, blending white is used. Nine of the colour tones in the scale are transparent and four are semi-opaque. To obtain opacity with bright colours Cremnitz white or zinc-white and lithophone are added. In three-colour printing three basic colours are used, numbers

1. bluish red (magenta) 7. gold yellow and 9. greenish blue (cyan)

In four-colour printing a neutral grey, brown or black is added. Most of the pigments used in printing are synthetic. Used individually or mixed they are chemically stable. It is best, however, to avoid mixing colours with a lead content (chrome yellow, Cremnitz white, minium) with pigments containing sulphur (vermilion, ultramarine, cadmium yellow, lithophone) as such mixtures blacken.

Black printing inks are made from soot obtained by burning various substances under low air access. Calcination of pulverized bones (bone black, also ivory or Paris black), pressed vines (vine or Frankfurt black), cork waste (cork black), or fruit kernels (kernel black) were originally used for the production of high quality, concentrated, table black colours of a warm shade, especially suitable for copperplate printing.

Today soot is obtained by the oxygenation of acetylene or by the distillation of natural gas — (the finest gas soot is called carbon black). The industry provides a wide range of special black colours for printing, such as illustration black, dabber black and transfer black. Their qualities are adapted to various printing techniques.

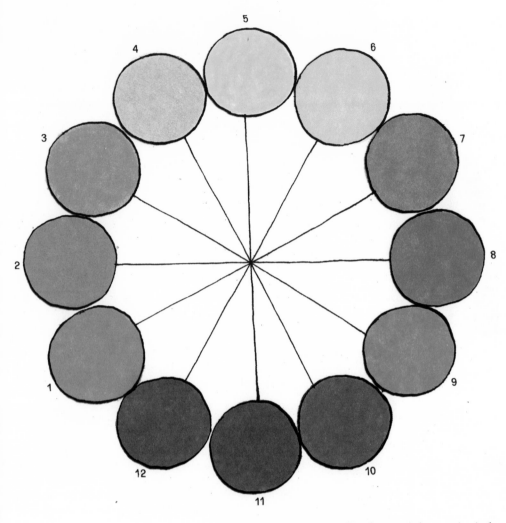

Twelve-part chromatic circle

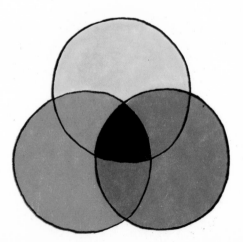

Diagram of the substractive mixing of primary colours

(I)
Josef Váchal (1884—1969)
The old engraver, 1954
Wood engraving in colour, made with rocking tool,
380 × 345

Printing
paper

Apart from the well chosen and well worked material of the printing plate and high quality inks the next requirement for a successful print is the use of good quality paper which suits the technique employed.

Paper has been made in the form known today since about AD 105. Tsai-Lun, an official of the Chinese Emperor's court, is thought to have been the originator of paper manufacture, and his invention soon spread to Korea and Japan. The basic material was the waste from silk manufacture or the long fibres of such plants as mulberry, hemp, bamboo, mitsumata. Western countries became acquainted with paper as the result of the Arabic conquests and the Crusades. Between the 12th and 14th centuries the knowledge spread from Spain to Italy, France, Germany and all over Europe. Until the 18th century paper was manufactured by hand. Old hemp, flax and cotton rags were washed in lye, boiled and ground to a fine pulp. This pulp (called paper milk) was lifted up in wire sieves, shaken to spread it out evenly and dispose of the superfluous water. Then it was tipped out on a felt pad, several sheets were pressed together to rid them of water, and the sheets were smoothed out and finally hung up to dry.

In the 18th century the manufacture of paper was to a large extent mechanized as a result of the construction of new grinding, boiling and rolling machines. In the middle of the 19th century a new raw material, wood pulp, was introduced, and later on cellulose from corn straw. This lowered the quality of the paper but production increased.

Today the required qualities of a specific type of paper are obtained by changing the ratio of the various raw materials. The highest quality paper is used for engravings and etchings and it should be made without any wood pulp or cellulose. (The wood content of a paper is determined by submerging it in a solution of 1 g of fluoroglucine in 50 cc of alcohol and 20 cc of muriatic acid.)

Paper for print-making is of different types and qualities: hand paper (hand pumped), copperplate carton, vellum paper (made from cloth waste, machine pumped), banknote paper, real Japanese and the imitation version Simili woodless paper for book-printing, intaglio printing, stone printing, offset, etc.

There are also transparent papers, smooth or with a structure, cartons and semi-cartons, which are white or chamois according to their colour. They are sold in different sizes and gram weights.

Brands of special graphic papers include: Arches, Fabriano, Ingres, Johannot, Lana, Losiny, Marais, Montval, Rives, van Gelden-Zonen, Vidalon, Zander and Zerkall.

Classification of original print-making techniques

Print-making techniques can be classified according to various criteria, firstly, according to the *material* used for making the printing plates or stencils: wood, stone, metal, rubber, etc., (in some cases derived terms have come into use, such as stone-printing, copperplate printing, steelplate printing).

Secondly, according to *the manner of working the printing plate* into: mechanical techniques (cutting or engraving in wood, metal or stone), chemical techniques (intaglio and relief etching, lithography) and photochemical techniques (photogravure, collotype).

The third and most useful means of classification is the division according to *the manner of printing,* that is, how the printing elements are placed on the printing plate — whether they are raised or hollowed out, whether they are in one plane with the other parts which are not printed or whether they are formed by the holes of the screen. From this point of view we get four groups of specific printing processes:

relief or letterpress printing,
intaglio printing,
planographic printing,
silk screen printing.

I. RELIEF OR LETTER-PRESS PRINTING

The oldest printing methods are those for letterpress. Their origin reaches far back into the cultural history of mankind and the manifold developments they have undergone throughout the ages have assured them of a basic and prominent position among all the other printing techniques.

The principle of relief printing consists of drawing the design on the printing plate or block and removing the parts that should not be printed from the surface of the plate by various mechanical, and in some cases chemical, means. Printing ink is applied to the remaining parts which have not been hollowed and therefore stand proud of the rest of the printing plate, and these areas are printed on paper with the application of pressure.

The printing plate or block can be made from a variety of materials: most frequently wood and metal, but also stone, loam or lino, paste, etc. The choice of the material and the method of working it give the printed drawing a specific character.

Techniques for making letterpress plates or blocks are:
stone engraving
woodcut
wood engraving (xylography)
photoxylography
chalk (Mässer) plate engraving
linocut and linoengraving
engraving in white on stippled background
metal engraving (metal-cut)
lead engraving
original zincography.

An impression can be pulled either by hand or by one of the types of relief printing presses. A modified copperplate press or lithographic press may also be used.

Letterpress is characterized by the sharply outlined, but flat, adhesion of ink on the paper. As a result of the pressure during printing the paper is slightly indented. This is apparent mainly on the reverse side.

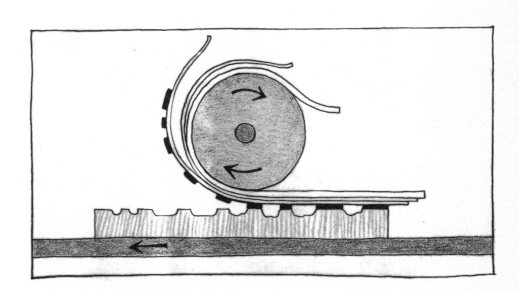

Diagram of letterpress printing

◁ (11)
Max Švabinský (1873—1962)
St John the Baptist, 1926
wood engraving, 715 × 480

THE TECHNIQUES OF PREPARING
AND PROCESSING PLATES
OR BLOCKS FOR RELIEF PRINTING

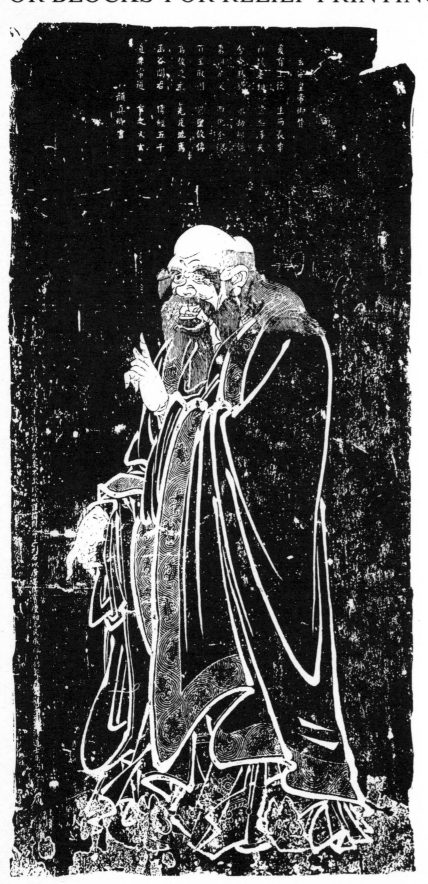

(12)
Unknown 13th century Chinese artist
(after Wu Dau-dsi, pre-700—750)
Portrait of the philosopher Lao-tse, 12
rubbing of stone engraving, 172 × 870

(13) ▷
Lucy (Canadian Eskimo folk artist)
Mountain bird, 1968
stone engraving

Engraving in stone

Stone is one of the oldest materials used for making relief printing plates. It was used for small stamps used to mark the property of privileged classes in Ancient Egypt and Babylon. In Ancient China similar stamps were used by artists for marking their literary or painted works. In China the technique of stone engraving gained importance at the beginning of the seventh century AD (T'ang Dynasty), when it was used for reproducing ink drawings by great painters. The soft flat stone was usually engraved or scraped by hollowing out the actual line drawing, and a negative, i.e. white impression on a dark grainy background was obtained. Impressions with a dominant positive drawing are relatively scarce in China, but are more frequent in Japan where stone engraving was brought to a high level of technical perfection and was used as a reproductive means until the end of the 15th century.

Stone was replaced by the more workable medium of wood, and stone was used only occasionally. The experiments of Michael Gerecht of Klosterneuburg near Vienna around 1530 are worth mentioning; but Gerecht, in an attempt to obtain a letterpress plate, etched rather than engraved the stone. Nowadays engraving in stone is largely confined to some ethnic groups, for example the Eskimo people, for whom other materials are not easily accessible.

The woodcut

The woodcut is a very old and the most widely used relief technique. The wooden block is cut from the length of a trunk and is then worked whith sharp knives and gouges to remove the non-printing areas. The design remains above the level of the rest of the wood and, after the ink has been applied, can be printed.

The development of the woodcut

The methods of printing fabric with ornamental, often multicoloured, designs used by the ancient Indians and Arabs were the predecessors of the woodcut as a print-making technique. In Ancient Rome property was also marked with wooden stamps called *tesserae signatoriae.*

But the most important development in this technique occurred in the Far East, partly as a result of the invention of paper manufactured from silk waste around AD 105. The idea of using cut wood blocks probably came from Korea around AD 751, but was soon taken over and developed in China during the T'ang Dynasty (618—906). The beginnings of the ancient eastern woodcut therefore precede the emergence of this technique in Europe by seven centuries. By then it was not only the drawings themselves that were reproduced but also the various accompanying texts which were cut in the same printing block (this is called *plate printing).* By assembling individual plate prints into folds, block books, as they were called, were made. The oldest known book of this kind is the *Diamond Sutra,* dated AD 868, which has six pages of half-page woodcut drawings. The lengthy production of block books was replaced in the year 1050 by the composition of texts from individual signs cut in wood; as a result there was a rapid increase of learning during the Sung Dynasty (961—1279). The emergence of the woodcut in the form of separate prints came about mainly as a result of the work of unsophisticated vernacular artists, who began to organize themselves into woodcutting workshops during the 12th century. At that time the technique of coloured woodcuts was already highly developed. In an attempt to equal the flowering art of scroll painting, black-and-white impressions were livened up with red made from cochineal and, later on, blue indigo. Soon the technique of multicoloured woodcuts developed to perfection and resulted in the creation of a number of outstanding works, in particular those of the painter Hu Cheng-yen from Nanking (1582?—1671?).

The technique of the woodcut reached Japan towards the end of the 18th century, along with other aspects of Chinese culture and the Buddhist religion. Books were printed in the Chinese manner, for example the 12th century *Sutra Texts on a Fan*. Later, in 1582, the first book was published using movable characters imported from China.

Early Japanese prints were votive pictures created in specialized woodcutters' workshops associated with religious centres, where each one of the woodcutters usually concentrated on a different aspect of the drawing, for example the face, garments or landscape. But from the beginning of the 17th century the production of woodcuts turned towards secular themes. Illustrations for classical and vernacular literature, picture albums and finally even individual graphic works were made in the so-called plebeian schools of Edo (modern Tokyo), Kyoto and Osaka. The vernacular artists gathered in these schools produced works marked by a live, realistic design, although lacking modelling and perspective in the European sense.

In so doing they created a most distinctive style, freed from Chinese influence, which was built on calligraphic drawing and a simplicity of design. Early woodcuts were printed in monochrome, sometimes complemented with a colour applied by hand. It was only in the middle of the 18th century that from 2 to 4 colour process blocks were added to the basic black block.

The Japanese colour woodcut is often very different from the Chinese woodcut. Whereas the Chinese colour woodcut attempts to reproduce as accurately as possible the effect of brush strokes and ink tones, the Japanese woodcut is developed from the character of their coloured drawings. This results in some technical dissimilarities, for example the use of opaque coloured inks, the cutting of blocks of the same size with readable characters, etc.

The foremost artists of the classical Japanese woodcut are Nishikawa Sukenobu (1677—1754), Suzuki Harunobu (1725—1770), Kitagawa Utamaro (1753—1806) — a pioneer of multicoloured printing — and especially the great master of this tradition, Katsushika Hokusai (1760—1849). Towards the end of the 19th century the Japanese woodcut strongly influenced the development of modern European painting, whereas in Japan it suffered a slow decline. This was the result of the non-existence of modern painters — graphic artists in our sense of the word, who could bring new creative impulses to the craft, which otherwise concentrated only on attaining reproductive dexterity.

In Europe the introduction of the woodcut as a printing technique dates from the end of the 14th century. The development here was also substantially influenced by the introduction of the manufacture of paper, the secret of which was

(14)
Bavarian master (around 1480)
Christ in the tomb with emblems of torture
woodcut with traces of polychroming, 226 × 160

brought from the Orient during the Crusades. Parchment was replaced by this cheaper material. The character of early woodcuts was determined by the simple means used: a simple, sometimes even clumsy, contour drawing, which lacked tonal value was cut with a knife in a block of pear or linden wood. Both the application of ink, using dabbers, and the pulling were done by hand. Impressions or some of the details were often coloured with inks using stencils.

The first European woodcuts were made as individual impressions, printed on one side. They were mainly holy pictures, intended as wall pictures, although they were also used for secular things, such as playing cards. Historians differ as to which of the known works is the oldest. These include the fragment of *The Crucifixion* (dated to 1370—1380), found in Mâcon in France, which represents a centurion with two soldiers below the cross; probably originating from Bohemia are the woodcuts *Christ in the Garden of Gethsemane*

ce ligatura alla fistula tubale, Gli altri dui cú ueterrimi cornitibici con⸗
cordi ciascuno & cum gli instrumenti delle Equitante nymphe.
 Sotto lequale triũphale seiughe era laxide nel meditullo , Nelq̃le gli
rotali radii erano infixi , deliniamento Balustico ,graciliscenti seposa
negli mucronati labii cum uno pomulo alla circunferentia . Elquale
Polo era di finissimo & ponderoso oro, repudiante el rodicabile erugi⸗
ne,& lo'incédioso Vulcano,della uirtute & pace exitiale ueneno. Sum⸗
mamente dagli festigianti celebrato,cum moderate ,& repentine
riuolutióe intorno saltanti,cum solemnissimi plausi, cum
gli habiti cincti di fasceole uolitante, Et le sedente so⸗
pra gli trahenti centauri. La Sancta cagione,
& diuino mysterio,inuoce cósone & car⸗
mini cancionali cum extre
ma exultatione amo⸗
rosamente lauda
uano.
✳✳
✳

dating from about the end of the 14th century and the *Rest on the Flight into Egypt* circa 1410. *St. Christopher* from 1423 is the oldest positively dated woodcut and it was discovered in the Buxheim convent in Germany.

In early prints the drawings were often accompanied by short texts which were either incorporated in the drawing or placed alongside it but always cut from the same printing block. Prints of this kind, created before the advent of book printing, are called *plate prints*. They have been preserved only exceptionally and the majority of those known today come from the regions of Bavaria, Swabia, Bohemia and the alpine countries. The idea of combining the texts of the plate prints

(17)
Hans Burgkmair the Elder
(1473—1531)
Unkeusch (Obscenity), from the cycle
The seven sins, 1510
woodcut, 2nd state, 168 × 72

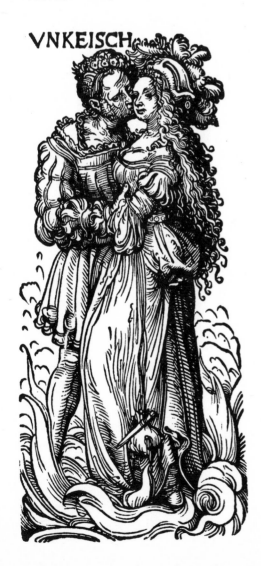

(18)
Hans Baldung, called Grien (c. 1484—1545)
St Thomas the Apostle, 1519
woodcut, 209 × 126

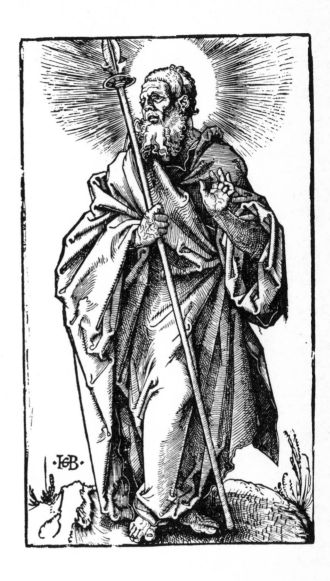

into continuous sequences similar to written books appears soon afterwards. However, unprinted pages were also glued together; the leaves were bound to make *block books*, as they were called. These are very rare — only about a hundred books of this kind have been preserved. The best known theme, already widely circulated in hand-written form in their time, is the picture typology of New Testament and Old Testament complements called *Biblia pauperum (Biblia picta);* the oldest printed edition (1430—1440) is preserved as a unique example in the University Library of Heidelberg. A high standard of woodcutting work can be found in block books from the

(19)
Albrecht Altdorfer (1480—1538)
Abraham's offering, 1520
woodcut, 122 × 93

book printing and therefore also for the basic European contribution to the spread of culture. It is considered that the best work attributed to Gutenberg is the typographically anonymous two-volume '42-line Bible' in Latin, printed around 1454—1456 in a maximum number of 35 parchment and 165 paper copies of folio format.

The period when the art of book printing was still in its infancy (hence the origin of the expression *incunabula,* books printed before 1501) is characterized by a strong tendency to imitate the handwritten book in printed letters, book layout and design. The internationally accepted date for *first prints* is 1500; a prerequisite of the further phases of development was the creation of a commercial basis for typographical material. Whereas originally the drawing, its cutting and hand printing were the work of one individual artist, now, with the development of printing houses, woodcutters began to form new specialized guilds. From an aesthetic point of view the art of book making was strongly influenced by the Italian Renaissance; one of the most perfect examples of a Renaissance book as a perfectly harmonious typographic and illustrative work is the *Hypnerotomachia Poliphili (The Dream of Poliphilos),* a love story written by the Dominican monk Francesco Colonna, illustrated with 168 woodcuts and printed in 1499 by Aldo Manuzio in Venice.

The Nuremberg painter Michael Wolgemut figures prominently among the first non-anonymous illustrators. Together with Wilhelm Pleydenwurff he decorated, with 1,809 woodcuts, the *Chronicle of the World* by Hartmann Schedel, which was published in 1493 in Latin *Liber Chronicarum* and in German *Die Weltchronik* at Koberger's in Nuremberg. This was the most profusely illustrated work of the 15th century and its popularity led to several smaller reprints. But it was Wolgemut's pupil Albrecht Dürer (1471—1528), one of the greatest of print-making artists, who really freed the woodcut from dependence on the book and gave it equal status with painting. Although he used other techniques, Dürer's extensive work in this field, for example the cycles *The Great Passion, The Apocalypse, The life of the Virgin Mary* or *The Minor Passion* are proofs of the unequalled mastery and limitless inventiveness of this artist.

Other notable creators of the archaic woodcut are Hans Holbein the Younger (1497/98—1543), Lucas Cranach the Elder (1472—1553), Lucas van Leyden (1494—1533) and Erhard Altdorfer (around 1485—1561), who in 1533 made woodcuts for Luther's Bible. Another development occurred at this time: a number af artists schooled their own woodcutters, making drawings for them directly onto the wooden plates which were then copied with absolute accuracy. These drawings were already a long way from the simple linear efforts of the early woodcutters; indeed they

Netherlands, for example in the *Ars Moriendi (The Art of Dying)* from 1460, which is preserved in the British Museum. Plate prints were also used for compiling primers and textbooks called *donates,* after Aelius Donatus, the author of the then popular Latin grammar.

A little later it became usual to separate the illustrations from the text. To start with, whole passages of text were cut on separate blocks and these were placed beside the drawing during printing. But in the 1450s Johannes Gensfleisch, called Gutenberg (c. 1397—1468), introduced the epoch-making idea of composing whole pages of text using individual letters. (The oldest attested print is dated 1454, the first authentic impression 14th August 1457.) To this discovery by the Mainz Master (later others solved the problem of casting letters in metal, discovered the appropriate printing inks and the correct construction of the printing press) we are indebted for the inception of

(20)
Lucas Cranach the Elder (1472—1553)
St Anthony carried off by demons, 1506
woodcut, 406 × 280

(21)
Urs Graf (c. 1485—1527)
The flag bearer of Lucerne, 1521
White line woodcut, 191 × 107

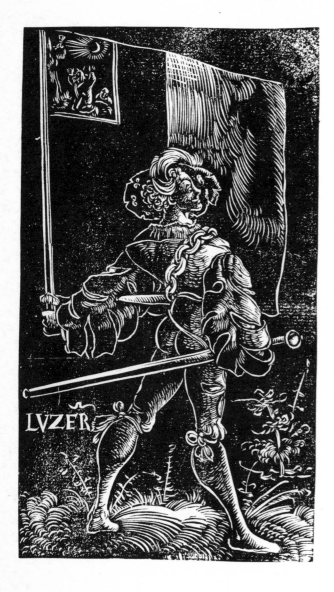

made full use of cross-hatching for modelling forms. The most common was the black drawing on a white background, and it played a most important role in the history of relief printing. But attempts were made to try other alternatives. One of these was the *white line woodcut (Weislinien-holzschnitt),* in which the drawing is reproduced in negative and shines out from the dark surface of the background. This type of woodcut appeared in Switzerland and its main protagonist was Urs Graf (c. 1485—1527).

The woodcut came nearest to painting with the introduction of the *chiaroscuro woodcut* technique, which imitated the effects of drawing with diluted ink on toned paper with the highlights painted in white; all the more so because bright colours were used in the printing process. Perfect chiaroscuro effects were achieved with the superimposed impressions of several blocks with graded half-tones. Credit for first using this method is given to Jost van Negker (1485—1544) from the Netherlands, who was using it in 1508, but it was also claimed by the Italian painter Ugo da Carpi (1480—1532), who was granted a concession for chiaroscuro in 1516 by the Senate of Venice. Outstanding results were obtained with this technique by Hans Burgkmair the Elder (1473—1531) and Hans Grien Baldung (1484/5—1545); but it was nevertheless most popular in Italy.

From the end of the 16th century the woodcut had to withstand tremendous competition from copper engraving and etching, with their richness of tone and potential for finer execution. It was even replaced in a field as much its own as the design of a typographical book produced by the technique of relief printing. Some artists attempted to maintain the technique of woodcutting on an imaginative artistic level; among them, in the Netherlands, were Plantin's collaborator Christoffel Jegher (1596—1652), who worked from drawings on wood by Rubens, and Jan Lievens (1607—1674), the pupil of Rembrandt, and in France Jean Michel Papillon (1698—1776), from whose extensive work the most worthy of note are illustrations to La Fontaine's *Fables*. He also wrote an excellent handbook *Traité historique et pratique de la gravure en bois* (1776); but on the whole it seemed as if the artistic potential of woodcutting had been completely used up. After Bewick's discovery of wood engraving in 1771, the attention of printmakers turned to this new medium.

It was almost a century before artists rediscovered the virtues of woodcutting — namely its simplicity and strength of expression. By that time there were no woodcutting workshops left and so even the actual manufacture reverted into the hands of the painter-print-maker. The revival movement spread, on the one hand from England — in connection with the influence of the bibliophile printer William Morris (1834—1896) based on the development of fine bookmaking — and on the other from France, where a number of strong individual talents, inspired perhaps by the work of mediaeval vernacular woodcutters, were working. Among these an important position is held by the characteristic work of Paul Gauguin (1848—1903), who illustrated his autobiographical novel from Tahiti *Noa-Noa* with woodcuts. The woodcut became an especially important medium for artists with a bias toward expressionism, such as the Norwegian Edvard Munch (1863—1944), the Swiss Félix Vallotton (1865—1925), the Frenchmen Georges Rouault (1871—1958) and

(22)
Hendrick Goltzius (1558—1617)
Night, from the cycle *Two ancient gods*, 1588
chiaroscuro woodcut, printed in black and grey,
348 × 265

Maurice Vlaminck (1876—1958), the Flemish Frans Masereel (1889—1972), the Germans Emil Nolde (1867—1956) and Ludwig Ernst Kirchner (1880—1938) both members of the Dresden *Die Brücke* group. Franz Marc (1880—1916), co-founder of the Munich group *Der Blaue Reiter,* Käthe Kollwitz (1867—1945), with her bias towards social themes and František Bílek (1872—1941), the sculptor and graphic artist from Prague, were among other artists who successfully used this medium. A rare attempt to revive the mediaeval block book is found in the work of the Czech graphic artist Josef Váchal (1884—1969).

With the coming of non-figurative art the interest of artists in this technique declined somewhat although both Jean Arp (1887—1966) and František Kupka (1871—1957), continued to open up new possibilities in woodcutting.

The technique of the woodcut

The preparation of the wood block

The correct choice of wood for the preparation of the wood block is a basic prerequisite; it determines the resulting character of the printed design and the success of the cutter's work. For finer work the hard wood of the pear, apple or walnut tree is used, although for more straightforward cutting the softer wood of the lime or poplar is sufficient. The wood must be perfectly dry without cracks or knots. The round timber is cut

P.P.Rub. delin. & excud. CVM PRIVILEGIIS. Christoffel Iegher sc.

(23)
Cristoffel Jegher (1596—1652)
after Rubens
The coronation of the Virgin Mary
woodcut, 338 × 443

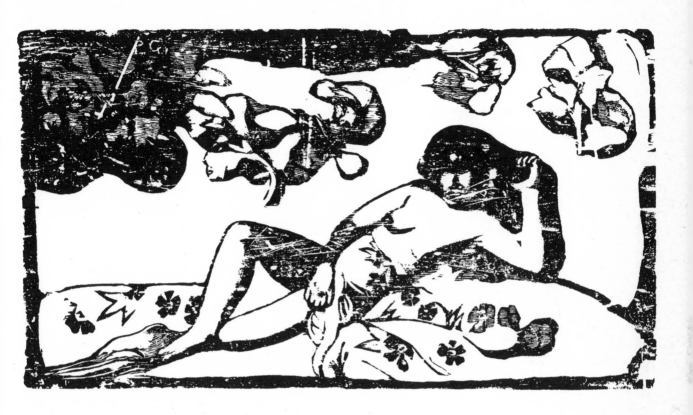

longitudinally into several boards of the same thickness (approximately 25 mm). The boards taken from the core of the tree trunk are the best as they have by far the densest annual rings. The boards taken from the perimeter become deformed as they dry out and are liable to crack during printing. The boards are planed down over the whole of their surface to the same thickness; this may vary in the case of hand printing, but in the case of book printing it must not exceed the height of typographic lettering, i.e. 23.566 mm. Some artists intentionally use blocks on which the natural structure of the wood stands out and shows on the impression. The boards are then cut into various rectangular formats according to need, impregnated with oil or grease in order to limit the deformations of the wood and help close the pores, and then left to dry out.

Laying out the design

The drawing can be laid out on the wood block in several ways. It can be sketched in pencil and traced in ink either directly on the wood or on a surface covered with a thin layer of zinc white with a water solution of gum Arabic. If working from a preparatory drawing made by pen or brush on paper it is transferred with the help of tracing and copying paper. Alternatively, the wood can be covered with a thin layer of ink and the drawing can be traced through paper covered with one of the lighter clay washes. The Japanese method uses thin tracing paper with an ink drawing glued directly onto the block with a water soluble adhesive applied over the whole surface and the cutting is then done through the paper.

In contemporary woodcuts the design is often cut with a knife directly in the block, cutting only the surface, and this produces a characteristic grid of negative lines in the impression.

In the case of both direct or transferred drawing the resulting impression will be a mirror image. The transfer drawing must therefore be placed with the drawing facing the wood.

During the drawing one tries to avoid, as far as possible, a too frequent crossing of lines, for example in shades; such parts are very difficult to cut. To achieve different tone values or modelling parallel lines are used.

(25)
Ernst Zmeták (b. 1919)
Village woman, 1947
woodcut, 420 × 330

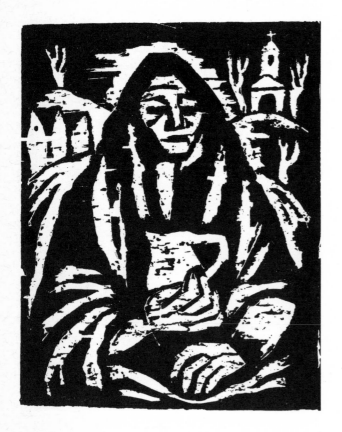

In this way one proceeds slowly from details to larger parts and when the design has been cut from both sides the remaining wood mass is removed with semicircular gouges of various sizes. When removing large areas without lines the gouge is applied to greater depth, sometimes using wooden mallets, so that the printing ink will not adhere to them.

The instruments used should be of high quality steel, well tempered and finely sharpened. During work they are kept sharp on a well oiled whetstone.

A higher rim is usually left on the perimeter of the design; this protects the larger gouged out areas from smudging when the ink is rolled on; but of course it has an aesthetic function as well.

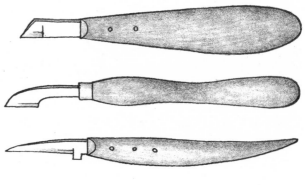

Cutting

The lines of the design made on the block, as described on the previous page, are carefully followed with a selection of sharp steel knives with short blades, fixed in firm wooden handles. Knives of various shapes can be used to make even the sharpest of lines. They are held either in the fist, thumb upwards, in the case of pronounced lines, or like a pen for details. The cut should always be made from the top downwards, towards the cutter. The knife is held slightly at an angle and the next incision, which is inclined in the opposite direction, removes the wood beside the lines. If the lines are parallel, incisions are made from one side, then the plate is turned around and cut in the opposite direction. In such cases it is useful to place the wood block on a leather cushion filled with sand, which enables the block to be turned easily. The depth of the incision depends on the density of the design. The incisions must be such that the lines have a tapering cross-section and that they are not undercut, otherwise they may break during printing.

Various types of knives and gouges for the woodcut

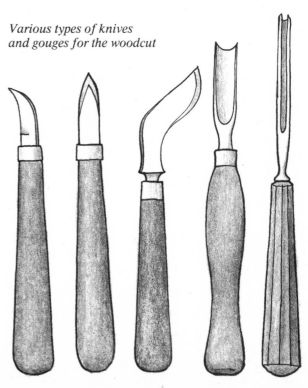

(II)
Ugo da Carpi (1480—1532)
after Raffael da Urbino
David killing Goliath
chiaroscuro woodcut, 261 × 387

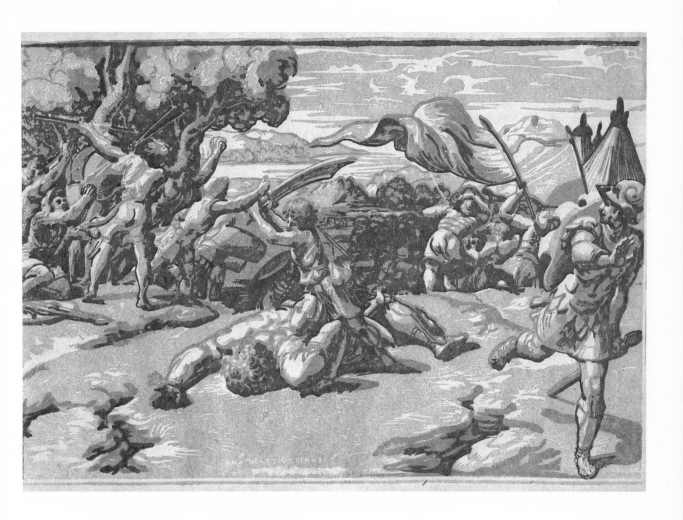

During cutting it is useful to make *states* or test impressions. These serve as a basis for making corrections until the final form of the woodcut is reached. Corrections of any parts damaged with careless scratches or by knocking the wood with an instrument are made quite easily; the area is moistened with a brush and water until it straightens out, although this sometimes takes 10—12 hours. The areas that have been incorrectly made, cut away or undercut can be mended only by extricating the faulty part and inserting a wooden plug of the same size, which is glued into the hole. The drawing is then made again.

(III)
Unknown 18th century artist from the
Ten Bamboos Studio, Nanking
Plum blossom over water
left half of a two-page illustration to
the book
*The Painter's Manual of the Garden
of the Mustard Seed,* 1782
woodcut in colour, 225 × 280 (both
halves)

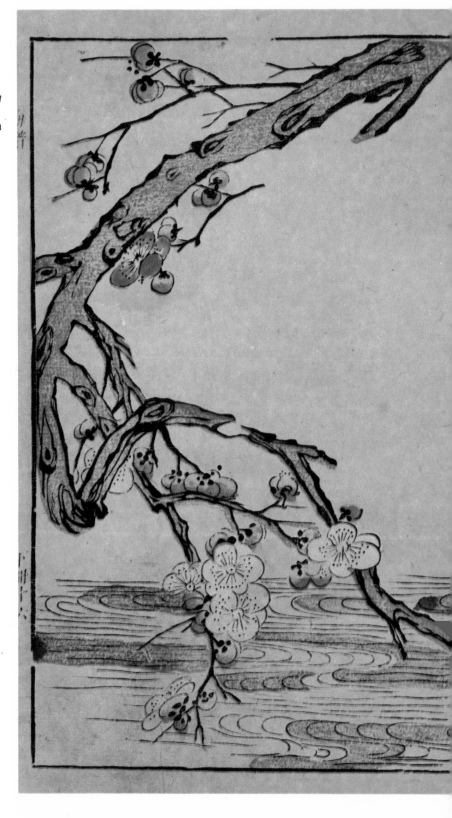

(IV)
Shumbaisai Hokuei (active between 1825—1843)
Fighting
woodcut in colour, 373 × 263

(V)
Josef Váchal (1884—1969)
The island of the blissful, 1912
woodcut in colour, 208 × 206

Wood engraving (xylography)

The technique of wood engraving developed from the original concept of the woodcut. But in this case the hardwood blocks are not cut longitudinally but across the wood trunk, and instead of knives copper engraving burins are used.

The development of wood engraving

In 1775 the Society of Arts in London held a competition for the best original woodcut in an attempt to promote the declining standard of print-making. The prize was won by a young English engraver Thomas Bewick (1753—1828), who used copper engraving burins on a smoothed boxwood block cut across the grain. He thus invented a technique which gave easier handling of the wood mass and made a richer gradation of tone values possible. Because of this its use soon spread, and for a long time it held a dominant position in book printing. The new technical possibilities were of course adopted mainly by specialized reproductive engravers, xylographers, who achieved such perfection that many great printer-illustrators made drawings for them directly onto the blocks and left the execution of the wood engraving entirely to their craftmanship.

In wood engraving there are two main methods of work: *facsimile wood engraving* where the engraver accurately follows the individual lines of the artist's pen drawing, and *tone engraving* where the xylographer freely transfers tones of a wash drawing, painting or photograph into a system of parallel lines. In this way the interpreter can, assuming he has a creative gift, express the modelling of the painter's drawing, and the richness of tone of the original design.

Important French artist-illustrators of the 19th century, such as Honoré Daumier (1810—1879) and Gustave Doré (1832—1883), who created the illustrations for Dante's *Divine Comedy,* the Bible and Cervantes' *Don Quixote,* worked with inspired engravers such as Henri Monier, Pisano, Paul Gusman and others. In the second half of the century a school for xylographers was formed around the painter-engraver Auguste Lepère.

As a result of the development of the book printing industry more rational reproductive methods asserted themselves and *photoxylography* was introduced. The design was transferred onto the plate photomechanically and engraved with parallel line gravers and interrupted line engraving machines. The development of coloured wood engraving, *chromoxylography,* went no further than mere reproduction and it tried to imitate painting by printing from a large number of blocks. Nevertheless, these techniques, though important in their time, were soon replaced by the technique of zincography.

But the tradition of good wood engraving did not die out. It moved on to original print-making and more creative tasks. A number of artists learned the technique of wood engraving perfectly; step by step they discarded means that were incompatible with style, they simplified the design and almost completely stopped using the ribbon gravers. With the approach of the modern enthusiasm for creativity the whole method of building up the drawing and even the way of using the graver became more free.

Nowadays wood engraving is used mainly for individual prints and it is a pity that it is so seldom used in book design. The boxwood block, which can be a homogeneous complement of the composition capable of withstanding even a large number of impressions, would enable the printmaker to contribute directly to the book-printing process without any intermediary steps.

(26)
Thomas Bewick (1753—1828)
illustration for his book *A History of British Birds,*
1809 wood engraving

(27)
Gustave Doré (1832—1883)
engraved by Pisano
illustration to
Dante's *Inferno*, 1861
wood engraving, 245 × 195

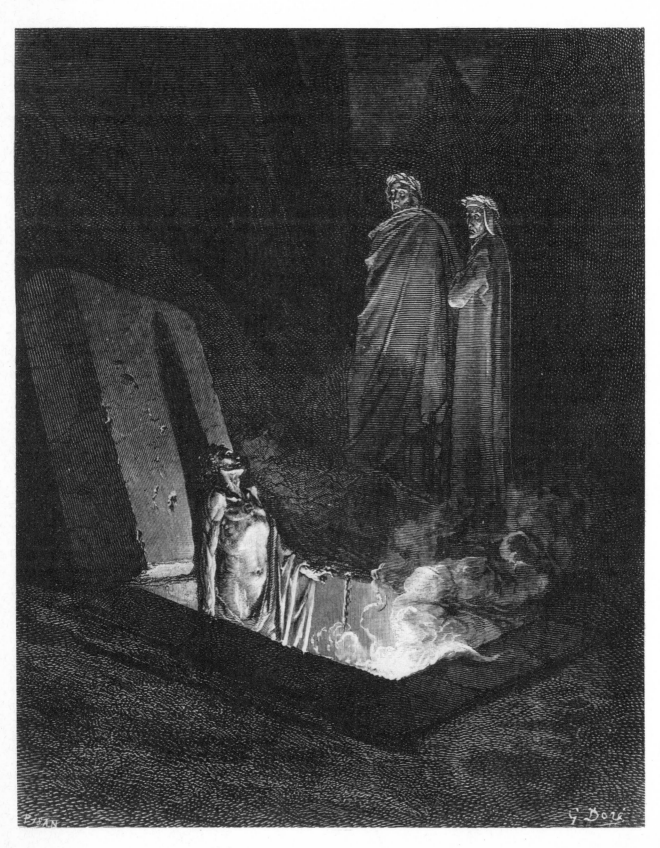

The technique
of wood engraving

The preparation of the wood block

For fine wood engraving work the most suitable wood is hard and thick boxwood which is usually imported from America or the Orient. For simple designs the more easily obtainable pearwood is adequate.

Blocks are bought ready-made in specialist shops or they can be made at home. A healthy tree trunk (felled in winter when the water content is lowest) is cut lengthwise into planks which are left to dry for at least a year in the open air, although they must be protected against the influence of the rain and the sun's rays. Wood dried in atmospheric air still needs to be dried in a heated space. The whole process can be speeded up in the drying chamber of a wood-processing factory.

The dried planks (the best are those from the trunk's core where the fibres are densest) are planed off on both sides and glued into the form of a rectangular prism about 40—60 cm long in such a way that the centres and the edges of the annual rings are next to each other. After further drying, this prism is again cut lengthwise but at a right angle to the original cut. The surfaces of the planks are planed off and glued together once again, but this time they are shifted so as to form a rigid chess-board pattern, which resists torsion and volume changes. The final cutting and planing on a machine to a uniform height of 23.5 mm gives several equal blocks. After smoothing with fine sandpaper they are impregnated from all sides to saturation point with tepid linseed oil and left to dry for several days. Finally the areas for engraving are dusted with finely ground pumice with a few drops of polish (a solution of 5 dg of shellac and 500 cc of methylated alcohol) and are polished to a high gloss with circular movements of a linen dabber.

Laying out the design

In wood engraving the whole design, including the tones, is transferred into an exact system of drawn lines. Therefore it is almost always necessary to proceed according to an auxiliary drawing, which is made first of all with a pen on paper or better still on a transparent plastic sheet such as Astrafoil; this simplifies the making of the mirror image. An ink wash drawing can serve as a model, whose tones are then freely translated into a graphic form with ribbon gravers. The design is transferred from the transparent paper onto the block by copying the contours. Indigo copying paper is used and the drawing is completed with Indian ink. To avoid coagulation of the ink on the polished surface several drops of ox gall can be added, or it is mixed with lithographic ink in the ratio of 2 : 1 (this ink is also used for drawing on the plastic sheets).

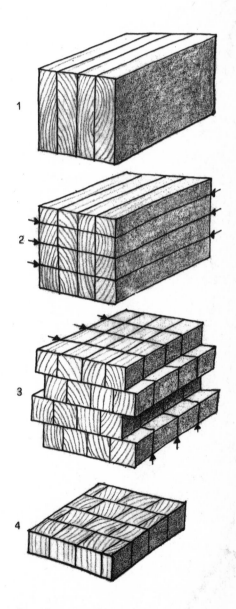

The procedure for assembling the wood engraving block

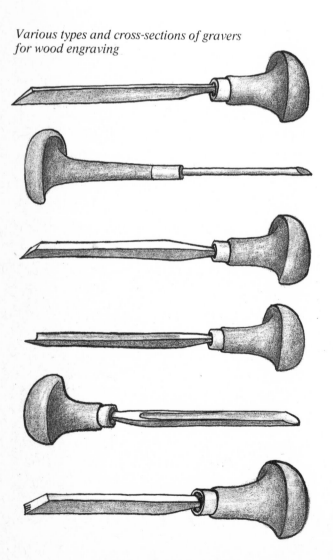

Various types and cross-sections of gravers for wood engraving

Engraving

Wood gravers used for producing the engraving are made from high-quality, well-tempered steel. The blades, of various section, are contained in a mushroom-shaped wooden holder, with the underside cut away. The length of the graver should not exceed 11 cm, as a longer instrument is hard to guide with the fingers.

The graver is held firmly between thumb and index finger and the handle is supported firmly by the centre of the palm. In this way one can regulate not only the route but also the depth of the incision, which is given by the angle of the graver to the surface of the block. At the same time the left hand holds the block, which rests on a rounded cushion filled with sand to ensure easy turning against the movement of the graver. The plate can also be held in a special vice.

The character of the incision depends on the

(28)
José Guadalupe Posada (1851—1913)
The Ghost of Don Quixote
wood engraving, impression on grey-blue paper,
150 × 275

(29)
František Bílek (1872—1941)
5th print from the cycle *Supreme Justice*
wood engraving, 216 × 147

(31)
Josef Váchal (1884—1969)
print from the cycle *Mystics and Visionaries,* 1913
wood engraving, 210 × 210

The correct way of holding the graver and the working position

shape of the blade. A narrow graver with a sharp point is used for fine and narrow lines; a graver with a flat tip for lines of a uniform width; a graver with a triangular section is used for incisions which broaden strongly; dense parallel lines are made with a ribbon graver; curves are made with gravers with rounded sides (with a lens-shaped or drop-shaped section). For work on details the best results are obtained with curved gravers. Semicircular gouges are used for removing larger areas.

To make sure the graver is easy to control it is necessary to sharpen it regularly on a fine whetstone made of hard natural sandstone. Several drops of machine oil are used for the purpose. When not working, the edges are protected by a cork.

The correct exectuion of the engraving is tested throughout the work on test impressions, called *states;* these are made by hand with a whalebone,

45

Photoxylography

(32)
František Kupka (1871—1957)
10th print from the cycle *Quatre histoires de blanc et noir,* 1927
woodcut, 203 × 155

In some cases transferring the design onto the engraving material can be made simpler by copying its negative photomechanically.

A thin layer of light-sensitive emulsion is applied to the smooth surface of a wooden block, with all traces of grease removed:

 10 cc fresh egg white, or 2 g powdery albumen
 250 cc of distilled water
 10 cc ammonia.

This emulsion — while still moist — is powdered with white pigment. After it has dried, the block is given a *preparation coating:*

 4 g gelatine
 15 cc of a 40% solution of chromium alum
 100 cc of hot water.

After the coating has hardened the following solutions aplied:

 60 g of silver nitrate
 500 cc of distilled water
 2—3 drops of nitric acid

The negative of the design, which is made to the same size, is placed facing the surface of the printing block (prepare as described above), weighed down with a glass plate and exposed under a strong light. The copy is stabilized with a fixing solution and after drying out an acetone varnish is applied.

back of a tablespoon or similar smooth surface, on thin paper.

Faulty parts of the engraving can be corrected only by cutting them out with a sharp knife and by inserting and glueing in a plug of the same size. After 3—4 hours the dried surface is carefully ground down and the missing part of the design is filled in. Undesirable small incisions are removed by filling them with mastic (and/or plastic wood); a thick cement made of dissolved chalk, wood flour and fast-drying varnish is applied with a small knife, and when it has dried it is smoothed off.

An engraver's vice, which can be used for all engraving techniques (the plate is held by the jaws which move on a rod with a left-hand and right-hand thread)

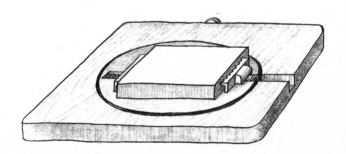

Chalk (Mässer) plate engraving

Wood engraving material is too expensive to waste. For small-scale work (e.g. greetings cards, book plates) and also for engraving bright colours for coloured wood engravings, one can replace the wood with the *Mässer plate,* which can be either bought or made at home. This plate, with a thickness of approximately 1.5—2 mm, is formed by a layer of whiting suspended in fish glue, floated onto the surface of the paper and smoothed out.

It is worked in exactly the same way as wood: both gravers and needle points can be used, and since the chalk is less resistant than the wood it means that other techniques can also be used.

First of all the plate must be glued to a hard base of plywood or wooden board if it is to be machine printed. The design is then drawn with Indian ink. The completed engraving is reinforced with a solution of shellac.

A drawing engraved on a Mässer plate may also serve as a model for a zinc plate as it imitates the original illustration engraved in wood.

(33)
Aleš Krejča (b. 1941)
The sign, illustration to the book *Woodworm Light* by Pavel Šrut, 1968
Mässer plate engraving, 170 × 100

The folding stick and scraping disc (made of steel or hard wood) for relief printing by hand

Linocut
and lino engraving

Cork lino is most suitable for expressive drawings with simple shapes, especially if they are of a large format (for example posters), as it is much easier to work with than hard wood. It can, as a cheap substitute, also be used for coloured woodcuts or wood engravings where the basic black-and-white drawing is made in wood and the other bright colours are made on individual lino plates.

Hollow lino engravers' gouges are used for lino engravings. They are pressed from steel sheets, V- or U-shaped sections and are fixed in wooden handles. Knives of the kind encountered in woodcutting are used for cutting.

Before starting work the lino is glued to plywood, or if printing with a machine, onto a wooden board, so that the height of the block is 23.5 mm. The lino is cleaned with spirit before using and then the auxiliary drawing is transferred onto the surface of the lino with copying paper from a transparency.

The method of working is the same in principle as when working with a wooden block, but the relatively brittle and crumbling nature of the material does not permit a too finely detailed

(34)
František Kysela (1881—1941)
Mandrake, illustration
lino engraving, 208 × 164

A knife and a selection of gravers for lino engraving

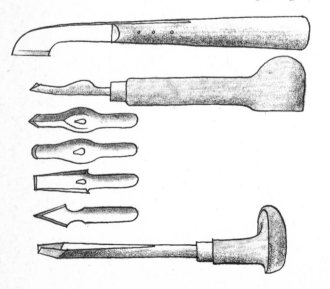

drawing. If fine lines are cut they will break off. Large white areas without any drawing are cut through to the base and the whole of the lino layer is removed, leaving only the base plate.

Lino gravers get blunt quickly. Their inner cutting edges are sharpened during work with fine grained carborundum whetstones or the appropriate triangular or semicircular files.

Nowadays other types of flooring material are successfully used in print-making, in particular PVC sheets. The cost is low, their hardness is combined with elasticity and they have stable volume. These factors make the engraving even of detailed designs possible. PVC is, in many ways, better than classical materials.

(35)
Ján Lebiš (b. 1931)
Sitting nude, 1955
intaglio engraving, 585 × 395

Engraving in white on stippled background

Metal engraving (metal-cut)

In the second half of the 15ᵗʰ century a small number of impressions (nowadays very rare) were made from metal plates prepared for relief printing by stamping. The smooth surface of the copper plate was perforated with awls of various shapes, e.g. stars, circles and crosses, in places which were not meant to be printed, whereas the untouched metal was printed after paint was applied with a dabber.

The form-giving elements are usually white contours (hence they are also called white cuts) and black surfaces enlivened with a more or less decorative application of hatching, points or ornaments.

This distinctive technique came from the metal workers' workshops of the Lower Rhine but it is also directly connected with the awl technique of decorating book bindings. The oldest known dated print is the *St Bernard of Siena* of 1454.

Although the technique of engraving in white on a stippled background disappeared during the 15ᵗʰ century, its principles can be used nowadays even if only as a supplement to other relief printing techniques.

Relief plates can be made from metal as well as from wood. Probably the first attempt of this kind, which was not repeated for a long time, was made in Japan, where, as early as AD 764, scrolls with Buddhist texts were made in this way; the Empress Koken (Shōtoku Tennō) then had them sent to all the temples. The text was engraved in relief on small copper plates and printed with a dabber method. It is therefore a copper engraving (p 67) with the difference that the design itself is not engraved in depth but is proud on the plate; the printing ink is applied to it, not into the hollowed-out places.

This method is seldom used nowadays, as it provides only very few new technical or creative possibilities. Compared to wood engraving it is difficult to make and it lacks the fineness and accuracy of copper line engravings.

Mention should be made in this connection of a technical speciality which can be used in the case of a copper engraving in depth, combined with the printing of the raised parts of the plate. A two-coloured impression can be obtained in one printing process from intaglio and relief which produces a special artistic effect. First of all, copperplate printing inks, usually for the basic, dark-bearing drawing, are applied into the engraved lines. Then the bright, book-printing inks are applied with a dabber or roller. The light and colour values can of course be reversed.

(36)
Unknown German artist (around 1450)
St Christopher
engraving in white on stipple background, detail

Engraving in lead

Relief engravings can be made easily on lead plates, using wood-engraving methods. This technique, which is as old as book printing itself, makes possible the creation of individual prints.

A more suitable mixture for engraving than pure lead is: 85% lead, 10% antimony and 5% tin. This alloy is lighter than the lettering alloys used by printing houses for casting printing forms for stereotyping. The surface of the plate can be cast to any size required, to a thickness of about 4.5 mm. It is levelled with alloy and filed down with fine glass paper.

The auxiliary drawing is made directly onto the metal or is transferred with tracing paper. To avoid the smudging of contours, they must be traced thinly with a needle. The metal mass along the lines is removed with a flat, slightly inclined wood graver; in this way a two-sided groove is obtained. The empty areas between the lines of the drawing are engraved in the same way and the furrowed metal is removed with a semicircular gouge. As the metal is fairly resistant one can use a small mallet for hitting the gouge when removing larger areas. Incorrectly engraved parts must be covered with a liquid alloy of lead and tin (1 : 1) before correcting them.

Bright, especially light colours blacken when in contact with lead, so for colour printing it is necessary to give the lead engraving a coating of shellac varnish after all traces of grease have been removed.

For large-scale printing the plate can be copper-plated, nickel-plated or steel-plated. If the printing is to be done in a letterpress printing machine, the plate is fixed with small nails to a wooden board; the height of the two together must be equal to the height of the typographic lettering.

Original zincography

The printing plate for this technique is the original metal plate etched for letterpress. The method (etching) is derived from reproductive chemical graphic processes, but the design is not transferred photomechanically, but is drawn by hand on the metal plate.

The plate can be made from copper, but a zinc plate is easier to get. It should be about 1.5—2 mm thick. Its surface is first of all tarnished with a saturated solution of alum with some nitric acid added. The auxiliary mirror image is transferred, using tracing paper or laid out with a soft pencil directly onto the plate.

The drawing is made with a pen or brush, using lithographic ink or a solution of bitumen in benzine. Half-tones are achieved with a brush and screen. The parts which are not to be printed are hollowed by repeated etching with nitric acid, diluted to about 8° Bé (Baumé). Copper plates are etched with ferric chloride. The first etching should be weak, ink is then applied to the drawing and bitumen is dusted over it. During further etching the sides of the emerging design are protected with bitumen, as the acid etches not only downward but also sideways.

The zincography technique enables a half-tone impression to be made with the character of a chalk drawing. The half-tones are made up of small points which gave the same effect as the screen used in the printing industry, but first of all the plate must be given a grain. Bitumen or resin powder is applied to the tarnished surface of the plate with a duster, in the same way as in the aquatint technique (p. 112). The plate is heated over a flame, the melted powder grains are fused to the plate and form a homogeneous grain.

The design is made with lithographic chalk or ink. After repeated careful etching, during which those areas which have been sufficiently etched are covered, the plate is washed with benzine and is then ready for printing.

The finished plate can be printed in letterpress machines together with the type if it is fixed onto a wooden block of the required height. This technique enables the artist to become directly involved in the letterpress process.

(37)
Paul Gauguin (1848—1903)
Cicadas and ants, 1889
original zincography, 200 × 262

A printing plate which is made from one of the materials already discussed, and prepared for letterpress, can be printed in one of several ways. The simplest, which is accessible to anyone and does not require any special equipment, is hand printing. This is quite adequate for small numbers of prints and has the advantage that the slow non-mechanical method of printing makes it possible to correct faults on the printing plate. Hand printing is used during the working of the plate to produce the states, enabling corrections to be made at any point before the final form.

Hand printing

Good *printer's black* with a very deep velvet tone (bone black or ivory) is taken from the tin with a knife and is mixed on a thick glass or marble plate or lithographic stone. It is given the right consistency by adding weak varnish or alternatively one of the siccatives. The thickness of the ink is determined by the character of the drawing and the type of paper to be used for the print. The ink is spread out on the surface of the mixing plate with a spatula and a rubber roller.

The printing ink is then applied to the relief drawing of the plate with a leather *dabber* or rubber *roller*. The layer must be homogeneous and continuous — this is achieved by rolling it out in all directions — and not too thick, so that it is not pressed out to the sides during the printing process.

A good result can be substantially influenced by the choice of *printing paper*. This choice is determined by the technique to be used and by the character of the drawing. Engravings in fine lines are printed on smooth, fine-grained, preferably thin paper; for printing forms with larger surfaces a thicker paper with a coarse structure is more suitable. In any case it should be well fixed so that it does not tear during printing. Prints look best on hand-made paper. For intaglio printing the paper should be dampened before printing (individual sheets are interlaid with wet backing and placed under a weight) as it takes the colour better. With thinner types of paper this may not be necessary.

The sheet of paper must be carefully placed on the printing plate in one movement. To make sure that the print is placed accurately onto the paper, a *loading frame* with loading marks drawn on it can be used. The paper is pressed down gently and covered with a fine smooth cardboard which protects the rear side of the print and prevents it from getting torn by the sharp sides of engraving.

The actual printing is made with the help of a *printer's folding stick*, which is rubbed in a circular motion with continuously increasing pressure. For printing larger designs an inking disc, made from a chrome-plated steel sheet, is used. A normal soup spoon or smooth river-bed stones are suitable substitutes for these instruments.

As soon as it is clear that the design is printed all over, the cardboard is removed and the print is pulled off carefully while holding one edge. The prints are left to dry separately or are interlaid with clean dry backing.

Tin with ink, agate and rubber inking roller

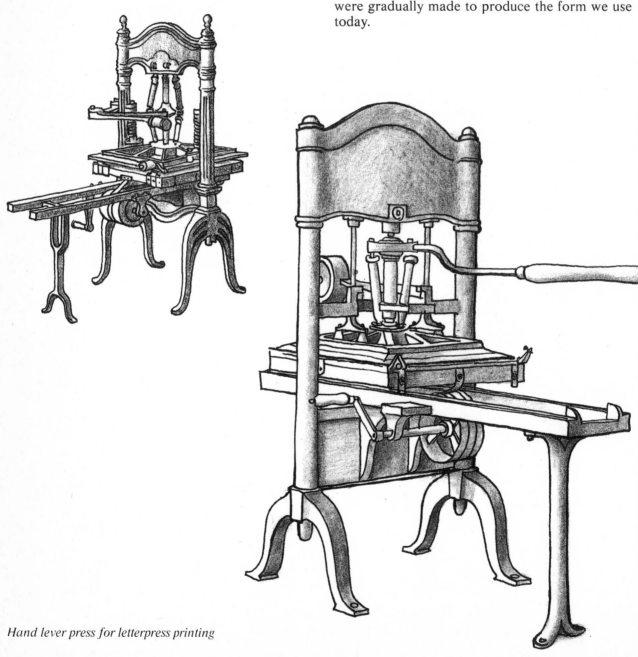

Letterpress
machine printing

The hand printing method is suitable for making a complete number of prints if this number is not too large. Otherwise it is better to do the printing on one or other of the types of *letterpress printing machines*. The simplest of these is the *hand lever press* invented by Gutenberg simultaneously with the invention of book-printing. He adapted a normal wine press by substituting a flat slab for the wine vessel. The printing plate was then placed on the slab. Until the end of the 18th century wooden presses were made on the principle of two surfaces pressing against each other, and were then replaced by the iron press to which improvements were gradually made to produce the form we use today.

Old types of hand lever presses (17th and 19th century)

Hand lever press for letterpress printing

(VI)
Josef Čapek (1887—1945)
Harlot, illustration to work by Apollinaire, 1917
linocut in colour, 215 × 150

The same principle, but with the ability to print at high speed and at low cost, was applied in the middle of the 19th century in America to the development of various types of platen machines *(Tiegeldruckpresse)*, in which the otherwise lengthy processes of applying ink and feeding in the paper were mechanized. These presses are suitable for printing small, exacting works. Another type is the *hand cylinder press,* which works on the principle of a cylinder pressed against a surface. This is also equipped with an apparatus to feed in the paper.

If the printing plate is to be printed in one of the types of high-speed presses, it must first be fixed in a metal enclosing frame called a *chase.* The plate and chase together are known as the *form.* To obtain the required quality of print the plate usually has to be prepared by equalizing the differences in height of the plate in relation to the surface of the cylinder. The preparation on the upper side consists of sticking pieces of thin paper onto the cylinder in those places where the printing plate does not make contact and the design is consequently insufficiently printed. The thickness of the paper and the number of layers are chosen according to the degree of unevenness of the plate. The preparation of the underside of the plate consists of evening it out and this also helps to prevent it from cracking.

(VII)
Pablo Picasso (1881 — 1973)
The fawn and the goat, 1959
linocut in colour, 210 × 115

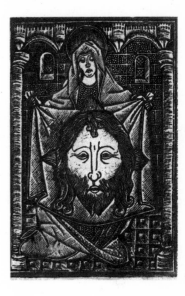

(VIII)
Lower Rhineland master (after 1450)
The Crucifixion
engraving in white on stippled
blackground, polychromed, 154 × 100

(IX)
Cologne master (around 1470)
St Veronica
engraving in white on stippled
background, 70 × 46

Apart from these machines, which have been designed specifically for letterpress printing, the print-maker may also use machines of a different kind, such as the copperplate printing press or the lithographic press for printing plates in relief.

Relief printing on a copperplate press

With a copperplate hand press it is only necessary to space out the rollers sufficiently and to adjust to a correct, uniform pressure on the plate. A sheet of clean cardboard is placed on the movable cast-iron bed and a loading frame or two laths of almost the same height as the plate are glued to the cardboard. The printing form is placed in the corner of the frame or between the laths and the printing paper is laid on it. This is covered with a smooth, firm cardboard sheet to avoid the relief being forced through excessively.

Finally, it is all covered with a felt blanket and run through cylinders. The print is removed from the plate with care, making sure that the design is sufficiently printed everywhere; if necessary, corrections can be made with a folding stick. If the printing plate is too uneven it is levelled out by a preparation of the top or underneath of the backing cardboard.

Relief printing on a lithographic press

A lithographic hand press, suitably adjusted, may also be successfully used for relief printing. To ensure that the printing plate does not move on the movable surface of the press when the pressure is applied it is necessary, first of all, to make a fixing frame. A rubber sheet is glued to the rear side of a strong wooden plate so that it does not slide on the metal of the movable bed

(X)
Pieter Schenk (1660—1718)
Renaissance vase with classical decoration
copperplate engraving in colour, 287 × 204

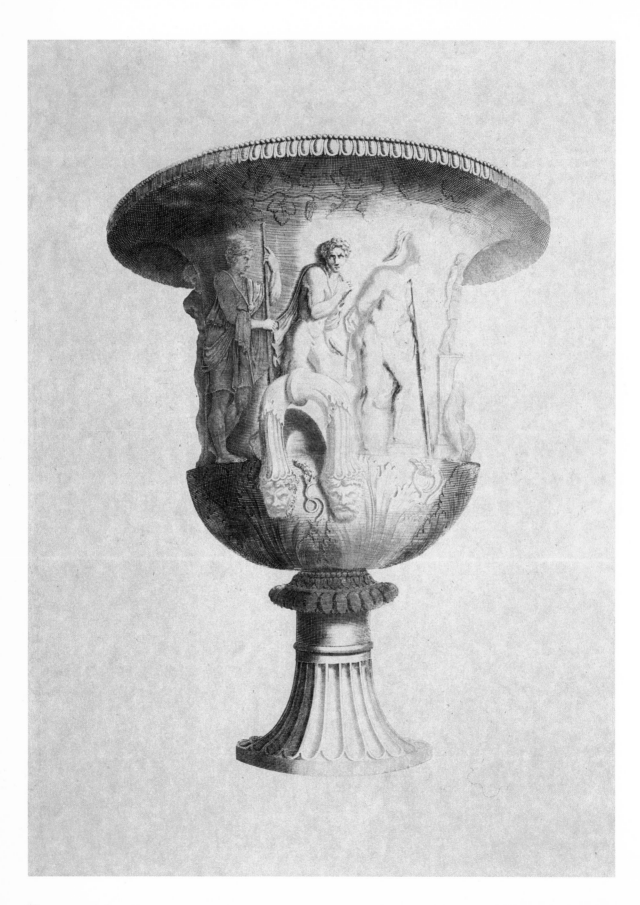

and if necessary this is fixed with wedges between the borders. To prevent it moving, two corner loading frames are fixed firmly to the plate immediately next to the printing form (so that it can be removed when the ink is rolled on).

Low printing plates, such as lino, can be glued either before or after being worked onto the fixing frame. When the ink is rolled onto the design, a frame made from the same material or a substitute of the same height is placed around the form, so that the pressure of the inking disc is not carried by the engraving.

The printing plate is placed on the loading marks, and covered with a smooth clean sheet of cardboard and well greased fibreboard.

The inking disc can be replaced by a metal roller fitted to a frame, which is fixed with a pin to the block of the machine. In this case felt is used instead of fibreboard.

Printing defects

Defects in final prints are often caused by the use of unsuitable or poor-quality materials in making the printing plate, by incorrect preparation, by the wrong choice of printing means, by bad ink or by the wrong kind of paper.

The smudging of the design with ink, especially in its finer and less deep parts, is usually caused by too much ink or by excessive thinness or density. The plate must be washed with benzol and dusted with talc and ink of the right consistency before being rolled again.

If the ink runs, it is a result of washing the plate with an insufficiently volatile solvent. It is better to use clean benzol rather than turpentine or petroleum.

If the ink soaks through to the back of the paper this is due to the use of thin ink, which contains non-volatile solvents. When these are separated from the pigments they grease the paper even in the non-printing parts.

To avoid *unwanted gloss* from ink on a dry print — which occurs, for example, with art paper or strongly glued paper — one should add 1—2% of Bologna chalk to the ink. Pearlescence — a grainy surface of the printed areas when bright colours are used for printing — comes of using ink which has been diluted too much.

The *tearing of paper* when it is being removed from the printing plate is caused by the use of insufficiently glued paper or by an ink which is too thick, sticky, or which includes half-dried lumps, which can also come from a dirty roller.

Thickening of the design in densely drawn parts is usually caused by excessive pressure from the machine, which results in the ink being squeezed out. Too great a pressure may also cause the printing paper to tear, especially when a thin paper is being used.

RELIEF PRINTING IN COLOUR

For greater clarity the method of relief printing in colour is described here separately, taking the specific case of the woodcut as a model. Wood is the most frequently used material after lino, and the procedures used here can be analogously applied to other materials.

Diagram of relief printing on a copperplate press

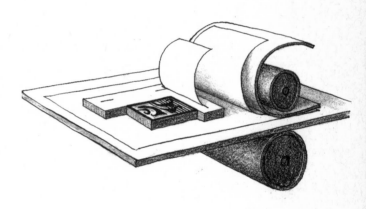

Diagram of relief printing on a lithographic press picturing the plate for fixing the printing form on a metal cylinder which functions as a scraper

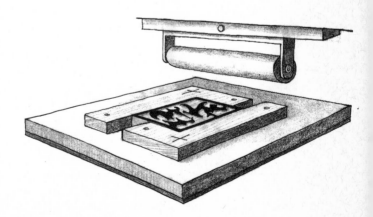

The chiaroscuro woodcut

The method of creating chiaroscuro designs using the register of several coloured half-tones, is a technique which was at one time very popular. It forms an intermediate step between the black-and-white and the coloured woodcut.

The working procedure does not differ from a normal woodcut. The basic (darkest) design is cut in one of the blocks and printed, the still-fresh imprint being transferred to other blocks as many times as there are colours to be printed. From the block which will be used for the lightest background, only those parts which are to remain white are cut away. On the other blocks the areas of the lighter and then darker tones are gradually cut away. To achieve a full-tone effect four blocks are usually sufficient.

To avoid using a large number of blocks it is possible to obtain the same effect by cutting first the lighter and then the darker tones in the same block. After cutting each tone it is necessary to print the whole number of impressions and finally the darkest design is cut in the block. This method requires great imagination for it is impossible to go back and change anything of the impressions of the preceding prints. Thus it is almost inevitable that the artist must solve all the problems on the preparatory sketch and execute the printing himself.

The printing colours are usually arranged in a continuous scale from light (usually ochre) to dark (black, dark brown or dark blue). Their register is made in the same way as in a woodcut in colour.

A loading frame

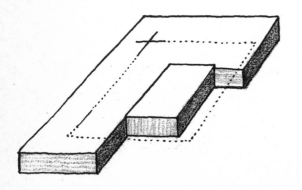

Woodcut in colour

Whereas the chiaroscuro woodcut is built on the analogous harmony of related colours, the woodcut in colour is based mainly on what is termed complementary harmony. The success of the work depends on the perfect mastery of the single-colour woodcut. There is no rule concerning the number of, and which colours to use for the final print. Here the artist must be guided by his own feelings and experience. It is important to realize that when two or more colours are overprinted a further colour is obtained as a result of optical mixing. This, of course, can be utilized and one therefore works from a sketch in colour or a coloured black print. (At this point it is also possible to save printing blocks by gradually cutting in further colours on one block).

In the case of hand printing, several colours can be printed from the same plate at the same time by applying them to the appropriate areas with a brush in the Japanese manner. The method used by André Derain is an extension of this principle: the basic colour design is cut in relief in one plate, then it is printed onto another plate and incised in depth. To the remaining raised areas various colours are then applied with a brush.

For certain simple coloured surfaces the wood block can be replaced by lino or plastic, but the printing blocks for all colours must always be of the same size. Only this ensures a perfect register.

Usually the block with the basic design is cut first. From this a black impression is made onto firm smooth paper and while it is still wet it is printed onto a further block, which is then going to be used for another colour. The forms must be matched exactly (the final successful alignment of the colours depends on this) and the transfer is therefore made with the help of a loading frame. After cutting the second colour block a register is made with the impression of the basic design and, depending on the result, the working of the other blocks is continued.

Printing with oil paint

For making relief prints several basic oil colours are sufficient to obtain a wide scale of colours either by mixing them in an ink duct or by their mutual overprinting. If using transparent colours of a light aquarelle coloration overprinting is used to achieve complementary tones. Transparency of colour is achieved with white transparent paste. The colour tone is tested by dabbing the colour on white art paper, the covering quality on

black paper. The sequence of printing the individual colours is, in this case, arbitrary, but it is useful to print the black first, then, once it has dried out, the yellow and then the red and blue. This gives the best chance of judging the register.

When covering colours are used for printing one reckons with their direct effect without overprinting. The most opaque quality is found in Cremnitz or Titanium White, Chrome Yellow, Vermilion and Ochre. These colours are more compact and light-stable than transparent colours, they print uniformly and have a less pearly quality.

Individual colours must in this case be printed in sequence, starting with the lightest tones (yellow) and so on to black. For making states, when it is necessary to print one colour after another without waiting for them to dry out perfectly, the wet colours are dusted with magnesium powder.

Printing with watercolours

This technique is seldom used nowadays, although ancient eastern artists used it almost without exception. Colours can be prepared from the finest colour pigments with a rice extract or a solution of gum Arabic and a little glycerol used as a bonding agent to make a thick paste. This can be diluted as required. A solution of gum Arabic can be used to dilute even hard watercolours. Some shops sell ready-made printing watercolours in tubes.

Diluted, but not too watery colours are applied to the block with a brush. The width of the brush depends on the size and character of the design. Brush application enables one to print several colours at the same time or, if required, enables one to change the intensity of one colour gradually. Another working procedure consists of applying several different colours which are then left to dry. Then, before printing, the whole surface of the block is dampened with a broad hair brush, which dissolves the colours so that they run into each other. Of course, on large surfaces, it is possible to use a rubber roller or dabber when applying watercolours.

Paper which is used for printing with watercolours must not contain too much size; it should be porous, preferably Japanese. Before making the impression it is essential that the paper be moistened well and evenly. The paper is carefully placed on the block, then it is covered with another, dry sheet of paper or thin cardboard. The disc is applied to the block with a gentle circular motion, until the colour is printed everywhere uniformly. This is tested by occasionally lifting the paper slightly. Finally the paper is pulled off, starting from one corner, and placed on dampened backing so that it remains sufficiently damp for printing other colours.

Register

One of the most important conditions for obtaining a high quality colour print is a perfect register, that is, the exact alignment of individual colour surfaces. This can be achieved by various loading methods.

A simple and reliable method is to use an L-shaped wooden loading frame, the block being placed in the angle and the paper laid according to marks drawn on the frame. If using paper with an uneven edge (handmade paper) the procedure is similar. But as it is not possible to rely on a straight cut edge it is necessary to make pencilled loading crosses on the reverse side or to make holes with a needle in all of the sheets and then fit the musing pins to the marks on the frame.

A very exact and practical method which is suitable for a large number of impressions is based on the experience of the Japanese. Two tables of equal height are spaced apart so that the entire quantity of paper required fits between them. This supply is fixed with a wooden vice to the edge of the first table and the coloured block is placed on the second table in the equivalent place (marked or defined by a frame). The printing is done by turning sheet after sheet and placing them on the block. When the particular colour has been printed the used sheet, still fixed in the vice, is inserted into the gap between the tables. After making the required number of impressions in one colour the sheets of paper are returned to the original vertical position, the block is changed and the printing of the next colour commences.

A less reliable, but often used method of register is done by loading onto the perimeter frame of the design. Obviously all the blocks must have exactly the same dimensions. Once the first colour has been printed, the block with the next colour is placed on the print and both are carefully turned over. If the design does not cover the whole surface of the form and does not have a perimeter frame, it is possible to leave auxiliary loading marks in opposite corners of each block. These are not inked, but are printed blind.

SPECIAL METHODS
OF RELIEF PRINTING

Material prints

All of the last mentioned techniques are based on the principle of hollowing out the parts that are not to be printed in the compact flat surface of a particular material. For certain special purposes it is possible also to use a reverse procedure: to add materials to the bearing base plate which then become printing elements. The printing form is therefore created by adding, adjusting and assembling to the level of the printing surface. The modern print-maker is thus provided with a number of further means of expression, albeit of a rather more experimental nature. The form-giving elements are the structure, shape and mass of the added materials (nails, wire, various textiles, wallpaper, paper, fabrics, etc.). The required design, either of a descriptive or purely abstract nature, is made by nailing or glueing these materials onto the base plate of the form (made of wood, metal, textiles, plastic, etc.). A characteristic feature of impressions made in this way is the fact that the printing elements are not always accurately defined and exactly at the same level. The resulting work usually excludes the possibility of printing in letterpress printing machines.

Impressions
of natural objects

Practically any sufficiently firm and more or less flat object or natural material can be used to make an impression. The plant leaf, flower, twig, piece of wood or bark, etc., is inked and placed on the paper and drawn through the press. A perfect positive impression of the contour and surface of the natural object is obtained. To achieve a reverse, i.e. negative impression, a stiff printing ink is rolled onto a smooth metal plate, a clean object is placed in position and drawn through the press. Then the object is removed carefully and the impression is made. This is, in fact, a form of monotype (p. 192).

To obtain a permanent printing plate the impression on the metal plate is powdered with bitumen powder, heated and the non-printing parts then etched in depth. A negative design on the block is obtained by impressing the object into soft ground (p. 108) on a plate. The clear metal is then etched.

A simple example of an impression of a natural object

Rubbings (Frottage)

Taking impressions from large stone, ceramic or metal relief was already a popular method in China in the years BC for making reproductions of such works for the Imperial archives and collectors. In recent times rubbings have been used mainly in archaeology to complement photographic records. In a rubbing a relief design is impressed without the need to apply ink to the extruded parts. Therefore there is no danger of damage to the object, or the necessity of elaborately removing the paints. Some modern painters, such as Max Ernst, raised the technique of rubbing to that of a graphic art in its own right, by representing their concepts with the help of rubbings of various natural objects or artificial materials and their structures.

The technique of rubbing can be practised in two ways. In the first, a thin, but firm printing paper of the right size is thoroughly dampened, or starched if necessary, applied to the object and, using a soft brush or clean dabber, pressed into the concavities of the relief until it adheres well. Then, with a large soft dabber or roller ink, it is applied to the extrusions. The paper is removed, stretched out and left to dry. The second method uses dry paper — but it must be prevented from shifting and the ink applied with a roller must be sufficiently stiff.

The character of the resulting impression is given by the degree of flatness or plasticity of the relief, by its height and by the structure of the material.

Relief printing forming relief impressions

On several, now very rare, impressions from the 15th century one comes across a special technique which is called the *paste print,* which combines the principles of embossing and relief printing. A wooden, or more often metal block with a hollowed out design was impressed into a thin layer of paste and applied to a paper prepared with size. The drawing was impressed in the manner of a seal, so that the extracted portions appear as raised and on the contrary the extruded surfaces thin out the layer of paste to a minimum (when the plate is not inked the paper shows through). The impression was sometimes, while still damp, dusted with wood powder, thus receiving a velvet appearance, or it was additionally decorated with gold leaf.

A relief appearance on paper of a design is obtainable by so called *blind embossing* from metal or wood blocks. The plate is printed, without being inked, using increased pressure, with a soft backing. Hand printing is virtually excluded. The design can be printed from both sides of the paper — as a result it is either raised softly from the surface, or recessed in depth and has a sharper contour.

The loading of paper for relief printing in colour using a wooden vice

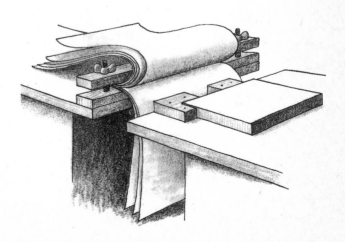

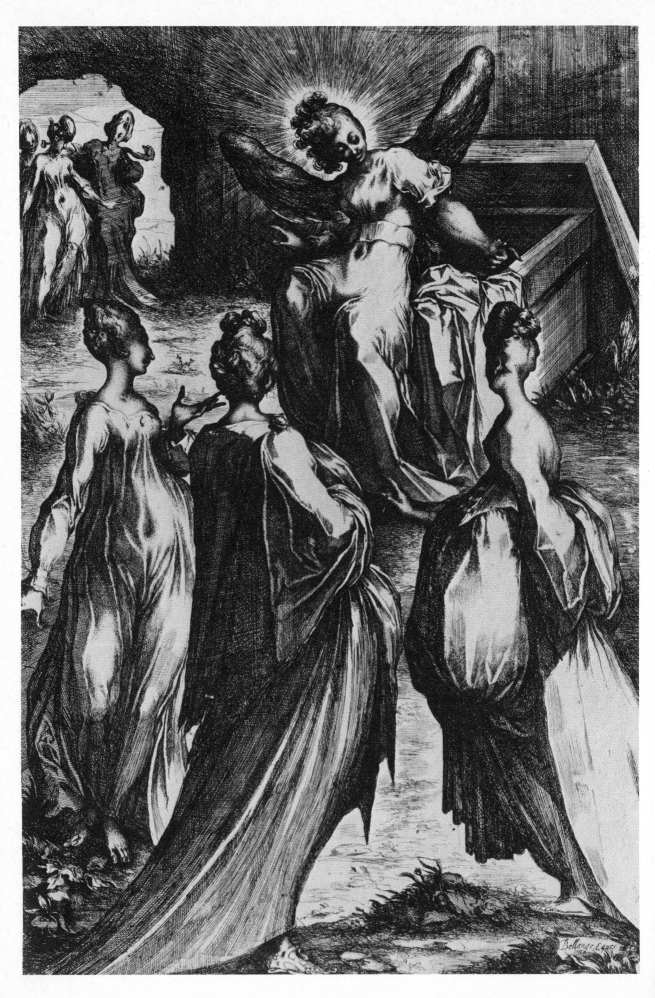

II. INTAGLIO PRINTING

Intaglio printing, the mechanical processes of which are of only slightly later date than those of relief printing, was for a long time the most perfect means of printing and from an artistic point of view ensured the best results. In its contemporary industrialized form it also guarantees a high-quality printing product.

In intaglio printing the lines or points of the design are hollowed out by mechanical or chemical means beneath the surface of a smooth metal plate. The intaglio ink is rubbed into these recesses whereas from the rest of the surface of the plate it is removed. During printing the powerful pressure of the printing machine presses the paper into the grooves in the plate, thus bringing the ink out.

The intaglio form is usually made from a copper or zinc plate, but sometimes it is also possible to use other metals, such as steel, iron, brass or aluminium.

The techniques of working intaglio forms

These can be mechanical, i.e. the various types of *engraving:*
 copperplate engraving
 steel engraving
 engraving in the dotted manner
 stipple engraving
 dry point
 crayon manner engraving
 mezzotint;
or chemical, i.e. the various types of *etchings:*
 line etching on solid ground
 stipple method etching
 etching in the crayon manner
 line etching with grain
 soft ground etching (Vernis mou)
 etching on brittle ground
 aquatint (grain etching)
 chalk etching (using light-sensitive bitumen)
 lift ground etching (Reservage)
 brush etching
 hand photogravure.

The printing of individual graphic art prints is done on a hand copperplate printing press. The printing industry, however, uses high-speed horizontal gravure presses, rotogravure presses and special machines for printing stamps and banknotes.

It is characteristic of intaglio printing that after the removal of the paper the ink adheres to the surface in slight relief and this provides one of the main attractions of this printing technique. The bevelled edge of the printing form also leaves a perceptible border in relief around the design.

A diagram of intaglio printing

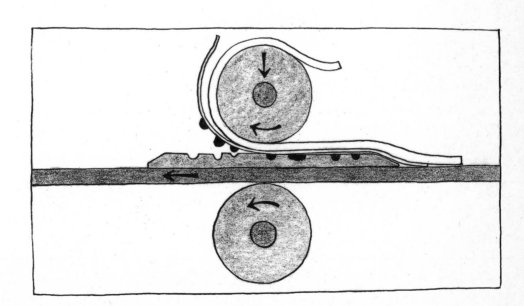

◁ (38)
Jacques Bellange
(active 1602—1617)
The three Marys, 1620
line etching 435 × 288

THE TECHNIQUES OF PREPARING AND PROCESSING PLATES FOR INTAGLIO PRINTING

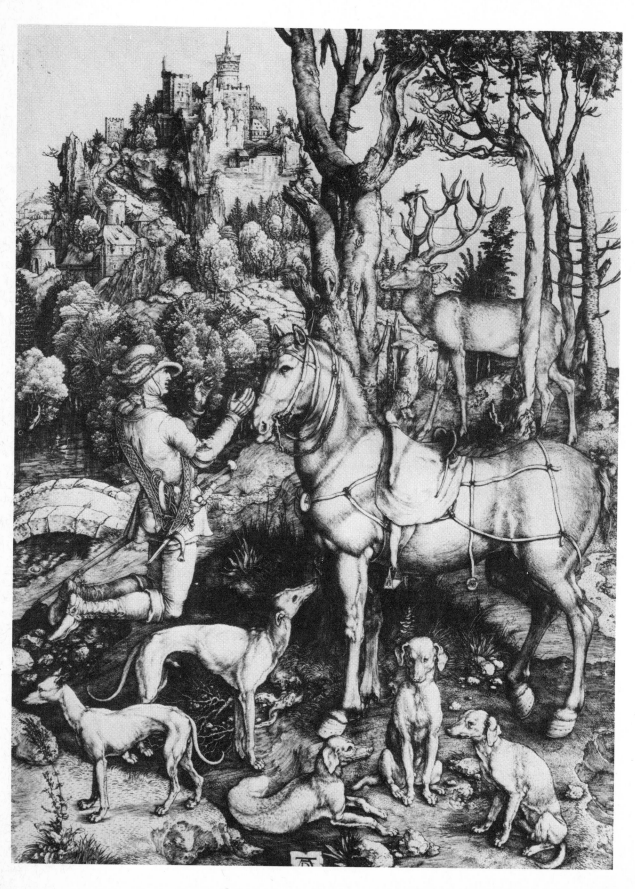

Intaglio engravings

The widely used expressions 'engraving' describes the complex of intaglio techniques of linear or tone drawing, whereby, through mechanical means, i.e. through the direct action of graving or roughening tools on the smooth surface of a metal plate, the design is hollowed out beneath the surface of the printing plate.

The individual methods can be applied exclusively or can complement each other. At the same time they can also be suitably combined with etching methods.

◁ (39)
Albrecht Dürer (1471—1528)
St Eustach (Hubert), 1501
copperplate engraving, 355 × 260

(40)
Master of the playing cards (around 1430—45)
Wilden-Koenig, card game
copperplate engraving, 134 × 96

Copperplate engraving

In copperplate engraving the design is engraved into the smooth surface of a copperplate with steel gravers. The incisions produced in this way are filled with printing ink, which is transferred onto paper by high pressure during printing.

The development of copperplate printing

The technique of linear engraving in copper is the oldest method of intaglio printing. Its direct forerunner was a technique called *niello,* used by Italian goldsmiths of the first half of the 15th century for decorative work in gold, silver and other metals. The test and archive impressions made from these engravings are now very rare. The Florentine goldsmith Thomasso Finiguerra (1426—1464) is said to have been the first to suggest that reproductions of drawings could be made using the niello technique. The earliest example is *The Coronation of the Virgin Mary* dated 1452. His work was developed by another Florentine sculptor and goldsmith Antonio Pollaiuolo (1432—1498), but the milestone in the development of Italian copperplate engraving is above all the work of the Paduan painter, sculptor and engraver, Andrea Mantegna (1431—1506).

The second largest centre of copperplate engraving was in Germany, and developed independently of the work of the Italian Masters. Already by 1410 — 1430 the so-called Master of the Playing Cards and a little later his disciple, the Master E S and other anonymous artists were using this technique and the very first dated example, *The Scourging of Christ,* 1446, comes from this region.

The first non-anonymous master of copperplate engraving was Martin Schongauer (1445—1491), who worked during the period when the influence of the Italian Renaissance was beginning to permeate Germany. The expressiveness of the refined copperplate engraving, as opposed to the coarser woodcut, encouraged a number of prominent artists to use this technique. The work of Albrecht Dürer (1471—1528) was prominent in this field as in so many others.

Towards the end of the 16th century and at the beginning of the 17th century the popularity of copperplate engraving spread rapidly through other countries, especially the Netherlands and France. Many copperplate engravers specialized in reproducing works by famous painters, achieving a remarkable degree of accuracy. It was this that to a large extent enhanced their popularity, and

a group of copperplate engravers grew up around the Rubens school of painting. Prominent positions were held there by, for example, Boetius Bolswert (1580—1633) and Paul Pontius (1603—1658), the founder of the famous Flemish school of engraving. A number of prominent masters of the burin, or graver, worked at royal courts; the Antwerp engraver Egidius Sadeler (1570—1629) worked for the Emperor Rudolph II and in Paris the portraits of courtiers were engraved by Claude Mellan (1598—1688), Robert Nanteuil (1623—1678) and the Antwerp-born Gerard Edelinck (1640—1707), the court engraver of Louis XIV.

Although the refined and demanding technique of copperplate engraving was continuously being enriched by new processes, the interest in its classical form slowly declined. Artists more and more frequently gave preference to the technique of etching, which made for faster, easier and more picturesque work. Nowadays copperplate engrav-

ing is found only occasionally in studios. Usually it is used for simple contour designs with additional cross-hatching and never approaches the sophisticated calligraphy of line modelling when it was in its heyday.

The technique of copperplate engraving

Preparation of the metal plate for engraving

The copper plate is the most suitable material for all intaglio engravings and is the one used most frequently. Copper, whether electrolytic

(41)
Andrea Mantegna (1431—1506)
Madonna and child
copperplate engraving, 210 × 221

(42)
Giorgio Ghisi (1520—1582)
Raphael's dream, 1561
copperplate engraving, 380 × 540

(redder and softer) or rolled, is basically characterized by great strength and, at the same time, suppleness.

The thickness of the plate should be between 1—3 mm, depending on the size of the design. It must have the same thickness throughout and the surface must be perfectly smooth.

Using a rasp, file and fine emery paper, the edges and corners of the plate are worked into oblique *facets* and finally polished with a steel burnisher; this ensures that during printing the roller rolls onto the plate smoothly, avoiding damage to the printing paper. If the surface of the plate to be used is damaged by grooves, it has to be ground down. A coarse sheet of emery paper, which is gradually exchanged for finer sheets, is wrapped around a wooden block with a flat surface and used with a circular movement and decreasing pressure to grind down the surface un-

til the scratches are removed. Finally fine pumice with a drop of oil is rubbed into the surface with a cork.

A zinc plate does not have the qualities of a copper plate, but it is much cheaper and can be successfully used in dry point, for example. The best plates are those used by reproductive zincographers but the stronger plate used by tinsmiths is also satisfactory. The great disadvantage of zinc is its instability; in humid air it oxidizes fast and permanently and gets covered with a grey layer. Before starting work, it is usually necessary to grind the surface of the plate with ground pumice and floated chalk and alcohol. The zinc plate is unsuitable for the mezzotint technique. A brass plate is better, as it is more durable during printing, although not as durable as copper. The best brass is golden yellow, and contains about 34% zinc, the remainder being copper.

(43)
Hieronymus Bosch (1450—1516)
engraved by Hieronymus Cock
The temptation of St Anthony, 1561
copperplate engraving

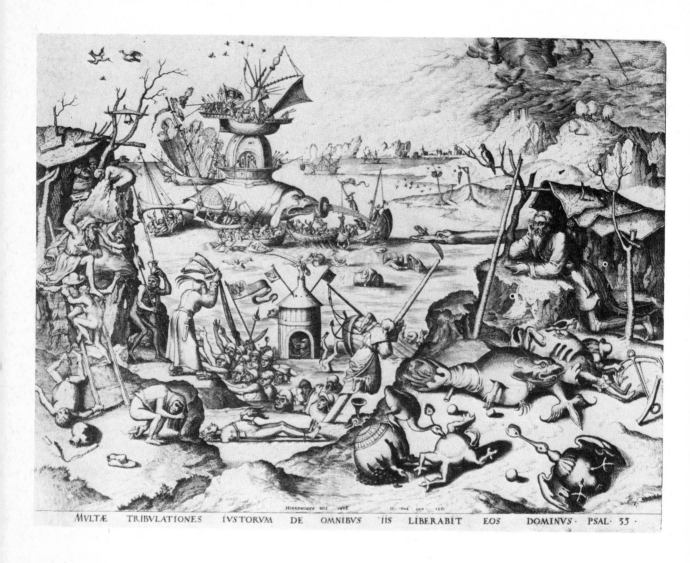

MVLTÆ TRIBVLATIONES IVSTORVM DE OMNIBVS IIS LIBERABIT EOS DOMINVS · PSAL · 33 ·

Laying out the design

The preliminary design on the surface of the plate can be made in several ways: either directly, for example with a greasy pencil or by light strokes of the graver, or by one of the tracing methods. In this case the contours of the preliminary sketch are drawn with ink on transparent tracing paper and with the help of black carbon paper are transferred to the plate. The transfer is then fixed with a solution of shellac in alcohol.

A transfer which is engraved with a needle on celluloid can be transferred to the plate by drawing it through a press after it has been inked. When the design is made with a soft pencil on thin paper, it is possible to make a transfer by printing it onto a plate with a thin coating of semi-dry dammar varnish.

In some cases it is very useful to pre-etch the main lines of the design using a line etching technique and when the solid ground, etching resist, has been washed off, to continue the work with a burin, by widening and adding to the already recessed lines.

Engraving

The technique of copperplate engraving, which appears to be simple as far as means are concerned, is in fact one of the most demanding of graphic art techniques. The engraver has to be a master of drawing, he needs dexterity in using the burin, concentration, patience and good eyesight. When studying old engravings one admires the incredible virtuosity shown in executing the

(44)
Claude Mellan (1598—1688)
John the Baptist, 1629
copperplate engraving, 365 × 270

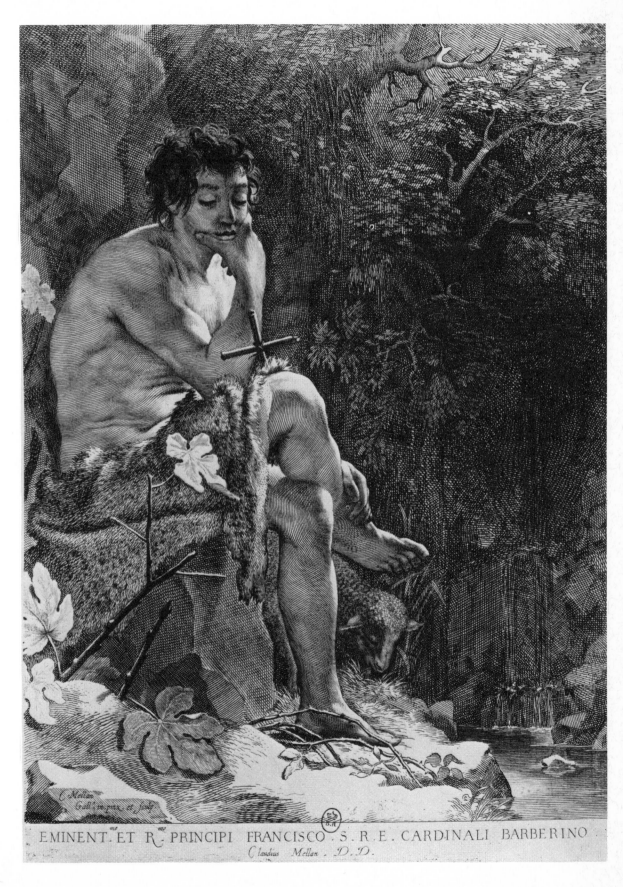

drawing or modelling the lines and the cross-hatching. This should surely be a profound source of enlightenment, but for the modern print-makers there is probably little sense in trying to compete with the dexterity of the professional baroque engraver, whose main aim was to achieve an accurate facsimile of the painted model. The modern drawing will therefore probably be based more on a certain monumentality of simple contours, with expressive but not manneristic cross-hatching.

Copperplate gravers (burins) are made from high-quality, well-tempered steel. The blade, with a length of about 12 cm, and a thickness of about 0.5 cm, is set in a wooden mushroom-shaped handle, with one bevelled side. At the end of the blade there is an obliquely ground graving surface, the bevel face, which prevents the graving point from entering the metal too deeply. The gravers are of several types — some are triangular in section, others square or rhomboidal with angles of various sizes, or elliptical. Each type is designed for a different strength and character of incision. Carved gravers are bent upwards, others, called ribbon gravers, can be used for engraving several parallel lines at once, as they have several points, separated by grooves. Copper resists the gravers

Various types of copperplate engraving gravers (burins)

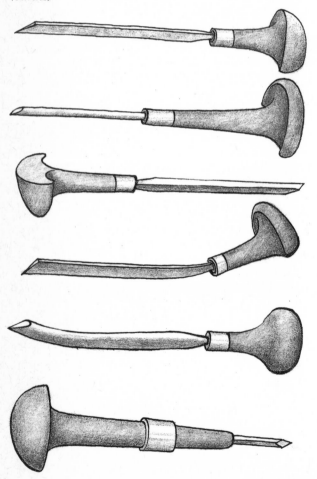

considerably and it is therefore necessary to maintain a sharp cutting edge by sharpening the gravers on a fine steel whetstone.

While working, the burin is held with the blade between thumb and first finger, while the handle rests firmly in the centre of the palm. The point of the burin should not extend beyond the hand by more than 2 cm, otherwise it is difficult to control. The cut-away part of the handle is held close to the plate during engraving and the blade is therefore almost parallel with the plate.

If working on a plate of medium size, it is placed on a *leather cushion* filled with sand. This makes it possible to turn and tilt the plate into the most suitable position. In particular, the creation of continuous curves requires perfect cooperation with the left hand, which moves the plate against the movement of the graver. Instead of a leather cushion some engravers use a special *revolving vice*.

The main contour lines are incised first. If working according to a fixed transfer it is subsequently washed off the plate. A rhomboid-shaped graver is used to make a thin incision which is gradually widened. This is done either by engraving in the same direction with increased pressure and, if necessary, by tilting the graver a little, or from the opposite direction with a wider graver. The character of a copperplate engraving is given above all by the parallel run of modelling lines, which taper off into highlights with rows of points, deepen and widen in shades, or which are superimposed by cross-hatching made at different angles. The characteristic of an engraved line is its sharp beginning, its gradual widening and finally the sharp ending.

As the graver moves, a spiral shaving of metal is lifted in front of it and the sides of the incision have raised sharp edges. This *burr* is removed by a sharp three-faced scraper, which is held at right angles to the direction of the lines. If this were not done, the ink would get caught here during inking and the non-printing areas could not be rubbed perfectly clean. This latter factor is creatively used only in the dry point technique.

The state of the work while in progress can be inspected during engraving by rubbing some printing ink and tallow into the incisions of the design. Softening the engraved lines or making corrections to faulty parts is done by scraping them out with a three-sided scraper in the direction in which they were engraved and by smoothing with a steel burnisher. If they have been scraped too deeply, hammer out the plate from the rear, level with the surface, and the smoothed parts can then be engraved again.

(45)
Robert Nanteuil (1623—1678)
Portrait of King Louis XIV, 1664
copperplate engraving, 386 × 304

Steel engraving

Engraving in the dotted manner

The technique and artistic effect of engraving on a steel plate are practically the same as for copper engraving. It was used for the first time around 1820 by the Englishman Charles Heath (1784—1848), who tried to make use of the favourable properties of steel, in particular its hardness, and therefore its ability to withstand an almost unlimited number of impressions. For this reason the steel engraving was sometimes used in the 19th century for making book illustrations. Nowadays it is to be found only where the most exacting technique is required, for example for printing stamps and banknotes. As a method for creating individual art prints it is virtually non-existent.

The engraving is made by a copper engraving burin into an unhardened steel plate, in the same way as with a copper engraving. After completion the plate is hardened by tempering.

The method whereby the tone drawing is built up by a system of numerous small points, punched into the smooth surface of a copper plate with an awl or dotting mallet, is called engraving in the dotted manner.

This time-consuming process was used very seldom, and then usually only as a supplementary technique for a linear engraving or a mezzotint. It was probably used for the first time by Jan Billeart of Amsterdam (c. 1470), and only achieved a greater degree of perfection as an independent print-making technique in the work of the Venetian engraver Francesco Bartolozzi (1727—1815). He worked in London from 1764—1802, where he founded a famous school of engraving whose influence was so great that it even spread to France.

The design of an engraving in the dotted manner, in its pure form, is created by punching, with

(46)
Cyril Bouda (b. 1901)
Still life with shrimps, 1940
copperplate engraving,
225 × 220

(XI)
Thomas Burke (1749—1815)
after Kauffmann
Cleopatra before Augustus, 1786
dotted technique in colour, diameter 294

CLEOPATRA *throwing herself at the Feet of* AUGUSTUS, *after the Death of* MARC-ANTONY.

CLEOPATRE *se jetant aux pieds d'*AUGUSTE, *après la Mort de* MARC-ANTOINE.

* *Vide Plutarch.*

* *Voyez Plutarch.*

From the Original picture, in the possession of Geo: Bowles, Esqr.

London, publishd as the Act directs, Jan 22d, 1786, by S. Sivares, No 13, Great Newport Street, & T. Burke, No 3, Barton Street, Westminster.

Du Cabinet de Madame d'Azaincourt. A Paris chez Demarteau Graveur du Roy, ruë de la Pelterie a la Cloche. Nᵒ 131.

(XII)
Gilles Demarteau (1722—1776)
after Boucher
Study of a girl's head
two-colour pencil technique, 206 × 160

76

varying force and density, small points into the surface of the copper plate. Weak, widely spaced punches produce light tones, deep and close ones produce dark tones.

In detailed work a heavy, sharp steel awl is used. This is held at right angles against the plate which lies horizontally. To obtain tone over larger surfaces a special *dotting mallet* is used. It has a sharp steel point on one side and is rounded on the other. The round face can be used for hammering out points too deeply indented. The mallet is fixed on a thin flexible handle which gives it a swing and enables a rapid sequence of punches to be made.

The burr, the metal which is forced out from the indentations to the sides, is usually removed with a steel scraper but can also be left as in the dry point technique.

The dotting mallet

(XIII)
František Tichý (1896—1961)
Commedia dell'Arte, 1942
dry point in colour, 300 × 390

(XIV)
Jiří Anderle (b. 1936)
Game for 122 persons, 1970
dry point in colour, 5th state, 630 × 495

(47) ▷
Francesco Bartolozzi (1727—1815)
after Roslin, 1782
Portrait of Marie Christine, Archduchess of Austria
dotted technique using a roulette, 425 × 315

Peint par M. le Chev.r Roslin et dessiné par M.r Benedetti Engraved by F. Bartolozzi Engraver to his Majesty 1782.

MARIE CHRISTINE

ARCHIDUCHESSE D'AUTRICHE DUCHESSE de SAXE-TESCHEN
GOUVERNANTE GÉNÉRALE DES PAŸS-BAS.
Dedié à Son Sérénissime Epoux, Son A. R.le Monseigneur le Duc Albert, Prince Royal de Pologne
et de Lithuanie, Duc de Saxe-Teschen Gouverneur Général des Pays-Bas.

 Par ses très humbles et obéïssants Serviteurs
A Vienne, chez Artaria Comp.ie à l'Estampe Vis à Vis S.t Michel Pub.d as the Act directs July 10.th 1782 by J. Vivrés N.o 14 Market Lane London. Artaria

The stipple engraving

Dry point

This method, which creates the design by the punching of irregularly shaped points into the surface of a copper plate, has a genetic relationship with the technique of engraving in white on a stippled background. But in this case it is an intaglio printing method, i.e. the various shaped points (stars, circles, triangles, etc.) serve the same function as the awl in the engraving in the dotted manner technique.

The mark of the instruments used for modelling or decoration are therefore used positively — the printing ink is not applied to the surface of the plate, but is instead rubbed into the punched-in indentations.

The dry point technique is in fact a type of linear engraving which is made not with a graver but with a steel needle directly into the smooth surface of a copper, or in some cases zinc, plate — it is a dry process which does not make use of acid.

This technique is first encountered as early as the 15th century in the work of an anonymous master now known as the Housebook Master or Master of the Amsterdam Cabinet (c. 1480).

The first really outstanding results obtained with the dry point technique were, however, the works of Albrecht Dürer (1471—1528). Later, the works of Rembrandt van Rijn (1606—1669) in this

(48)
Albrecht Dürer (1471—1528)
St Jerome, 1512
dry point, 209 × 184

(49)
Jacques Villon (1875—1963)
L'équilibriste, 1913
dry point, 400 × 300

medium achieved an even higher standard. In recent times a considerable number of artists have turned to dry point, appreciating its technical simplicity which at the same time retains an unmistakable quality of expression. Among these artists, for example, are Auguste Rodin, Edward Munch, Pierre Bonnard, Max Beckmann, Pablo Picasso, Marc Chagall, Lovis Corinth and Jacques Villon.

The dry point design is incised with a sharp *steel needle,* which is usually fixed in a wooden holder and held in the same way as a pencil. The depth of the incision made in this way in the metal is in direct proportion to the pressure applied to the needle and the sharpness of its point. The metal forms a sort of *burr* on each side of the incision, but this extruded burr is not removed as in a copperplate engraving. It is in fact employed as a characteristic element of the design, for when the ink is applied the burr holds the copperplate printing ink at the sides of the lines and there it often prints more distinctly than the ink which is held in the incisions. This then produces continuous veils of ink in dense tangles of lines, sometimes even on the surface of the plate. The final engraved design comes out softly when printed, without sharp contours, and acquires an unmistakable velvety appearence.

In the course of work the state of the design is verified by rubbing in black ink with tallow. Corrections to those parts of the engraving which are too dark are made with the scraper which is used to reduce the burr, and a burnisher is used for

smoothing out weaker lines. Lines or surfaces which are not expressive enough are incised again with a needle.

In place of a needle it is also possible to use a diamond set in a wooden handle. Although dry point is primarily a linear technique this does not rule out the possibility of using other instruments for enriching the design, such as rounded files, coarse whetstones and so on. Larger surfaces can be toned with coarse emery paper. Dry point can also be combined with the crayon manner, used in a mechanical way, and supplementary work done with a roulette can give it a multitude of fine tints.

All impressions from a dry point design should be made by the artist himself. The sensitive rubbing in of ink, the application to areas without incisions and the picking out of highlights can to a greater extent than with other techniques influence the final effect of the impression. The application of the ink and the great pressure during printing cause the burr to be rapidly lowered. This factor is of major importance, for the impressions lose their richness. It limits the total number of impressions which in any case should not exceed thirty. For a larger number of impressions the plate must be steel-plated, but even this does not increase the resistance very greatly. For this reason, from a collector's point of view, impressions with a low serial printing number are considered of most value.

(50)
Jiří John (1923—1972)
Winter sun, 1965
dry point 217 × 303

(51)
Bernard Buffet (b. 1928)
Bridge in Soissons, 1964
dry point, 643 × 490

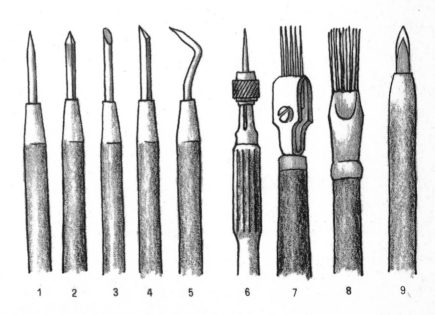

Various types of fixed (1—5) and ex-changeable (6—7) needles, wire brush and scraper (8—9)

1 2 3 4 5 6 7 8 9

Engraving in the crayon manner

The crayon manner applied in a mechanical way is a technique whereby a tonal design is created on a smooth copperplate surface by the action of special roughening instruments. The resulting effect is that of a pencil or crayon drawing.

This method developed in the first half of the 18th century in France, originally as a method of drawing on hard etching ground or resist. However, the engraving instruments for this technique — the *roulette, moulette* and *mattoir* — began to be used for work directly on the plate. This method is usually combined with the dotted manner or with dry point, although it can be used exclusively.

(52)
Louis Marin Bonnet (1743—1793)
after Huquier
Portrait of a lady with a hat
engraving in the crayon manner, 235 × 180

Various shapes of the steel roller or the roulette

Various types of roughening instruments for the crayon manner (roulettes, moulettes and the mattoir)

84

Mezzotint

Mezzotint is a technique of tone engraving in which the design is created by scraping away the dark printing grain of a copper or brass plate.

This method of tone engraving was invented in 1642 by a German army officer and amateur graphic artist, Ludwig von Siegen (1609—1676). But it was most popular in England and is therefore sometimes called the dark manner or *English manner*. The mezzotint, with its ability to create soft transitions from dark velvet tones to highlights, answered the need that artists of that period felt for a more picturesque effect in their engravings. Among the many who used this technique the most prominent were: John Raphael Smith (1752—1812) and Richard Earlom (1742/3—1822), who is famous for his perfect reproductions of the paintings of Rubens and Van Dyck. The development of the mezzotint in colour was pioneered by Jacques Christophe Le Blon (1667—1741). This was important in the popularization of the works of the English school of portrait painting.

The grain of the plate

For mezzotints a thicker copperplate (1.5—2 mm) is the most suitable. The required grain is obtained with what is called a *rocker tool*. This is a rounded steel blade, the cutting edge of which is sharpened into one or more rows of sharp teeth. The rocker tool is held by its massive handle at right angles to the edge of the plate and while applying heavy pressure it is rocked towards the opposite edge. This produces a row of lines made of points indented below the level of the plate,

The rocking tool for the mezzotint

Diagram of mezzotint design (unaffected grain prints deep black, partly scraped-off grain produces half-tones and where the grain has been removed the ink does not adhere)

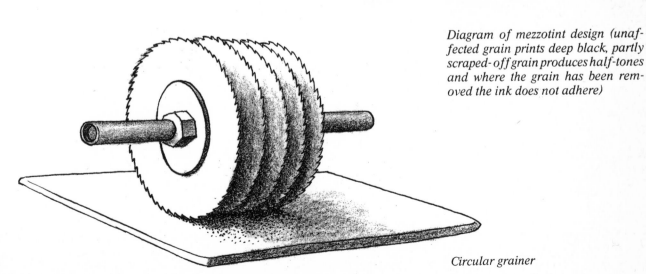

Circular grainer

(53)
Richard Earlom (1742/3—1822)
after Rubens
Portrait of Rubens' wife, 1782
mezzotint, 2nd state, 459 × 354

(54) ▷
Yozo Hamaguchi (b. 1909)
Maize, 1963
mezzotint, 235 × 645

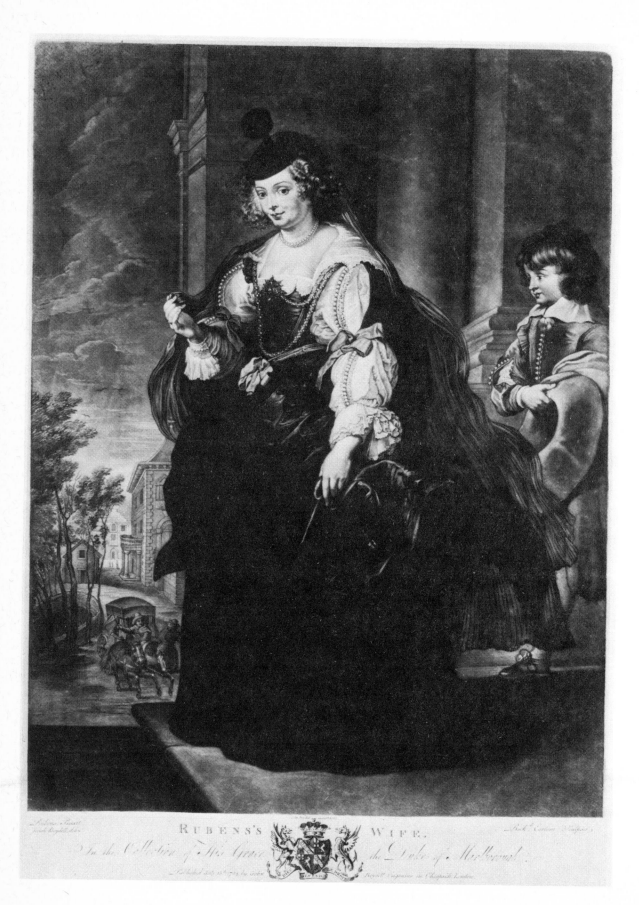

and at the same time surrounded by pressed-out metal burrs. The entire surface of the plate is roughened in this way, first in one direction, with parallel lines, then at right angles to the first direction, then diagonally and finally in the opposite diagonal direction. This process is repeated until all the smooth untouched areas disappear. When seen from the side the surface of the plate seems to have a perfectly uniform matt finish.

The roughening of the plate is relatively laborious and time-consuming, especially in the case of large formats. This probably explains why mezzotints are so rare in modern graphic art. Indeed attempts have been made to simplify and speed up the process. Good results have been achieved, for example, with a *circular grainer,* which is made up of several circular saws with diameters of 10—15 cm, all firmly fixed to a metal axle at a distance of 5 mm from each other. The grainer is held with both hands gripping the ends of the axle

— which are provided with thin tubes to give it easier rotation — and it is then rolled in all directions over the surface of the plate with sufficient pressure; in this way a relatively sharp and dense grain is obtained.

Some print-makers roughen the plate by passing it several times through a copperplate printing press under high pressure with coarse emery paper, which is renewed each time. The plate can also be roughened with carborundum, which is sprinkled over the surface and pressed in by circular movement of a lithographic stone. Small-format plates can be roughened by the roulette or moulette and in some cases an etched aquatint grain can substitute for the mezzotint grain. But none of these methods produces a grain of equal quality to that of the classical procedure, because their grains are shallow, blunt and do not have a burr. They are therefore easily worn out and do not produce sufficiently rich deep tones.

Scraper and burnisher for the mezzotint (simple and combined)

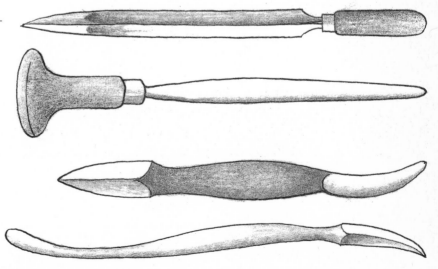

(55)
Francisco Goya (1746—1828)
The Colossus, 1810—1817
scraped aquatint, 287 × 206

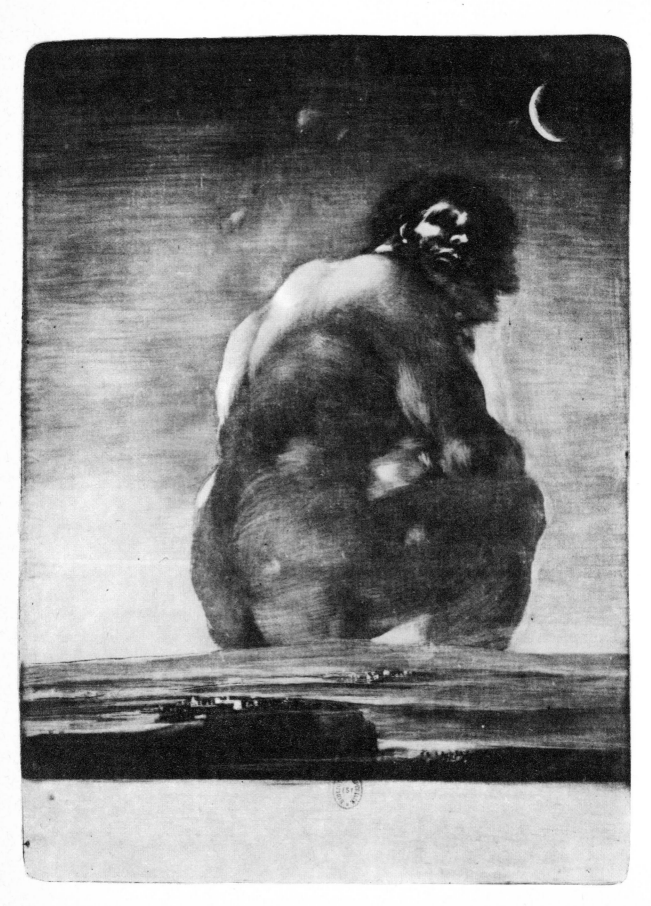

The properly roughened surface of the copper plate is given a thin coating of diluted black tempera, or else a printer's black ink mixed with tallow is rubbed into it. The design is sketched in with white chalk or the contours of a preliminary sketch transferred onto the surface.

The creation of a mezzotint design is done in reverse order to that of other intaglio techniques, i.e. it is made by lightening the dark grained surface, starting with the half-tones and so on to the lightest parts. This is done by scraping away or by smoothing out the grain in areas which are to be lighter. The lower the mezzotint grain, the less ink it will hold; where there is no grain, the printing ink does not adhere at all and these parts when printed remain white.

The grain is scraped away with a triple-edged *steel scraper,* which is held almost horizontally, so that it does not cut too deep. The work is done slowly with the design drawn first in half-tones. The highlights are only brought out at the end — sometimes only after a test impression has been made. For highlights and places where soft transitions are required, a rounded steel burnisher is used for levelling out the grain.

Corrections of errors are made after the surface has again been roughened with the rocker tool. Corrections to parts which are too light are best made with the moulette or by dotting with the engraving needle. Sharp dark lines on a light background are engraved at the end of the work with a needle. When the scraped engraving is completed and before ink is applied, the rubbed-in black colour must be washed out. Negative, light, small surfaces and lines on a dark background are difficult to wash out when applying the paint — and a sharpened piece of hard wood is used to dig them out. As the mezzotint grain is sharp it is better to use a soft leather dabber than a fabric one for rubbing in the ink.

Intaglio etchings

The general term 'etching' is used to describe an extensive group of intaglio techniques of linear or tone drawing, in which the design is hollowed out in the smooth surface of the metal plate with the help of one of the etching agents. As a group these processes are called wet processes, as distinct from the dry, mechanical processes of engraving.

The etching techniques are so rich in expressive means, that they constitute some of the most rewarding and appealing fields of print-making. Individual procedures can be used separately or in combination with others.

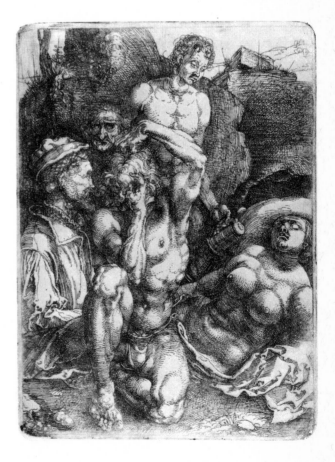

(56)
Albrecht Dürer (1471—1528)
Despair, 1515—1516
etching in iron, 185 × 135

Line etching
on solid ground

Line etching is based on the technique of cutting the design with an engraving needle into the layer of protective ground which has been applied to the metal plate. The metal uncovered by the design is brought out by a solution which etches the metal in depth.

The development of etching

The precursors of etching as a print-making technique were the methods of the metal engravers of the 15th century, who simplified the laborious and time-consuming work on decorative engravings by using acid. It is not known who was the first to use the etching process for printing. At that time, means for etching copper were not known, and the first etchings were made on iron plates. Among these are six prints by Albrecht Dürer (1471—1528), of which *St Jerome,* dated 1512, is probably the oldest dated etching. The concept of the linear design of an etching was at that time largely dependent on the calligraphic forms of copper engraving. However, after the invention of etching procedures in copper, the two techniques began to be combined; this produced what is called the *etched engraving,* which combined the advantages of both methods.

The important artists of the 16th century who used this technique of etching included, for example, Albrecht Altdorfer (1480—1538), Urs Graf (c. 1485—1527) from Switzerland, the Italians Francesco Mazzuola (1503—1540) and Federigo Barocci (1528—1612), the Dutchmen Lucas van Leyden (1494—1533), Pieter Breughel (1525—1569) and Bartolomäus Spranger (1545—1611). In Holland, where conditions for the development of etching were the most favourable, it reached its highest artistic and technical peak in the work of Rembrandt van Rijn (1608—1669). This genius of painting and graphic art, the creator of about three hundred masterly line etchings, fundamentally influenced the whole further development of the technique. His sensitive, but at the same time relaxed painter's drawing released it from dependence on the linear image of copperplate engraving.

Other prominent representatives of etching in the 17th century included Jacob van Ruisdael (1628—1682), the Frenchmen Jacques Callot (1592—1635) and Claude Lorraine (1600—1682), Guido Reni (1575—1642) and Giovanni Francesco Grimaldi (1606—1680) from Italy. An extensive graphic art legacy (of over 300 etchings) was produced with this technique by the Prague-born Václav Hollar (1607—1677), who worked for the greater part of his life in London.

About the middle of the 18th century new procedures appeared in the working of drawings and etchings, which gave rise to tone etching. But the classic line etching technique remained the same,

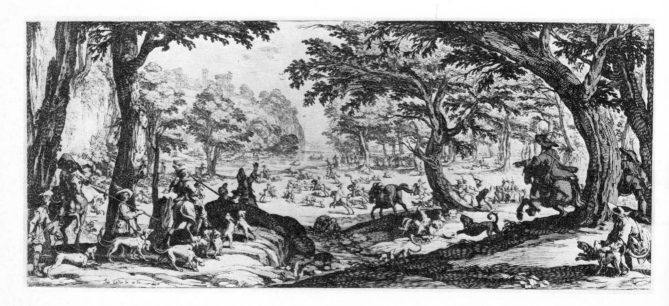

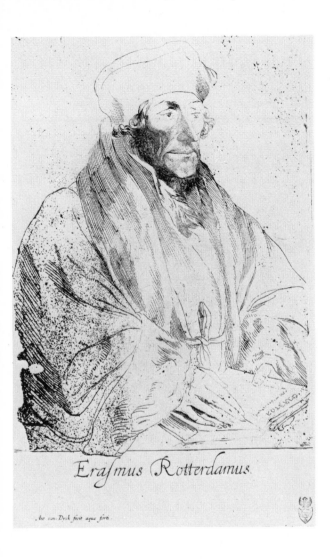

(58)
Anthony van Dyck (1599—1641)
after Holbein
Portrait of Erasmus of Rotterdam
line etching, 4ᵗʰ state, 205 × 154

Erasmus Rotterdamus

Ant. van Dyck fecit aqua forti

◁ (57)
Jacques Callot (1592—1635)
The great hunt, 1619
etching and engraving, 198 × 467

due to the clarity of its expressive means and the magnificent results already obtained with it in the field of print-making. In contrast to copperplate engraving, it never ceased to attract print-makers of all generations. Among others these included William Hogarth (1697—1764), Sir Francis Seymour Haden (1818—1910), Jean-François Millet (1814—1875), Édouard Manet (1832—1883), James Abbot McNeil Whistler (1834—1903) and Pablo Picasso (1881—1973).

The technique of etching

Preparation of the metal plate for etching

The same basic rules apply for the preparation of a metal plate for etching as they do for copper plates for engraving. The most suitable material is a *copper plate* with a uniform thickness of 1.5—2 mm, well rolled out, perfectly smoothed, and with all traces of corrosion removed by polishing. Copper of a lightish colour should be chosen as it is harder. The redder it is, the softer it is, and the etching process will take longer. After grinding the facet it is also necessary to remove all grease from the surface, preferably using a chalk solution with ammonia applied on a cloth. If the plate is then submerged in water, it should be uniformly wet over its entire surface when taken out. If this is not so, the process of removing grease must be continued, if necessary by submerging the plate for a period of several minutes in diluted lye (1 : 20) and afterwards rinsing it thoroughly. A mirror-like shine on a plate is not desirable in etching — the etching ground adheres badly to the surface, sometimes flaking off, and the engraving needle has an unpleasant tendency to slip during work. Such a plate is given a matt finish by submerging it in a 3% solution of nitric acid. It must be well rinsed afterwards.

Cheaper, but also softer *zinc plates* are used for simpler work though with these the etching process is much more violent. Zinc is not suitable for combining etching and engraving or in cases where a hard metal is required. For a large number of impressions it is possible to have the plate steel-plated after it has been copperplated. In the case of etching for colour printing it is almost essential to galvanize the zinc plate, as a number of colours would get dirty during printing.

Steel and *brass plates* are suitable for large numbers of impressions, but are seldom used. They are too hard and any kind of further working with a graver or the making of corrections with a burnisher is very difficult.

Preparation of the etching ground

The etching ground prevents the etching solution from reaching the plate in places other than where the design is to be. It must therefore be adequately resistant to the etching solution, it must be adhesive, it must not crack and flake and it must be so hard that it does not get scratched and does not melt when touched by hand.

The ground can be bought ready-made in specialist shops. But its preparation is simple, as it is made by heating a mixture of wax and bitumen according to one of the following recipes. After weighing out the appropriate measures of all the materials these are melted, starting with the wax, in a large vessel while mixing continuously with a wooden rod. The heating process produces a thick, toxic smoke; it is therefore better to do this in the open air.

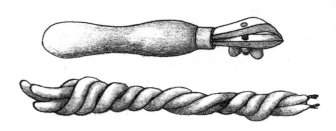

Plate holder and smoking candles for blackening the ground

Solid ground

Recipes according to different authors — quantities given in grams:

(Rembrandt)	(J. Callot)
50 beeswax	60 wax
15 Syrian bitumen	50 mastic
15 mastic	6 bitumen

(A. Boose)	(T. F. Simon)
50 wax	100 wax
30 mastic	75 paraffin
15 bitumen	75 Burgundy pitch

(J. L. Raab)	(J. Kubas)
60 wax	50 wax
50 bitumen	45 bitumen
60 mastic	10 copal
10 Burgundy pitch	4 soot
2.5 Venetian turpentine	

Leather roller for applying ground

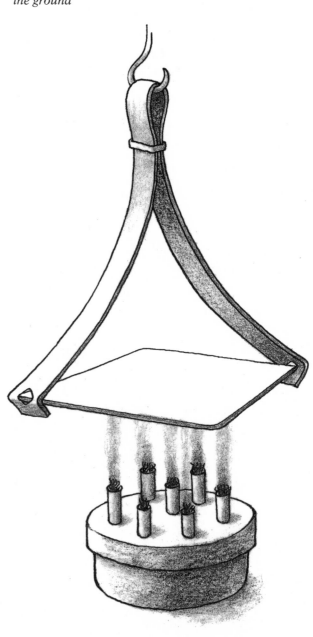

Blackening of hard ground over burner (the plate is fixed in a plate holder made of sheet steel)

(59)
Václav Hollar (1607 — 1677)
View of the Tower of London,
from the cycle *English Views*
line etching, 142 × 252

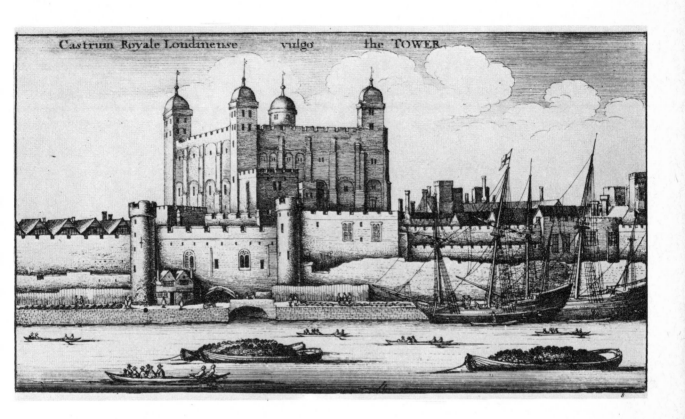

Hard ground can be coloured during the preparation process by the use of fine gas soot, which is always added last. Once all the ingredients have melted the solution is left to settle, then poured through a thick sieve onto a soaped lithographic stone or a glass plate, and while still in a semi-hard state it is cut into cubes or sticks. The ground can also be made by pouring the solution into cold water and kneading it into sticks before it hardens.

Application of the ground

A plate from which all traces of dirt, grease and excessive gloss have been removed is heated uniformly over its whole surface by placing it on the hotplate of a gas or oil lamp, or even of an electric stove. The surface of the plate is rubbed with the stick of ground in several places. The slowly melting ground is rolled out, while still warm, with a *leather roller* into a thin, uniform layer without

Various types of leather dabbers for applying ground or ink

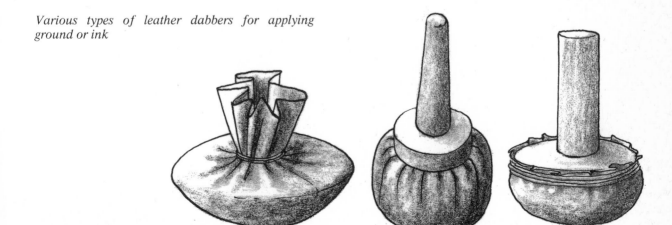

93

cracks. The leather cover must be glued on so that it leaves no marks. A hard rubber roller such as those used by photographers for polishing can also be used. The ground can also be patted on with a *leather dabber*. The plate must not become too hot — otherwise the ground gets burnt, becomes brittle and less resistant to the mordant or etching solution. Should the ground start to smoke and bubbles begin to form, it must be washed off the plate with turpentine oil and applied again.

The instruments used for applying the ground should be carefully protected against dust, grains of which produce specks in the ground which are usually not very resistant to an etching solution.

If the ground has not been coloured with soot during its preparation, it appears, after it has been applied to the plate, as a yellow-brown coating, which is too light to make the trace of the etching needle sufficiently visible. In this case the plate is blackened in an upside-down position over an oil lamp or 5 or 6 tapers bound together. The flame must be far enough away and the plate moved continuously in a circle so that the ground does not get burnt. As soon as the surface is blackened by smoke, the other side of the plate is placed under a stream of cold water — the violent cooling makes the ground glow.

(60)
Rembrandt van Rijn (1606—1669)
Adam and Eve, 1638
line etching, 2nd state, 164 × 117

(XV)
Johnny Friedlaender (b. 1912)
Thursday, 1965
etching in colour, 496 × 392

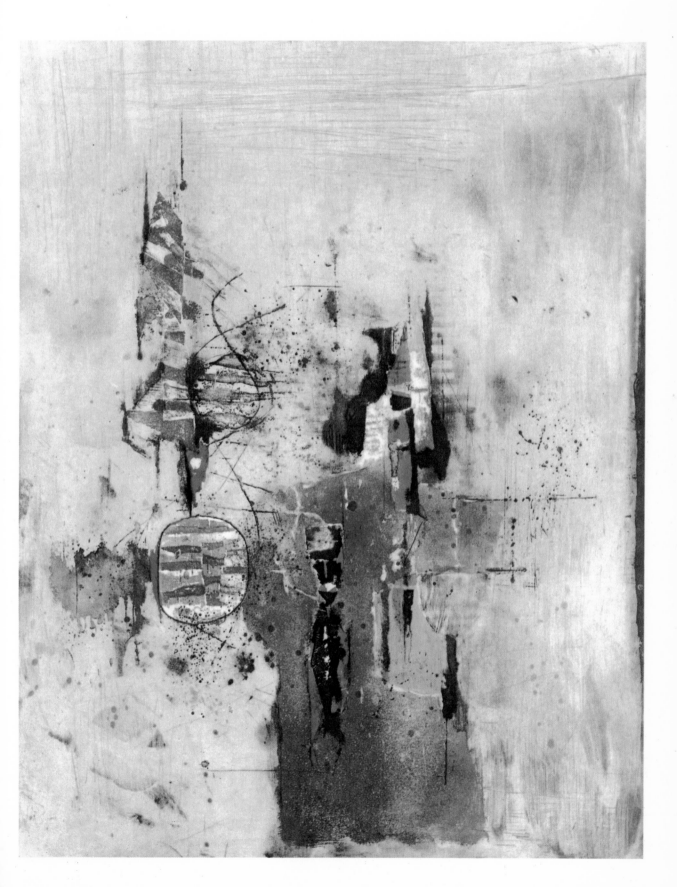

(XVI)
Jan Souček (b. 1941)
Mirror image, 1975
line etching in colour with
aquatint, 300 × 215

(XVII)
Hercules Seghers (c. 1589 – c. 1640)
The enclosed valley
aquatint printed on canvas, 108 × 194

Fluid ground

Fluid ground is basically a hard ground which has been dissolved in one of the volatile solvents. It is much easier to apply, especially in a cold state. The solution is poured from a bottle onto the centre of the plate and with swift light strokes of a soft brush it is spread out over the surface. It is used for large plates or for the additional etching of corrections in the design. The ground must be left to dry in a place devoid of dust. After drying it is not usually blackened by smoking.

Recipes for fluid ground:

(L. Bergmann)	*(Delechamps)*
3 parts wax	10 parts wax
9 parts bitumen	20 parts bitumen
2 parts Burgundy pitch	80 parts turpentine oil
25 parts turpentine oil	

Laying out the design

Only skilful draughtsmen can afford to draw with the needle directly into the ground without a preliminary drawing. Usually the drawing is laid out in at least its main contours — the simplest way is to use a normal semi-hard pencil or a red crayon. Working from a preliminary sketch, the contours are transferred from a transparent paper, with the contours drawn in with Chinese ink. The paper is then turned over and rubbed with a ruddle or placed over red copying paper and the overlapping edges are bent over and fixed to the underneath of the plate. The transfer is then traced with a hard pencil or a blunt needle, lightly, so that the ground is not damaged.

(XVIII)
Vojtěch Preissig (1873—1944)
Bluebird, 1900
soft ground etching in colour,
496 × 377

Drawing the design in the ground

A *steel needle* is the basic, all-purpose, classic drawing instrument for line etching. It is usually fixed in a wooden handle and the point can be of various shapes, straight, curved, oblique, etc. For the execution of any design two needles of different widths are usually enough. The elongated point of the needle should not be too sharp, but on the contrary slightly rounded. The needle should only penetrate the etching ground, it should not get caught in the metal and thus limit the essential freedom of the drawing. The needle is held like a pencil, but at more of a right angle. The hand should hardly touch the ground so that its warmth does not melt it and it is better to have it supported by a raised wooden bridge.

While drawing it is necessary to respect the particular character of a line made by a needle, as distinct, for example, from a pen-drawn line. The needle must be used with an even pressure at all times, no matter what kind of line is being drawn, — the bright traces of the metal so revealed should be of an even width — their differentiation is achieved later by a varying intensity of etching. The action of the mordant or etching solution must be borne in mind, especially the fact that it acts not only in depth in the metal but also in width. Hence in the dark parts of the design the drawing should have sufficient distance between the lines. If this is not respected it can happen that dense clusters of lines and, above all, cross-hatching get overetched and produce a hollowed out area, which will not hold the ink during printing and will come out grey. Fine lines which are to be etched weakly, can be spaced quite closely.

In addition to the needle already mentioned, a number of other engraving instruments can be used for drawing in the ground, such as diamonds, nails, various hooks, files, scrapers, wire brushes or paint brushes, glass paper and so on. Such aids, though they sometimes produce interesting effects, should be used only exceptionally and with moderation, and with a special effect in mind.

It usually takes some time for the beginner to get used to the fact that he has to draw the contours and the hatching in the negative, i.e. bright on a dark background, and for this reason some print-makers use what is called *white ground.* This is basically a standard hard ground, which is not blackened, but, as the ground cools off, is painted with a thin white glue-based paint on which, while still warm, white aluminium powder is applied with cotton wool and then left to cool slowly. The results are not really perfect from a technical point of view and it is better to get used to drawing in the negative.

During the drawing the needle removes small particles off the ground, which must be dusted off from time to time with a soft brush.

Corrections of the places wrongly engraved must be made by painting them over with a brush dipped in fluid ground or in fast drying bitumen varnish and by engraving the design again correctly. The covering brush technique can also be used during drawing to achieve highlights and reflections, for example in crosshatched or similarly treated areas, rather than painstakingly leaving gaps in the lines.

Building up the design

This can be achieved in two different ways, each of which can be applied consistently, though usually a combination of the two is used.

The first and most common way consists of engraving the design in the ground completely and then differentiating the depth and width of individual lines by repeated etching in stages and with a gradual stopping up of those parts that have been sufficiently etched. The second method consists of engraving only the darkest parts of the design in the ground and in etching those parts first. Then the lighter parts are added and the etching process is repeated. This method of gradual drawing and etching until the finest lines are obtained produces the required gradation of the design. It is always useful to apply this method to produce the darkest parts of the design so that each successive hatching made at a different angle is added only after etching the previous one. There is then less danger of overetching, and the bottoms of the crossing lines are at different levels and can be relied on to hold the ink during printing.

At this point one must therefore already have an overall concept of the design which must be divided into several spatial, plastic or light planes. In accordance with these, the decision is then made concerning the intensity of etching and hence the depth and width of the lines in the various parts.

Before starting to etch, the design must be carefully examined. All unwanted lines and also the edges and the underside of the plate are brushed with a bitumen or shellac varnish.

Bitumen varnish: 350 g Bitumen of Judea
dissolved for 24 hours in
250 cc of waterless benzol

The well stirred solution is sieved into a brown glass bottle and tightly stoppered. A small quantity of the varnish is poured from this reserve solution into a smaller bowl immediately before use. The rapid drying of the varnish can be slowed by adding several drops of benzine or toluene.

Shellac varnish: 250 g shellac flakes
dissolved for 48 hours in
500 cc of pure methylated spirit.

The solubility of this varnish is slow and it is less easy to remove from the etched lines. In addition to this, it is also less resistant to etching.

There should not be too long a period between the completion of the design and the etching, as the oxidation of the naked metal results in uneven action of the mordant or etching solution.

Etching the design

The etching process is just as important in the creation of an etching as the engraving of the design. It is only at this point, by the correct choice of the mordant and the time allowed for its action, that the design is completed and enriched by the appropriate gradation of lines which create the plasticity, spatial effects, the lights and shades.

Mordants

Copper or brass are best etched with a solution of *iron perchloride* or ferric chloride in distilled water with a concentration of 32—34 Bé. The density is measured by Baumé's hydrometer (a glass tube with a scale weighed down at the bottom with shot), which is submerged in the solution, the surface level showing the degree of concentration. The etching solution works best at a temperature of about 24°C, a lower temperature slowing down the etching process. The reserve solution is prepared by dissolving some 2 kg of crushed salt crystals in a litre of distilled water. After prolonged use the etching decreases — this is apparent from the fact that its orange colour changes into green as a result of the action of the dissolved copper. During etching a layer of cupric

(61)
William Hogarth (1697—1764)
The dance, 2nd print from the cycle
The Analysis of Beauty, 1753
etching and copper engraving,
364 × 490

(62)
Giovanni Battista Piranesi
(1720—1778)
The jail, print from the cycle
Carceri d'Invenzione, 1761
line etching, 360 × 237

(63)
Charles-François Daubigny
(1817—1878)
Two shepherds in a wood, 1874
line etching, 2nd state, 255 × 196

chloride settles on the plate and this must be wiped off from time to time with a feather, with cotton wool or by constantly rocking the dish in which the plate is placed.

Ferric chloride etches relatively slowly but steadily, without creating gases harmful to health. The lines of the design are etched by it at right angles, i.e. in depth, and they only widen very little, while their edges remain smooth. Control of the etching process is made slightly more difficult by the fact that the design changes its colour at this point to black. The veil formed in this way can be removed by dipping the plate for a moment into a water solution of nitric acid. While working it is necessary to protect one's hands with rubber gloves and to make sure that the ferric chloride does not come into contact with the skin.

Nitric acid (acidum nitricum) is primarily used for etching zinc plates, but it can also be used for copper ones. It is sold at a concentration of approximately 40° Bé. For etchings on zinc use a distilled water solution of 9 — 11 Bé, i.e. a ratio of 1 : 4 — 5; for copper a solution of 15 — 20 Bé, i.e. a ratio of 1 : 2 — 3. The appropriate amount of water is poured into a measuring glass and the acid is added, always in this order, according to the chosen ratio. To avoid oxidation and therefore the blackening of the etched plate, it is advisable to add a small amount of a solution of crystallic alum to the mordant. A reserve solution is made by dissolving 480 g of pulverized alum in 1500 cc of boiling water and filtering it.

Nitric acid etches violently both in depth as well as width. At the same time dangerous fumes are released. Small bubbles form on the metal and these must be wiped off regularly with, for example, a goose feather, as they would make uniform etching impossible. Prolonged use of the acid results in a decrease of the etching effect. The etching solution acts best at a temperature around 18°C.

As an *etching vessel* it is best to use a plastic tray such as those used by photographers. These are sold in several sizes. It is also possible to do the etching in an acid-proof stoneware or glass bowl.

If working with a plate that is larger than any available tray an improvised one can be made on the plate itself by building up a low *wax barrier* around its edges. For this purpose a mixture can be prepared by heating:

6 parts beeswax
7 parts Burgundy pitch or bitumen
3 parts French turpentine
3 parts tallow

The partially cooled mixture is poured into tepid water, where thin strips can be made from it, and these are stuck around the plate while still supple.

For the etching agent to achieve a uniform effect on the metal it is advisable to make what is called a pre-etching. A copper plate can be submerged for a moment in an exhausted solution of ferric chloride or iron perchloride, which is kept specifically for this purpose. A still more effective way is to expose the plate for about 10 minutes to vapours from thick blotting paper which has been dipped into a 20° solution of nitric acid. The blotting paper is laid on the engraved ground and weighed down with a glass plate.

Differentiating the design by etching

If the creative intention is to accentuate the linear qualities of the design while refraining from rich and spatial effects, the engraved design is exposed in its entirety to a single action by an etching agent for the appropriate period.

A single etching can also be used to create a design which is made up of non-uniform lines, if the thin lines have been drawn by just cutting through the ground to the surface of the plate, whereas the strong ones have been incised with a sharp needle deep into the metal. The mordant acts much faster in those parts where the metal has been affected.

From a technical point of view, however, these procedures do not make full use of the creative possibilities of etching. A more dynamic graded presentation of the lines is usually preferable, such as is obtained through staged etching.

If the gradual stopping-up method has been chosen, the plate with a finished design is sub-

Vessels for the preparation of mordants (bowl, bottle for the acid, powder box, measuring cylinder, etching tray and Baumé's hydrometer)

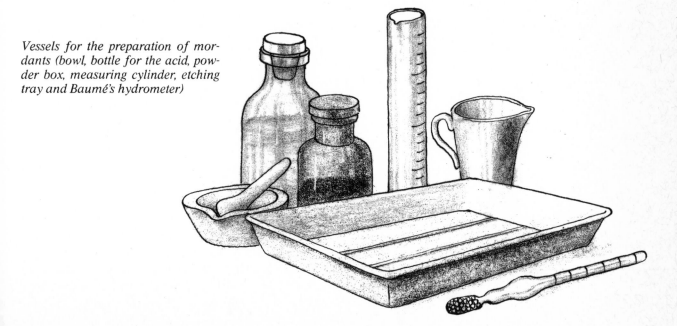

merged in an etching bath for long enough to ensure that the lines which are to remain weakest are sufficiently hollowed out. Then the plate is rinsed thoroughly under water, dried with blotting paper and the parts considered to be sufficiently etched are brushed over with a bitumen covering varnish. This process is repeated as many times as there are depths of etching in the design and until even the darkest parts have acquired the necessary depth. The state of the etched lines should be checked now and then with a magnifying glass, after a small part of the ground has been washed off with a cloth dipped in benzol. If the etching is to be continued, this part has to be painted over with varnish.

In the method of etching with gradual drawing-in, in which only the contours or darkest parts of the design have been engraved, the plate is sub-

merged in the mordant and etched, but not to the full extent. After rinsing and drying, the parts of the plate which are to be slightly lighter are then drawn in. The etching continues, including the parts already started. This continues until the design is completely drawn and the lightest lines have been etched in. In this method the stage of covering with varnish is completely omitted.

The time required for etching to varying depths can never be gauged absolutely accurately. It is determined primarily by the artistic intention, by the type of metal and etching agent used and finally by such factors as the metal composition, the concentration, temperature and state of depletion of the mordant. The only way of doing it is to observe the etching process very carefully. A useful tip is to take a small piece of the same metal, with several types of line drawn in the ground, and place it in the mordant beforehand or at the same time as the plate with the design. Every now and then on this small piece a part of the ground is uncovered and so the etching process is inspected. In this way a continuous scale of lines is obtained, their depth and width increasing the longer the etching time. If these etching times are noted down, together with the data for the metal and mordant, a table is obtained which will also be useful for successive work. Roughly speaking, the intervals for etching zinc with nitric acid are about one minute, for etching copper with nitric acid about five minutes and for etching copper with ferric chloride about ten minutes. If a more spatial effect is required it is better to choose a smaller number of varying depths, but with longer intervals.

When the final etching has been concluded the plate is rinsed well under running water and dried. The ground and covering varnish are washed off the front and rear sides of the plate with a small cloth or brush dipped in benzol (if shellac has been used it is dissolved with methylated spirit).

After this the first test impression (the first state) is made. If it fully corresponds to the artistic intention, work with the plate is completed and the whole number of impressions can be printed. There are usually some corrections and additions to be made. Small corrections to the completed etching are made in a dry state with a needle or graver; lines etched too deeply are weakened by cutting them down with a scraper and smoothing them with a burnisher. If a large part needs to be redrawn, the plate must be covered with ground again. First of all ink is rubbed into the etched design (as before printing), then it is dusted with bitumen and talc and the surface of the plate is wiped with the palm of the hand. Then the hard ground is rolled on once more with a leather roller. The ground is not blackened with soot, or only to a minimal extent, so that both the old and the new parts of the design are visible.

If the whole design has been etched insuffici-

(64)
Édouard Manet (1832—1883)
Jeanne
line etching, 2ⁿᵈ state, 156 × 106

(65)
James Ensor (1860—1949)
Cathedral, 1886
line etching, 240 × 180

(66)
Giorgio Morandi (1890—1964)
Still life, 1933
line etching, 243 × 238

ently and it is necessary to deepen all of it, a thin layer of special ground is rolled onto a slightly warmed plate with a smooth rubber roller. This ground is prepared from:

500 g of copperplate printing or book-printing ink
15 g of beeswax
10 g of stearine

The mixture is rolled out first of all on a warm clean metal plate and then it is applied to the etched plate — carefully, so that the whole surface is covered but the etched lines are not filled in. The etching of the design is then completed in a weak acid.

If it is only necessary to deepen the design in some parts; a stronger acid mixed with a little gum arabic can be applied to the drawn-on ground with a brush.

The stipple method etching

In an etched design all the tonal values can be made by dots, just as in the technique of engraving in the dotted manner. However, in etched designs the dots are drawn in solid ground applied to a copper or zinc plate in the same way as for line etching. In its classical form this technique is rather time-consuming. It was most frequently used in the 18th century. Nowadays it is hardly ever used as a technique in its own right, and it is usually found only as a complement to other techniques.

The point of the engraving needle (which is held at a right angle) is used to model the design in the ground by indenting variously concentrated points. The metal is struck quite lightly. An instrument made up of a number of needles can be used to advantage. Large clusters of points can be made with a wire brush or blunt steel brush.

The completed design is etched in depth in the same way as a line etching and the various depths of the design are differentiated by covering and by varying the intensity of etching.

Etching in the crayon manner

The term 'crayon manner' is applied to the intaglio technique which imitates the tone drawing made by a pencil, chalk or ruddle with the help of special engraving instruments for drawing in the ground.

It was used successfully for the first time by the engraver Jean Charles François (1717—1769), who was active at the royal court in Paris. In 1740 a procedure for printing in colour using this technique and based on three basic colour plates was patented by Jacques Christophe Le Blon (1667—1741). Outstanding results in reproducing and accurately copying chalk drawings were achieved by Gilles Demarteau (1722—1776).

A copper or zinc plate is first of all covered with hard ground as for a line etching. The design is drawn in the ground with pencil-shaped instruments which make various types of engraving mark. At the end of the *roulette* there is a varying sized steel cylinder with a surface roughened with dots, short lines or regular or irregular grain. The *moulette* ends with a cone-shaped piece which turns round its axle and is covered with irregularly spaced points. The *mattoir* is a small steel ball, which turns round the axle of the holder; its surface is covered irregularly with sharp points. The design which is drawn with these instruments is sometimes combined with the dotted manner for detailed work. The etching is made in the normal way.

Starwheel copperplate press

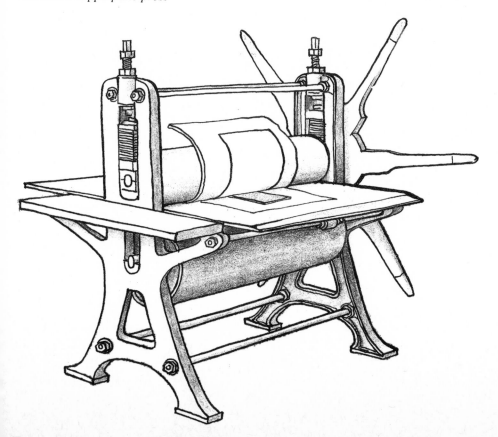

Line etching with grain

The plate is covered with a thin layer of fluid ground without wax, e.g. bitumen dissolved in turpentine oil. The design must be executed in one operation (subsequent additions to the drawing cannot be relied upon) by scraping through the ground with needles of varying thickness. Unlike normal line etching the density of the lines is not important, and in shaded parts it is even possible to uncover whole portions of the metal.

The plate with the completed design is dusted with bitumen or resin powder and heated in the same way as when producing the grain in an aquatint. The incised design is now interrupted and softened by fine resin grains. A varying intensity of soft grained lines is achieved with staged etching and stopping up.

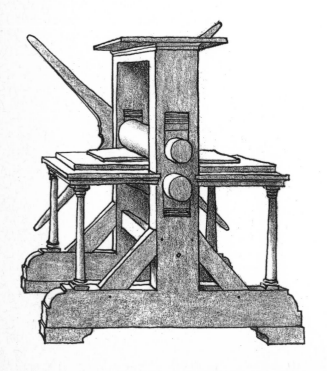

17ᵗʰ-century wooden copperplate printing press

Soft ground etching (Vernis mou)

If a ground that never hardens is applied to a copper or zinc plate the fact that it is easily disturbed can be used creatively. If a material, for example paper or fabric, is placed on the plate with a soft ground and drawn upon, the ground adheres to the underside of the material in those places where pressure is applied and the metal is exposed in soft grained lines. The plate is then etched with a mordant.

This method was used for the first time more than 300 years ago by Dietrich Meyer the Elder (1572—1658) in Switzerland, but it only found full favour in the art of the 20ᵗʰ century, when a number of print-makers were attracted by its simplicity and picturesque effect.

Soft ground etching combines well with the aquatint technique. It is also suitable for creating the basic design in an etching for colour printing.

The preparation of the plate and the ground

The smooth cleaned metal plate is heated slightly and wiped with ball-bearing vaseline or tallow on a cloth; after a short time the grease is partially wiped off.

The *soft ground* is made by melting
2 parts of hard ground with
1 part vaseline or tallow.
This ratio is approximately right for a temperature of 18 — 20°C; for a lower working temperature add more vaseline; for a higher one add more hard ground.

According to L. Bergmann's special recipe soft ground can also be prepared as follows:
3 parts wax are melted with
2 parts powdered bitumen; while mixing continuously add
1 part tallow.
The mixture is then boiled for 5 minutes and left to cool and turpentine oil is added until the mass hardens.

Application of the ground

The ground is applied to a slightly heated plate with a clean leather roller or dabber. The layer of rolled-on ground must be of uniform thickness over the whole of the surface of the plate. The thickness depends on the coarseness of the grain of the material to be used for drawing. The ground is of course very sensitive to touch and one must therefore manipulate the plate carefully.

(67)
Jaromír Knotek (1944)
The music garden, 1975
soft ground etching in colour,
330 × 430

It is best to use drawing pins to fix it by the facet to a drawing board or to insert it into adhesive corners stuck to a hard cardboard.

Laying out the design

First of all the overall concept of the design is sketched with a ruddle onto thin firm paper with a very distinct grain. The format of the plate is marked on the paper. Then the paper is placed carefully over the plate with the ground (making sure that the formats correspond) and is fixed to the cardboard. In this way a reliable foundation for the actual work is obtained and the design can be drawn into the ground.

Drawing in the ground

Pencils of varying hardness and sharpness are used for drawing over the sketch. The pressure is modified to create richly differentiated lines. The ground adheres to the reverse side of the paper as a result of the pencil and thus exposes the metal in lines, which retain the structure of the paper

used. If the grain of the paper with the sketch on it is not sufficiently pronounced another paper with a rougher structure can be placed underneath it in parts or even under the whole of the design. A design executed over fabric also comes out very well; the fabric can be of varying thickness and quality, from fine silk to coarse linen. The choice of these materials depends on the artistic intention and the character and form of the design. For large areas a leather dabber or folding stick can be used instead of pencils. This is rubbed over such areas with the appropriate pressure.

Apart from the above mentioned methods of drawing the design over a structured material it is also possible to work directly in the soft ground, for example with a fairly firm bristle or wire brush. A hard linear design is emphasized by using the pencil or etching needle directly in the ground.

Etching

A design which has been in soft ground is etched in practically the same way as a line etching, but a weaker mordant is used, as the heat produced can endanger the ground. Copper plates are etched with ferric chloride and zinc plates are etched with a highly dilute solution of nitric acid. To prevent damage to the ground the gas bubbles that form are not removed by wiping them off but rather by moving the etching bowl and tilting it to the side. From time to time the plate is lifted out, rinsed with water and the etching process is monitored with a magnifying glass. Bear in mind the fact that, owing to the greater thickness of the applied ground, the etching will appear to have progressed more than is really the case once the ground has been removed. Care must be taken not to over-etch, especially lines drawn with great pressure and those which cross each other densely. When a part is sufficiently etched the rinsed plate is dried (using a fan dryer or air pump) and the finished part covered with bitumen varnish. When this has dried the etching is continued and the process is repeated as necessary until the final form is achieved. Once the etching has been finished the ground is washed off with turpentine or benzol and a test state can be made.

Correcting an etched design

The necessary additions and corrections of lines which have not been etched enough are made in a dry state with a roulette or moulette as the mark made by them combines well with etched lines. It is also possible to use a graving needle for short irregular lines and points provided they are placed sensitively so that they will not appear out of place in the overall effect of the etching.

The parts which have been overetched are corrected by scraping the metal with a triple-edged scraper and smoothing it out with a steel burnisher.

Hand copperplate press with bottom drive

Etching
on brittle ground

A very soft linear or tone design can be made on ground which flakes off under the drawing instruments, thus providing the engraved lines with finely frayed edges.

Preparation and application of the ground

One of three recipes for preparing the ground can be used:

1) A weak solution of bitumen mixed with turpentine or benzol and with a low grease content is poured onto the plate and distributed over the whole surface by tilting it. The superfluous solution is poured back into a bottle.

2) Resin is dissolved in adulterated spirit and coloured with a purple methyl (aniline) colour. This is applied in the same way as the previous ground. If the mixture coagulates on the plate while drying, it means that the alcohol has too high a content of water. This can be removed by adding a little potash or green vitriol to the alcohol as these will combine with the water and produce a sediment at the bottom of the vessel. A new ground is then prepared from the decanted waterless alcohol. The flaking quality also increases if the prepared ground is denser and the layer of ground thicker. Both types of ground can be applied with rapid strokes of a brush so that no traces of the strokes remain. But this procedure does not ensure uniformity of the layer, although this is a necessary condition. To be able to draw immediately after the ground has been applied it is necessary to heat the plate and then cool it off again, otherwise it takes about a day before the ground becomes sufficiently brittle.

3) A normal hard ground is applied to the plate and when it has cooled off it is dusted in a dusting box with resin, which is melted as for an aquatint, so that it combines with the hard ground.

The technique of drawing

A linear design on brittle ground is made with an engraving needle, but its trace is somewhat wider than in the case of a line etching and it has uneven edges. The density of drawing is arbitrary, and a grid of lines can even turn into an open area. Larger areas of the metal can be exposed with a scraper. Soft edges of shaded areas are achieved by removing the ground with a hard eraser which is fixed in a holder. The result produces the effect of wash drawing. Very soft lines and even whole tones can be made with a roulette with a slightly coarser grain.

The principles of soft ground work can also be applied with interesting results to a pencil drawing on brittle ground. A fabric with a more pronounced, firm structure is placed between the ground and the drawing paper (a bronze or nylon screen is the most suitable); if necessary it can be stretched over a wooden frame (this principle is the same as that used in the silk screen process). Under the sensitive pressure of the pencil the mesh crushes the ground and exposes the metal in soft lines or tones.

Small parts of the flaked-off ground are removed with a fine sable brush as the work progresses. When the drawing is finished the plate is dusted thoroughly.

Etching

If the complete design is of a primarily linear nature similar to that of a line etching, it can be etched immediately in exactly the same way. But if unbroken areas of metal are exposed in the ground, the drawing will need an aquatint grain.

The etching can be done in one step, or the various depths or tones of the design can be differentiated by gradual covering.

Aquatint (grain etching)

The technique of grain etching, aquatint, from the Italian *aquatinta*, is a method which produces toned designs on a metal plate after this has been provided with a grain by fusing on bitumen or resin powder. It is possible to influence the intensity of the individual tone surface by varying types of grain, the strength of the mordant and the length of the etching time, as the surfaces are broken up by the grain into the individual printing points out of which the whole picture is built up. The resulting effect is very close to an ink or sepia wash drawing, hence the aquatint is sometimes called the *wash* or *ink manner*.

This attractive picturesque technique, which originated in the middle of the 18th century, is attributed to the Frenchman Jean Baptiste Le Prince (1733—1781), a pupil of Boucher, who lived for several years at the Court of the Tsar in Saint Petersburg. One of his first aquatints is *The Balalaika Players*. Later he concentrated mainly on the making of prints in colour.

The most important artistic contribution in this field is found in the work of the highly gifted Spanish painter and graphic artist, Francisco José de Goya y Lucientes (1746—1828). He only devoted himself to graphic art towards the end of his life, but his aquatint cycles, particularly *Los Caprichos* and *Los Proverbios* are evidence of his amazing artistic and technical mastery. The aquatint attained great popularity at the beginning of this century, as it answered the need for a relaxed, painter's drawing even in graphic art work.

Preparation of the plate for the aquatint

A smooth metal plate, preferably made of copper, is first of all worked mechanically, given facet on the edges and, when all traces of grease have been completely removed in the same way as for a line etching, it is given an aquatint grain. This can be done in one of several ways, the most reliable and therefore most frequently used is dusting it with fine bitumen which is subsequently fused to the surface of the plate by heating. Instead of asphalt a finely pulverized resin powder, or dammar or copal resin can also be used.

Three types of aquatint dusting boxes (with paddle gear, the tip-over kind, revolving in a stand)

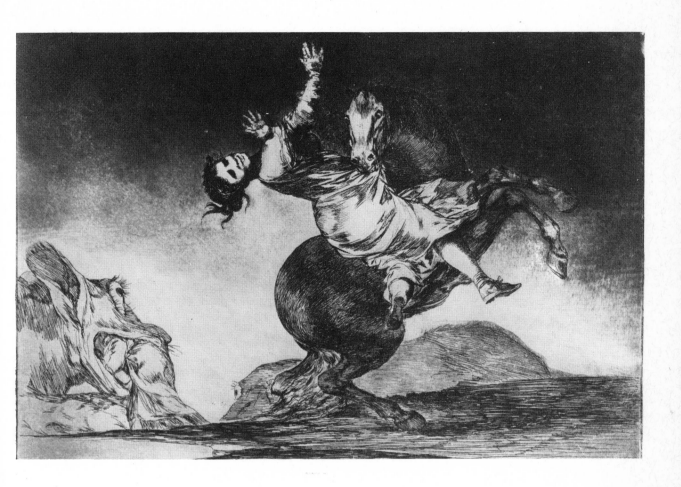

Dusting the plate

The dusting of the plate is done either by hand or in one of several types of dust box. The *hand method* consists of bitumen or resin sprinkled onto washed linen which is folded in two or three layers; the linen is then rolled into a bag and by shaking this over the plate its surface is dusted as uniformly as possible. In this way an attractive, coarse grain is obtained, which is suitable for simple designs or large formats.

The *dust box* is basically a simple box made of plywood, with well glued edges, approximately 50 × 70 × 120 cm in size, which is provided at one end with a sliding grid for holding the plate. Between one and three kilograms of powdered bitumen or resin are poured into the box. Depending on the type of box, the powder is shaken either by turning the box over several times, or by blowing with a bellows inserted in an opening specially designed for this purpose, or by turning a paddle gear placed at the bottom of the box, or by turning the whole box on an axis with which it

is fixed to a stand. As soon as the powder in the box is sufficiently shaken up the metal plate is inserted. When extracted after three or four minutes it is uniformly and densely powdered. As the larger and heavier particles of dust settle sooner, the fineness or coarseness of the grain can be influenced by choosing the moment for inserting the plate into the dust box and the moment for extracting it. If a coarser grain is required, the plate is inserted immediately after agitating the dust and is left inside for a short period. To produce this sort of grain, the plate must be heated up a lot afterwards, but it is then relatively resistant to etching. The grain has a pronounced structure and is suitable for creating deep dark tones. When the plate is heated even more, it produces a vermiculated grain. A fine, dense grain is obtained by inserting the plate at a later stage, when the powder swirling in the dust box is finest. This must be heated very carefully afterwards to prevent it from fusing into a homogeneous layer of ground. This sort of grain cannot be etched very deeply and it is therefore used for lighter tones.

(69)
Emil Nolde (1867—1956)
Scholars
aquatint, 270 × 295

The melting of the grain

The powdered plate must be handled very carefully as the slightest knock or draught can damage the deposited dust coating. The plate should be placed on the hot plate of a stove or fixed by two opposite corners in iron clamps and heated from below with a spirit burner or a gas bunsen burner. To make sure that the heating of the plate is uniform and as gradual as possible either the plate or burner is kept moving continuously. The melting and fusing process must be watched carefully with a strong magnifying glass.

Other methods for obtaining an aquatint grain

There are other methods for obtaining an aquatint grain. None of these can replace the classical dusting procedure — the grain has a completely different quality — but sometimes just that kind of grain may be required. A sufficiently fine, dense grain can be obtained by submerging a plate which has been coated very thinly and uniformly with ball-bearing vaseline into a layer of resin powder. The powder adheres to the vaseline, any excess is shaken off and the plate is heated in the usual way.

If neither bitumen nor resin are available it is possible to use solid ground. This is applied to the plate in the same way as for a line etching but without blackening it. The ground is then covered with a glass paper of medium coarseness and the plate drawn through a copper-printing press at printing pressure. This is repeated about six times — with a new sheet of emery paper each time —

1 2 3

Aquatint grain (1 — fine, 2 — vermiculated, strongly heated, 3 — applied by hand)

Riko Debenjak (b. 1908)
Tree, bark and resin No 2, 1965
etching in colour with aquatint, 420 × 316

until the ground is perforated densely and uniformly over the whole area.

The etching times for this sort of grain, which is of a reverse character (i.e. black points on a white background) should be slightly longer than it normally takes.

Another method consists of sprinkling kitchen salt through a fine sieve onto a layer of hard ground which is melted over the surface of the plate. When this has cooled, the excess salt is knocked off and the plate is submerged in water. The salt grains that have penetrated the ground dissolve and thus expose the metal in small irregular points.

The following method is also based on the principle of the penetration of the hard ground. A plate with rolled-on hard ground is coated with a water solution of sugar and soap (1 : 1) and into this sticky layer salt or wine-stone are sprinkled through a sieve. When this has dried, the plate is covered with thin rigid cardboard, drawn through a press and submerged in water. The grains penetrate the ground and are dissolved in the water to produce an irregular grain. The advantage of this procedure is that it makes it possible to produce the aquatint grain only in some parts of the design (for example in combination with a line etching) if the sticky solution is applied with a brush only to those places where a certain tone is required. For certain special purposes an aquatint grain can be

(XX)
Roberto Matta Echaurren (b. 1912)
print from the cycle *Passage et sage du couple,* 1964
soft-ground etching in colour with aquatint, 278 × 375

(XXI) ▷
Robert Mangold (b. 1937)
Red, 1975
aquatint in colour, 390 × 390

prepared by overprinting. Printing ink is rolled onto a paper or fabric with a fine, but pronounced structure and by drawing it through a press it is printed onto the plate. The overprinted ink of the structure is then dusted with fine bitumen powder and the excess amount is blown off. The heating of the plate causes the bitumen powder to combine with the ink and a grain of a negative character, resistant to the mordant, is produced.

If a grain with the positive character of the texture is required, a plate with soft ground and a piece of paper or fabric laid on top is drawn through a press. As with the technique of drawing on soft ground, the coarse surface of the over-

printed material exposes the metal — in this case in a continuous surface of attractive grain.

Laying out the design

If working with an *asphalt grain* which is dark and opaque, it is only possible to make an overall sketch of the design with a lighter pencil or ruddle. If the contours of a preliminary sketch are to be transferred, this is done by making holes in it with a needle. This is placed on the plate and the grain and fine white powder is rubbed into the small holes with cotton wool. These guide lines

are fixed by warming the plate just enough for the white to combine with the asphalt.

If working with a *resin grain* which is transparent, the auxiliary sketch can be made before the grain is formed by blackening the metal chemically. On zinc the drawing is made with a pen dipped in the following hot solution: 16 g of blue vitriol and 8 g potassium chlorate in 100 g of water; the green sediment is filtered off.

For drawing on copper a water solution of sulphur flower, gum Arabic and several drops of glycerine is prepared. The sketch is drawn with a pen and when completed it is heated and turns black.

A transfer, made with a needle in astrafoil, is coloured with a greasy colour or sulphur flower mixed with olive oil and then transferred onto the plate by drawing it through a press. The lines are then fixed — on zinc by dipping it in a solution of ferric chloride, on copper by heating.

Aquatint without a linear design

In its pure form the aquatint is a technique for toning individual parts of a design, which does not make use of contour lines. It makes the most of the painter's handling of the brush and the result is similar to an ink or sepia wash painting. Various tone values are achieved by varying the etching times of the mordant on the metal and bitumen varnish is used to stop up the parts which have been sufficiently etched.

In the first phase the underside and edges of the plate and then those parts of the design which are to remain completely white are painted over with a brush with bitumen varnish. After the first etching, rinsing and drying of the plate, the parts which are to remain only slightly toned are stopped up and the etching is repeated. Starting with the lightest, this process continues until the darkest

and deepest parts of the design are completed.

To bring out the highlights during the first etching it is possible to use a greasy white chalk used for writing on glass instead of bitumen varnish. It is even better to use a soft lithographic chalk, which is so resistant to the mordant that it is possible to make up to three tones. In such a case it is, of course, better to provide the plate with a light resin grain, which makes the design more visible. When the given tone has been drawn in the plate it is heated slightly, thus melting the resin a little so that it reaches the metal.

Aquatint with a linear design

Aquatint offers a wide scope of possible combinations with other basic or auxiliary drawing and etching methods. This greatly increases its richness of expression. There is often a need for firm contour lines which will hold the design together like a skeleton. These lines must be made prior to graining the plate by one of the linear techniques, such as dry point, line etching or soft ground. A linear design with positive or negative values can be made with the help of one of the lift ground processes (see p. 122).

To choose the right combination of techniques, and even for the actual work on the plate, it is usually best to start with the original drawing — a sketch, wash drawing, or sometimes a coloured drawing made with a brush, pen, pencil or ruddle.

Dry point drawing must be made with slightly greater pressure, so that the extruded burr can withstand the etching. Dry point and line etching, for which a further toning is intended, must be formed with simpler, less frequent lineament, and not too much shading. The aquatint grain combines ideally with the textured lines of soft ground. This combination is also suitable for etching in colour.

The positive lift ground process makes it possible to create dark contour lines that can be etched either directly as a line etching, or preferably after the grain has been dusted and fused on.

A similar, somewhat softer effect is achieved by etching in brittle ground. A negative pen or chalk lift ground process enables the design to be enriched with bright lines or soft highlights which have been stopped up in the toned areas.

Aquatint with one etching stage

As distinct from the last described method, where the plate must be etched as many times as there are tones in the design, there is another method which involves only one stage of etching. In this the differentiation of the various dark surfaces is achieved by the density of the grain.

The plate is dusted with fine powder of bitumen or resin coloured with soot and the grain is melted on. The design is made by removing the grain with a scraper, or a needle for the detailed work, and leaving it on only in the highlight areas. The plate is scraped away everywhere but in the parts with the first weak tone. The work is continued in this way until the parts with the darkest design are reached. The black tone, which is dusted on last, therefore has only one layer of thin coarse grain. The lighter the particular part of the design, the more layers of coarse grain cover it. The white parts have an unbroken bitumen covering. The etching is done in one stage, keeping the darkest tone in mind. As soon as the required depth is achieved — the effect of the mordant is inspected with a magnifying glass and the etching must not, of course, penetrate under the grain — the plate is removed and washed with benzol. The resulting impression is of a somewhat different character to that of an impression from a plate which has been etched several times — the design is far softer, especially if it is an engraving needle that has been used predominantly.

Etching an aquatint

The texture and intensity of an aquatint tone depend not only on the density and size of the

Section through plate with an aquatint grain (1 — slightly etched, 2 — strongly etched, 3 — overetched)

fused grain, but also on the method of etching. An aquatint is usually made on a copper plate and preferably etched with ferric chloride with a concentration of about 20 Bé, as it acts gently and slowly; the plate need not be heated. Nitric acid, diluted with water at a ratio of 1 : 6, is used only when working with zinc.

Etching times

Etching time depends on the coarseness or fineness of the grain used in the work. The rule is that a finer grain is etched less deeply, whereas coarse grain (which covers larger areas of the metal) must be etched deeper if a tone of the same darkness is to be obtained.

A good guide (especially for beginners) for determining etching times is to make an *etching scale* in advance. A sample of the metal that is to be used later, about 5 cm wide and 12 cm long, should be provided with the same aquatint grain as the main plate. This small plate is gradually staged out with bitumen varnish, in about six 2-cm wide strips, and etched alternately for periods of 30 seconds, 1, 3, 5, 7 and 10 minutes for copper fine grain and 1, 3, 5, 7, 10 and 13 minutes for coarse grain on copper. These times can be halved for zinc. When the etching is completed the sample plate should be inked up and printed on paper with the different times indicated. This aid should be kept for reference for when approximately the same quality of grain is required again.

At this point the main plate with the design can be etched. With the method of gradual staging out the parts which are already sufficiently etched (use the etching scale as a guide) are covered with bitumen varnish. After the covering varnish has dried the plate is again etched for the appropriate period, rinsed with water, dried and the next tone is painted or staged out. The plate, of course, gets covered with more and more layers of bitumen varnish, as the darkest parts are reached and the development of the design becomes difficult to follow. The quality of the etched tone is best checked on a small surface of scraped-off varnish at a point where it meets a tone etched one step earlier. (This is covered later.) The deepening grain must be carefully observed with a magnifying glass. The greatest danger is that the grain will be etched from underneath (as already mentioned the mordant acts not only in depth but also in width); in such places small islands of metal which are protected with dusted-on resin break off completely, the lower grain does not hold enough ink and is printed grey instead of black. Should it happen that the darkest tone is over-etched, it is sometimes possible to save it by dusting the plate once more and by fusing on the grain, this time with a greater density, and etching the part again.

When the etching is completed the plate should be washed with turpentine or benzol. At this point the complete picture can be judged, as it is built up of a continuous series of half-tones. A test impression may also be made. In some places the transitions between individual tones need to be softened. Such small corrections of an aquatint

Aquatint etching scale with etching times

2

4

8

15

30

60

Chalk etching (using light-sensitive bitumen or asphaltum)

are made in a dry state, either by brightening it — i.e. by carefully lowering the grain with a scraper and smoothing it with a burnisher — or by darkening it with a roulette. To brighten larger surfaces, the grain can be lowered by etching over. If it is necessary to regrain the plate to obtain a darker effect on a larger scale, then this grain must always be denser and more fused than the previous grain.

The scraped aquatint

The lowering of the aquatint grain with a scraper and burnisher· as in the mezzotint technique, enables one to make the soft shading of a tone drawing. This auxiliary technique is called the scraped aquatint and it can sometimes be used on its own. The method was used by Goya in his print *The Colossus* (wrongly described as a mezzotint). Among contemporary artists it is brilliantly used, for example by the Austrian printmaker Alfred Hrdlička.

The plate is first of all provided with fine aquatint grain, which is etched either in one stage or by gradual stopping up. The bitumen or resin grain is washed off with benzol and the plate is thoroughly degreased with alcohol. The design is then formed by scraping away the etched grain to the required tone.

When working on a printing plate for etching it is possible to make good use of the properties of Syrian bitumen or asphaltum, which becomes scarcely soluble in turpentine under the exposure of light.

The asphaltum is dissolved in French turpentine and applied to a metal plate with a broad sable brush; the coating must be absolutely uniform and have just the thickness that gives it a yellow-brown colour. The drawing is made with a lithographic chalk or a black pencil — similar to those used by photographers — in weak daylight or better still in artificial orange light.

The plate with the completed design on it is placed under direct sunlight and after two, or at most three, hours the exposure is completed. It can also be placed under an ultraviolet arc lamp in which case the exposure is completed in less than half the time. The black drawing has acted here as a negative — in the places where the asphalt has not been exposed, its properties do not change, but elsewhere it becomes non-soluble in turpentine oil. Thus if the asphaltum coating is washed off those parts covered with the design (use cotton wool dipped in turpentine to do this), the metal of the plate is exposed. The plate is then given an aquatint grain and etched as an aquatint. After etching the design in depth it is submerged for about an hour in paraffin, in which even the bitumen exposed to light softens sufficiently to be wiped off.

To estimate the correct exposure time it is useful, while exposing the main plate, to expose a small sample of the metal with the same kind of drawing on it — this serves for testing when the exposed bitumen stops dissolving. The light from an arc lamp is even more effective than sunlight.

The design can also be made separately on transparent material such as astrafoil, matt glass, etc. This has the advantage that the design need not be made as a mirror image.

Lift ground process (Reservage)

The auxiliary lift ground techniques serve to create a grainy linear design or a white negative design on a tonal surface in an aquatint. They can occasionally be used as creative methods in their own right. The alternatives are either to draw beneath the etching ground (thus preventing it from adhering to the plate and making it easy to remove), or onto the ground with media that dissolve it.

Lift ground process using ink

Standard fountain pen ink is mixed with a small amount of a dense solution of gum Arabic and several drops of glycerine. The drawing is with a pen or brush on a thoroughly degreased plate. The dry drawing should be slightly glossy and it must not flake off. Corrections are made by scraping off with a scraper.

A solution of resin in alcohol (i.e. flaking ground) is brushed or poured over the design when complete. When the ground has dried out the design is washed with water using a wad of cotton wool or a sable brush. If the design is built up of very fine lines it can be etched directly; in the case of wider lines or small areas the plate is given an aquatint grain. The etching can be done either in one stage, or by a gradual stopping-up of the lines with bitumen varnish. The fineness of the grain is determined by the nature and scale of the design.

Positive lift ground process using tempera

A pen or brush design with a grain that combines well with the tones of an aquatint can be made with an appropriately diluted tempera paint on a thoroughly degreased plate in a similar manner to the lift ground process with ink. When the tempera has dried, a thin layer of solid ground is rolled onto the plate with the design. Then it is placed in tepid water and, after about 15 minutes, the dissolved tempera is wiped off with a wad of cotton wool. This also washes away the ground above the drawing and exposes the metal. When the plate has dried, bitumen or resin is dusted on and an aquatint grain is fused on. After sufficient etching the bitumen is washed off with benzol.

Negative lift ground process with ink

A positive linear design, etched, for example, in solid ground, can be enriched by a negative, white design on a darker aquatint tone. A uniform layer of a solution of ink, gum Arabic and methylated spirit is applied to the plate, and when dry, the design is engraved with a blunt needle or roulette. The design when complete is brushed over with a thin layer of flaking ground and the underlying layer of ink is washed off with a brush under running water. Now only the drawing made in the flaking ground remains. An aquatint grain is applied and etched.

Negative lift ground process using Indian ink

A negative design in a tone surface can be made very simply using a pen dipped in ordinary Indian ink on a perfectly greaseless plate. When the design has dried it is dusted with resin powder which is fused on. After a single or gradual etching procedure the grain is washed off with benzol and the Indian ink is washed off with spirit. In the parts with the design, the Indian ink prevents the mordant from reaching the metal.

Negative lift ground process using chalk

A design made with a soft ground or a lift ground technique can be suitably combined with a negative tone chalk drawing on a darker aquatint area.

A lithographic chalk is used for drawing on a plate that has a fused-on resin grain in those parts that are to remain white. Then the etching is done in the usual manner. The particles of greasy chalk which get caught in the gaps between the grains protect the metal against the action of the mordant. It is better to use a fairly soft chalk as it provides more resistance.

Lift ground process using oil

The design is made with a brush on the plate covered with hard unblackened ground. The paint is prepared from olive oil and soot. The oil affects the ground in the places marked by the design; this ground is gradually wiped off with a cloth, thus exposing the metal. The completed design is given an aquatint grain and etched.

Another method involves taking a finely tex-
tured sheet of paper lightly marked with the de-
sign and thoroughly soaking it in kitchen oil (the
surplus oil is removed from both sides). The paper
is placed on a plate covered with hard ground and
both paper and plate are fixed with drawing pins
to a drawing board. The drawing is made with
a hard pencil so the grease of the paper is trans-
ferred by the pressure to the ground. Enormous
care must be taken not to touch the paper any-
where else.

Finally the paper is removed and a little while
later the ground is energetically wiped off the
places covered with the design. Then, when an
aquatint grain has been applied, the plate can be
etched.

(70)
Thomas Gainsborough
(1727–1788)
Landscape
lift ground etching, 280 × 347

Brush etching

By adding a tone, auxiliary brush etching methods can well be used to enrich a simple linear design — for example, those made by line etching, by etching on flaking ground, on soft ground and so on.

Adhesive ground

Before completing the etching of the linear design an adhesive ground (1 part sugar, 1 part soap in 10 parts of water or a 100 cc solution of dextrine in water with 5 cc glycerine) is applied to the parts where a tone is required. This is applied with a brush, the surface sprinkled with fine emery and the surplus shaken off. Smooth paper is laid on the plate, which is drawn through a press. The emery grains are pressed through the hard (soft, flaking) ground all the way to the metal and this produces a fine grain in the parts covered by the deposit. The adhesive deposit of emery is then washed off with water and the etching of the plate is completed. A graded shading can be achieved with this method in the following way: after drawing the plate through the press for the first time the adhesive ground is washed off, then it is applied again in those parts that are to be darker, then sprinkled again with emery and drawn through the press, and so on.

(71)
Vojtěch Preissig (1873—1944)
Nude, 1913
brush etching, 160 × 215

Brush etching with etching paste on copper

The etching paste is obtained by mixing powdered sulphur with olive oil on a glass plate with a spatula. This can be used for drawing with a brush on a copper plate. When the plate is heated the sulphur affects the metal and, depending on the thickness of the deposit, creates small areas of varying depth of grain on the surface. This grain is on the whole rather shallow and therefore cannot withstand a large number of impressions.

Brush etching on zinc

A completely etched zinc plate with a linear design can be toned, once the ground has been washed off, by brush etching with a weak mordant — a solution of blue vitriol and potassium chlorate (2 : 1) in water. Prior to this, it is necessary to give the plate an aquatint grain. The brushed over parts turn black immediately and are etched slightly in depth. A little while later the plate is rinsed in water and quantities of fresh solution are applied.

Brush etching with oil paint

Largish areas can be toned unevenly and a linear design can be given a tone by etching over a coating of oil paint from a tube (zinc or titanium white). The mordant penetrates through the fine channels of the damp colour deposit all the way to the metal and produces the necessary gradation of tone, in reverse proportion to the pastiness of the paint.

A uniform fine grey grain is obtained by etching a layer which has been rolled onto the plate with a roller. Additional white paint is applied with a fairly hard brush to the parts which are to remain white; the stroke of the brush should be as relaxed as possible — in some places the bristles penetrate all the way to the metal and this appears after the etching as the structuring of the tone.

Since the white paint layer does not withstand too intensive an etching process it is necessary, if richer tones are required, to work with a plate with an aquatint grain. This is the only way to ensure that the tone is made up of small points. The texture of the grain is also advantageous in that it shows up the strokes of the brush to a much greater extent.

Negative brush etching

A fine resin powder (from a dusting box) is applied with a damp watercolour brush to a plate covered with an aquatint grain in those places where highlights are required. The resin grains, which float freely in a drop of water, settle in a layer of unequal density between the grains which have already been fused on. The plate is then left to dry and the surplus resin is removed with a dry brush. The procedure can be easily controlled, as the light powder gives a good idea of the future highlights. The resin is fused on by heating the plate and then the plate is etched.

Direct etching

The technique of brush etching on zinc or copper can be raised to an individual creative method — this is called direct etching. A plate with an aquatint grain is brush etched with any of the mordants already mentioned or directly with nitric acid or a more concentrated solution of ferric chloride. The acid acts very violently and it must be applied with a glassfibre brush. To make sure the acid does not run during drawing it can be thickened a little with a solution of gum Arabic. The etching process must be interrupted from time to time and the plate rinsed under running water, so that the process of deepening the grain can be checked with a magnifying glass.

A type of portable copperplate press

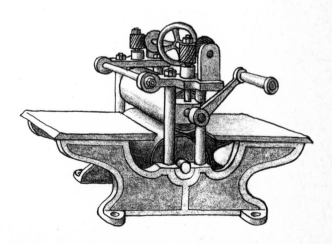

Hand photogravure

Hand photogravure is the link between the aquatint technique and modern machine photogravure. This method was based on the discovery by Fox Talbot in 1852 that dichromated gelatine, if subjected to light, is non-soluble in water. This technique was substantially developed by the Czech painter Karel Klíč (1841—1926), who sought a method of transferring and etching a tone photograph onto a metal plate. He made the first photogravures in 1878 and won a number of prizes and awards for them. From 1889 he continued his research in England. In 1891 he solved the problem of rubbing the printing ink from the surface of the plate with a thin steel blade, called a doctor blade, so that he was able to replace the copperplate printing press with the more efficient printing machine. In 1895 he replaced the bitumen or resin grain with a gravure screen. The gravure glass screen consists of dark squares with clear lines between them. This screen is exposed to a pigment paper, a light-sensitive gelatine layer on a paper support. A second exposure through a transparent positive hardens the gelatine in the areas previously covered, during the first exposure, to varying depths.

When the gelatine is transferred to a copper plate with the help of a squeegee, ferric chloride can be used to etch the plate.

The original process involved a copper plate being prepared as for an aquatint. Gelatine, light sensitized with potassium dichromate, is then poured over the whole surface.

When dry, this layer is exposed through a translucent paper carrying the drawing or through a photographic transparent positive. Etching is progressive in relation to the varying thickness of hardened gelatine. The shadow or dark tones carrying the least hardened gelatine etch first and deepest, the light tones where the hardened gelatine is thickest etch last and to a lesser depth.

The combination of various intaglio methods

Each of the intaglio methods described so far provides different possibilities for artistic expression. Each one can be used individually as the sole means of creating a work of art, but it can also be combined with other techniques. There are many possibilities, and it is up to the graphic artist to choose a combination which will produce the most harmonious result. It is seldom necessary to combine more than two different techniques — plates with too great a complexity often lose their freshness and therefore also their attractiveness.

The most frequent combinations of techniques are the following: copper engraving and etching or dry point, dry point and the crayon manner, line etching and aquatint, etching on flaking ground and aquatint, lift ground technique and aquatint, dry point and aquatint, soft ground and negative lift ground technique using chalk, scraped aquatint and oil brushed etching.

A type of portable copperplate press

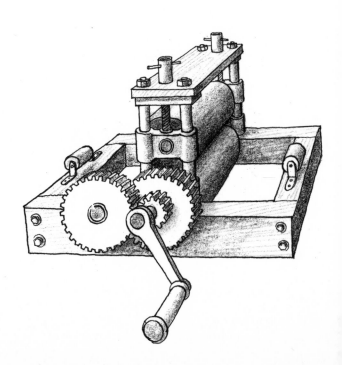

THE TECHNOLOGY OF INTAGLIO PRINTING

Some artists leave the work connected with the actual printing of the complete edition (especially if it is a large one) to a professional copperplate printing workshop. But the majority of print-makers print the complete edition of their plates themselves. In any case it is practical for them at least to print the states. This saves a lot of time and it is only during the printing that the charm of the respective techniques can be fully appreciated.

Apparatus for printing

Engravings and etchings are made on *a copperplate press*. This machine is made up of two side supports which hold two massive parallel steel cylinders placed one above the other. The lower cylinder is connected by cog wheel gear to the driving star wheel. The height of the upper cylinder from it can easily be adjusted by two spiral screws and this determines the printing pressure. Between the cylinders there is a solid steel plate, and the completed printing plate is placed on this when it has been inked.

Ink

Copperplate printing black ink was originally made from bones (bone black) or vines (vine black.) Nowadays industrialized production uses calcinated gas soot mixed with the cleanest boiled linseed oil. The consistency of the ink should be as soft as butter and — as the printers say — 'short'; when dry, it should not be glossy. The tin of ink should be opened carefully so as not to damage the rim.

As little air as possible should get inside the tin, which must not be left open unnecessarily. If not being used the lid should be taped down all round. The ink should gradually be drawn off the whole surface with a spatula. To limit oxidation a circle cut from a greasy carton can be inserted. If the ink is too stiff a little linseed oil should be poured over it. The deep rich tone of the black ink can, if necessary, be broken down into another (usually brown) shade by adding oil paint from a tube (for example, Burnt Sienna, or Van Dyck Brown).

Inking the plate

The appropriate amount of ink is rubbed onto a lithographic stone or a very strong glass plate.

Here, if necessary, its thickness can be adjusted — for thinning, a copperplate printing boiled oil or linseed oil is used, for thickening powdered black or lamp soot. Thick ink is required when the impression is intended to have a perfectly clean surface and plastic relief of the printed lines. Thin ink leaves a transparent tone on the plate.

To rub in the ink one uses a rubber or plastic spatula. This is also used for drawing off any superfluous paste. When a thick ink is used the plate is warmed slightly. The surface is wiped with a flat gauze pad and finally with the palm of the hand. An impression of a plate cleaned in this way is sharp and rather severe — it is best suited for copper or steel engraving. To achieve a certain softness of the lines over the whole design or in its parts, it is possible to heat the plate again, wipe out some of the ink in the recesses with soft organdie and spread it over the surface. This procedure links all the elements of an etching together. Some parts of the design and in some cases the whole design can also be linked together by a transparent tone from an imperfectly wiped out thin ink.

After inking the plate the facet must be cleaned perfectly — if necessary with a little floated chalk — and then it is possible to start the printing. A sheet of clean paper is placed on the movable plate of the press; the format of the printing paper and the placement of the printing plate is marked on the paper. The inked plate is placed face upwards according to these marks, and a damp sheet of printing paper is placed over it. The paper is covered with a felt blanket, 3—5 mm thick, and passed through the cylinders. The pressure must be uniform and correctly adjusted. The damp paper is pressed into the recessed design, where it takes up the ink — this then appears slightly raised in the print.

Copperplate printing paper

Copperplate printing paper should be of the best quality — supple, soft, without too much size and therefore sufficiently absorbent. The best paper is hand made (from rag pulp collected on wire sieves) and has the typical uneven edges. The highest quality handmade paper is Japanese paper, which is characterized by its long fibres. Most frequently one uses copperplate printing paper which is made specially for this purpose.

Before starting to print, all the paper is brushed on both sides and dampened with a wet sponge.

Individual sheets are interlaid with blotting paper or newspaper, then stacked between two zinc or glass plates and weighed down with a light weight. The paper is used only when it is uniformly damp all over. The dampening of sized paper takes longer.

The damp sheet of paper is placed on the plate so that the edges correspond with the marks on the backing sheet. As dirtying one's hands is unavoidable during the inking of the plate, it is useful to dust them lightly with talc, thus decreasing the danger of soiling the paper. A strip of folded paper is a simple aid which can be used for loading and unloading the paper. A soiled paper backing sheet should always be changed.

With a larger number of impressions a felt blanket that gets too damp can cause problems; therefore a sheet of blotting paper or filter paper is placed between the blanket and the damp printing paper.

A finished print is carefully removed from the plate by holding one corner and lifting it gently along the diagonal until it separates from the plate. Immediately afterwards it is placed between two sheets of blotting paper, and after several hours, while still damp, the prints are stacked one over the other and weighed down with a slab or placed in a bookprinting press. The prints are left under pressure until they are completely dry and flat, otherwise they get wrinkled. Deeply etched prints with a high ink relief are left to dry, lying separately until quite hard; then the paper is dampened again and left to dry under a weight.

If the printing process is interrupted for a long period the plate must be washed perfectly clean with benzol, as dried ink in the recesses would cause problems during further printing. If for some reason the ink dries up, then it should be removed either with a brush and ethyl ether, or by submerging the plate for a longer period in a lye solution.

Imperfections in intaglio printing

An imperfect impression of the design may be caused by the plate being inked too little, by the paper being too dry, by insufficient pressure in the press, by faulty or hardened felt, by an over-etched or insufficiently etched design, by dust on the inked plate, or by the remains of the etching ground and so on.

The paper can get torn usually as a result of adhesive ink, or ink which has oxidized for too long, or as a result of using an unsuitable thinner, or by inking a plate which is too warm, or finally as a result of using a paper which is too thin or too damp.

A greasy print or ink that runs may result from the ink being too thin, or maybe from using an unsuitable thinner, or from printing on too thin a paper with a high ink relief.

Remember that the printing plate gets worn out by repeated inking and printing under great pressure. It is therefore necessary to limit the total number of impressions appropriately so as to obtain only high quality prints. To a large extent the number depends on the technique chosen, the depth of etching and the type of metal used. A copper plate can withstand approximately 200 impressions and a zinc plate about 100 to 150 when etched or engraved but not for dry point when only 30 impressions are possible.

Individual prints are numbered immediately after printing and faulty ones are discarded. At the end the crossed impression is made.

(72) ▷
Jamez Bernik (b. 1933)
Letter 208, 1963
combined technique, 490 × 645

INTAGLIO PRINTING IN COLOUR

An intaglio print in colour can be made from one plate — by applying various colours to various parts of the design, or from several plates, in which case each plate is used for a different colour.

It is best to use copper plates, as some light colours (for example yellow) become soiled when printed from zinc. As it is necessary to achieve a perfect register, thinner than normal plates are used. These are cut and ground in a vice to exactly the same size. The edges are not ground into facet but are only rounded. To produce the coloured design all the basic and auxiliary techniques and their combinations can be used. Usually one of the linear techniques (line etching, soft ground, positive lift ground process) is combined with an aquatint tone technique. The colour harmony of the subject is produced either by the direct effect of the printing colours, mixed in an ink duct, or by the subtractive mixing of translucent colours, printed one over the other. Although in print-making it is more difficult to make consistent use of three-colour printing, or even four-colour printing, than in the industrial reproduction process, it is best to be economical and use the smallest number of plates. However, the fullest colour effect must always be maintained. To judge the combination and intensity of the individual colour values correctly it is necessary to use the colour circle diagram and an aquatint etching chart printed with primary colours. To be able to determine a correct working programme a watercolour sketch ought to be made beforehand. This will prove to be indispensable.

Two-colour and multicoloured printing

If inexperienced, it is well worth trying out the whole procedure with two-colour printing — this is both technically and aesthetically less demanding than printing with bright colours from several plates.

The basic design, which is made on one plate, for example with the soft ground technique, is printed onto a natural toned paper (for example grey-green). While the print is still damp it is transferred by passing it through the press onto another plate. Working out the highlights with a white chalk on the natural paper with the dark design also provides a guide for making the same highlights on the plate — for example with the negative lift ground process using chalk. An aquatint surface without the white highlights is then printed in black or red-brown.

A similar effect can be achieved by direct printing onto natural coloured paper. In such a case only the highlights, and not the colour, are printed from the second plate. These are made, for example, with a roulette in a brittle bitumen ground and white ink is rubbed into the etched design. The white ink is prepared from letterpress opaque white by adding oil painting Titanium white. It can be slightly toned so that it harmonizes with the colour of the paper.

For the multicoloured print the impression of the basic design is transferred onto as many plates as there are colours to be used for building up the picture. The basic design is printed (on white paper) and coloured with watercolours; according to the coloured sketch the parts which correspond to a particular colour are marked out on the individual plates either by painting out with bitumen varnish or with the tempera lift ground process. After dusting and fusing on aquatint grain the plates are etched in stages in the same way as the black and white plate. Plates for printing the light colours should be etched deeper than plates for printing dark colours.

Zieglerography (soft ground in colour)

The German graphic artist W. Ziegler's (1859–1932) invention of a method for producing at one and the same time both an original design in colour and its colour elements for intaglio printing was an interesting development of the soft ground technique in the field of etching in colour.

As many metal plates are prepared as there are colours to be used for building up the design and each of them is provided with soft ground. They all must be of the same size to ensure a perfect register. Low stops are fixed to a drawing board on two sides and then a drawing paper with the required grain is fixed over it with drawing pins. One of the plates with the rolled on ground is inserted underneath the paper so that it lies immediately next to the stops. It is then possible to start drawing with coloured pencils or a harder type of chalk in the same colour tones as those to be printed with later. For each coloured pencil there is a corresponding plate. The whole coloured design is therefore drawn on the paper, but it is vital to remember to change the metal plate each time a different pencil is used.

This simple and ingenious method automatically breaks up the coloured design into its individual colours. At the same time the paper provides a continuous check on the resulting effect of the overlapping colours, as the register of all the plates will be an accurate reproduction of this original pencil or chalk design.

Copperplate printing colours

Apart from black copperplate printing ink, which is supplied in a tin, colours sold in tubes are usually used for printing in colour. Inks of several basic colours suffice for a wide scale of colour values which can be obtained by mixing them in the inking system or by register. To achieve soft pastel shades add mixing white. The slight toning of a copperplate printing colour is achieved by adding the particular oil painting colour required. Copperplate printing boiled oil or linseed oil is used as a thinner. The colours are rubbed with a dabber into the etched design without heating it. The surface is wiped with a clean fabric dabber or with the palm of the hand.

If the various colour tones are only used on small surfaces which are relatively far apart it is possible to print two or even three colours from one plate. If the design is not etched deeply, all plates can be printed immediately one after the other. Each is coloured with the appropriate inks and usually printed in rapid sequence, while the preceding colour is still damp.

Nevertheless it is better to print further colours only when the previous colour has completely dried and the relief has hardened. In this case the whole edition is printed first in one colour. The paper must then be dampened before the next printing. The sequence of printing the individual colours depends on the overall colour concept, but usually starts with the yellow, followed by the drawing colour, then the blue and finally the red. Paper for printing in colour must be firm and it is always pulled through the press in the same direction, because it expands when damp.

The loading of the paper

The loading of the paper for printing in colour can be done in one of several ways. When printing the colours in sequence the following procedure has proved to be the best: a larger sheet of firm paper is placed on the movable steel plate, the coloured plate is placed in the middle of the paper and the position is marked with a pencil. Then the damp printing paper and the felt blanket are placed in position and pulled through the press under pressure. The cylinders are turned until the plate has moved to the other side, but the ends of both papers and the felt must remain pressed down. The felt blanket and the printing paper are lifted and the loose ends are turned up over the upper cylinder. The plate that has been printed is exchanged for the next one, which is a different tone colour, and this is placed precisely in the marked position; the paper and felt blanket are turned down and the whole set is pulled to the other side of the press. When all the colours have been printed the plate is moved until the printing paper is loose and the finished print can be taken out.

With a large number of impressions it is a good idea to place a thin zinc sheet below the plate instead of the paper. Along the perimeter of the printing plate small indentations are made in the zinc plate from the rear side with the cutting edge of a chisel. These marks show in relief on the upper side. The printing plates are thus easily placed in position without danger of slipping, but the main advantage is that this makes it possible to wipe off unwanted ink at any time, which is important, as dirtying with ink cannot usually be avoided. If the prints of each colour are left to dry, it is not possible to load the paper in this way. In this case the simplest method is as follows: the print from the first colour, which has been dampened again, is placed on the felt blanket face upwards; the next coloured plate is placed exactly into the impressed frame of the previous plate. One hand is then placed underneath, the other on top and the whole is turned upside down onto the plate of the press.

(73)
Lucio Fontana (b. 1899)
Concerto speziale No I, 1964
etching in relief, 640 × 500

The combined technique

Only those techniques in which the printing elements are either raised or recessed have so far been described. But in some special techniques the design made by the raised and recessed parts can be combined.

The simplest example of such a printing method is a two-coloured printing pulled from one metal plate. The design which is made by one of the intaglio linear techniques is inked in the normal way with an intaglio printing ink and the surface of the plate is wiped clean. Then, using a dabber or roller, a lighter letterpress colour is applied to the raised plane of the plate. The inks and colours can of course be reversed.

This field includes the majority of prints described as having been produced by a combined technique. The term is far too general and does not describe all the technical peculiarities that have been invented by various artists.

An intaglio plate is prepared by either engraving or etching the design in the metal. The printing elements are formed by gradually adding to, or sometimes by assembling various materials on, the surface of the plate, i.e. as in *material relief printing*. But in this case the ink is applied not only to the raised parts, but is also rubbed into the etched or engraved parts. The ink is then partially or completely wiped off the surface, and sometimes another colour is applied, as previously mentioned. The most frequently used means of creating the required design deposit or texture is nitrocellulose lacquer. This is a liquid that can drawn in before it dries, it can be baked, and other elements (sand, metal filings etc.) can be embedded in it. The characteristic appearance of such prints gave rise to the term *textural prints*.

Intaglio embossing

A special type of printing, in which both the raised and the recessed parts of a metal plate are used, is known as embossing, whether coloured or not. From a technical point of view it is derived from deep etching; the plate is etched to an extreme depth, so that under high pressure in the press the paper is permanently deformed. This technique is more appropriate for printing without ink when the whole artistic effect is based on the clean relief. To produce such a print a sufficiently thick metal plate is needed. The design has a planar character and it is made with a brush and a bitumen stopping varnish. The plate must be submerged for many hours, sometimes even days, in acid. From time to time the sides of the deepening relief are stopped up so as to avoid etching in width. The printing is then done on very thick and strong hand-made paper, which is dampened thoroughly, and with a very thick felt blanket.

An embossed effect is also produced on some prints made with what is called the *active technique*. This entails working the metal plate with a hammer, perforating it with sharp objects, bending it, grooving it and perhaps cutting it into irregular shapes. During printing the paper takes over the shape and the relief of the plate. The effect can be enhanced by colour.

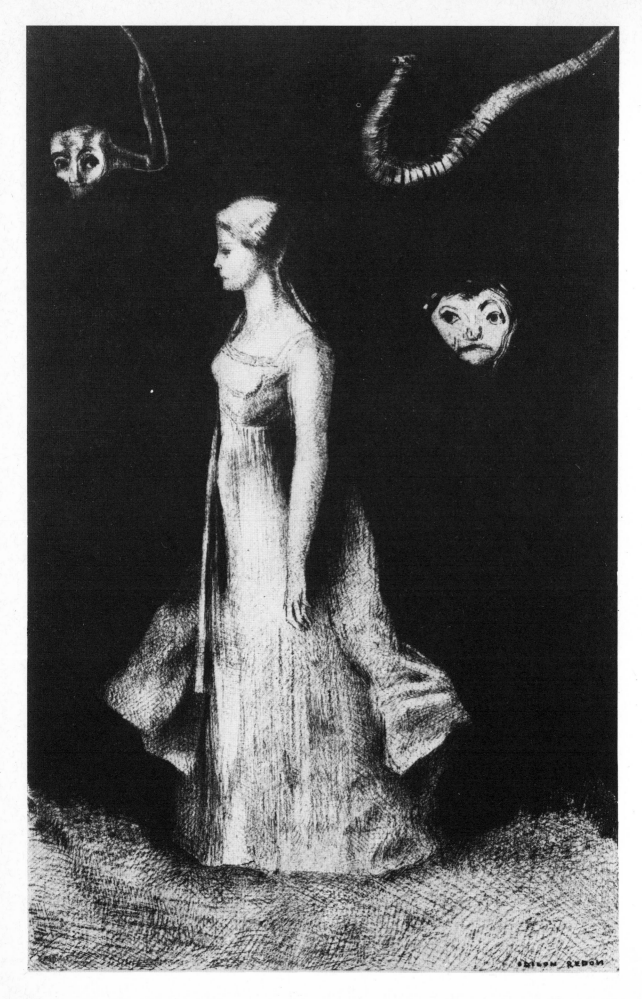

(74)
Odilon Redon (1840—1916)
Woman with ghosts
litho chalk drawing, 2nd state, 259 × 226

(XXIII)
Vladimír Boudník (1924—1968)
Rasputin, 3rd print from the cycle *Rohrschach tests,* 1967
combined textural technique, 345 × 490

(XXIV)
Jaroslav Šerých (b. 1928)
Impression of distress, 1967
combined technique in colour
500 × 270

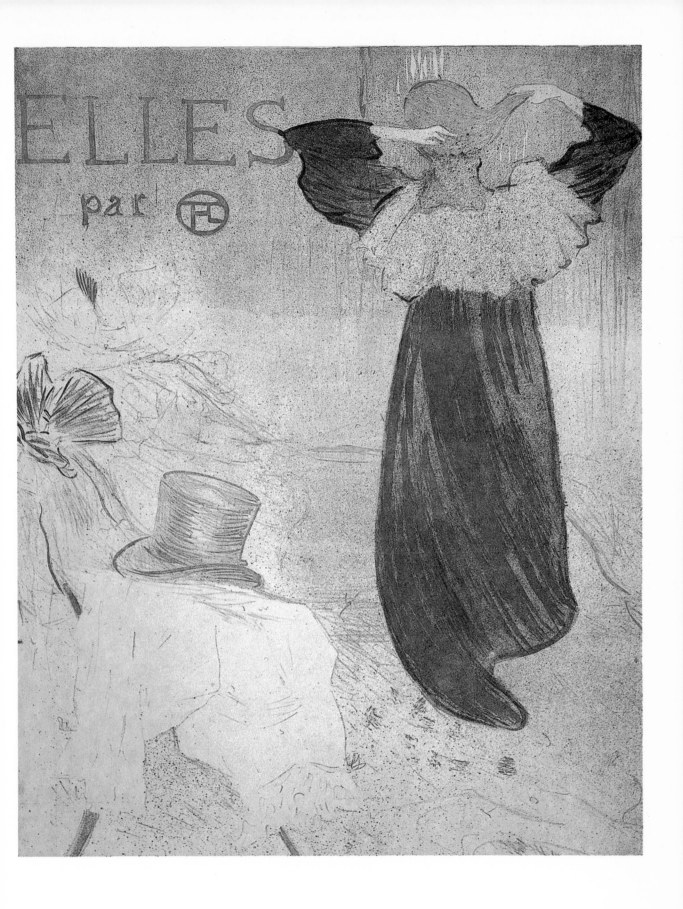

(XXV)
Henri de Toulouse-Lautrec (1864—1901)
Frontispiece from the cycle *Elles*, 1896
lithograph in colour, 521 × 405

(XXVI)
Paul Cézanne (1839—1906)
Bathing
lithograph in colour, 221 × 270

III. PLANOGRAPHIC PRINTING

Planographic printing techniques are a more recent group of print-making techniques which appeared only towards the end of the 18th century and since then have developed dynamically in the field of reproductive techniques. Their characteristic trait is that the printing parts are on the same plane of the plate as the non-printing parts of the surface. Planographic techniques make use of the simple principle of antagonism between grease and water.

Lithographic stone is the most frequent printing form but an aluminium or zinc sheet, gelatine, etc. can also be used. The printing principle is based on the fact that the design is drawn with a greasy material which readily accepts the greasy printing ink, whereas the non-printing parts are dampened with water and repel the greasy ink. Original prints are usually made on a lithographic press, or sometimes on an offset press.

Techniques for working planographic printing forms:
lithography
 litho pen drawing
 — brush technique
 — dotted technique
 — splatter technique
 — aquatint on stone

 litho chalk drawing
 — poupée technique
 — pencil technique
 — dabber technique
 litho wash drawing
 litho mezzotint
 lithography on paper (autography)
 transfers
 photolithography
the combination of lithographic and intaglio printing:
 lithographic engraving
 lithographic etching
 algraphs
 offset proofing process
 collotype

A design of a flat and soft character, which rests lightly on the surface of the paper without being impressed into it (as opposed to relief printing) is typical of planographic printing. Nor does it form a marked relief with the printing ink as in intaglio printing — such a relief only appears to a certain degree with techniques made into the depth of the stone. Only occasionally in some lithographs are the edges of the printing form, i.e. the stone, pressed into the paper in the way the facets are in intaglio techniques.

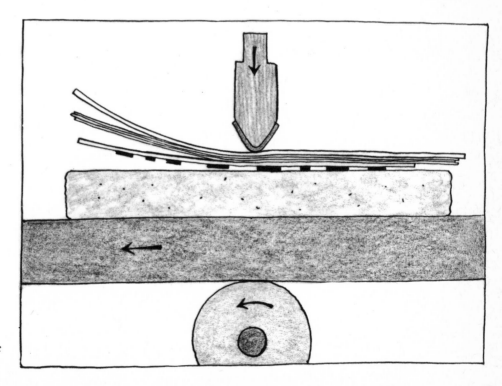

Diagram of planographic printing

THE TECHNIQUES
OF PREPARING AND PROCESSING PLATES
FOR PLANOGRAPHIC PRINTING

Lithography

The basic and most widespread method of planographic printing in original print-making is by printing from a stone block. It is a very beautiful and the same time simple technology. It comes closest to a simple drawing on paper, faithfully recording the artist's drawing, and the multiplicity of processes that can be mutually combined provides a broad range of creative means.

The principle of lithography is relatively simple: it is derived from the chemical properties of lithographic stone, i.e. fine-grained calcareous carbonate. The lithographic stone receives the greasiness of the design and if the surface is prepared by etching, it is capable of maintaining this property. During printing, if it is kept damp, the stone repels the greasy printing ink in those parts where there is no drawing, whereas those parts which have been drawn on are greasy and receive the ink.

The development of lithography

Attempts to make use of etched stone for printing were made as early as 1530 by Michael Gerecht in Klosterneuburg near Vienna. He was then trying to make forms for relief printing by etching in stone. The first person to understand the chemical reaction of Solnhofen limestone and to make full use of it was the Prague-born Alois Senefelder (1771—1834), originally a law student at the University of Ingolstadt, later an itinerant actor and dramatic poet. During experiments aimed at reproducing texts and music scores, he discovered by chance a completely new field of printing techniques and right to the end of his life kept trying to perfect it. He kept adding, for instance, more and more procedures: in 1789 he discovered how to engrave in stone, in 1799 it was autography and the chalk manner, and in 1826 he made the first multicolour print. In 1799 his invention was recognized as being original: the Elector of Bavaria granted him the privilege of practising lithography. Together with Aretino they formed a lithographic institution in Munich and he helped found the lithographic printing houses in Offenbach, London, Vienna and Paris. In 1809 he was appointed Inspector of the State Lithography Printing House for Maps in Munich. Not only did he perfectly master his chemical printing process, *chemische Druckerei* as he called it, but he also constructed various types of printing press (the first dated 1798), in particular the *scraper press,* on whose principles all the machines used today are based. He invented all the drawing aids, materials and instruments necessary for each particular technique. In 1818 in Munich, and a year later in Paris and London, he published a work in which he described his experience up to that date. *Völlständiges Lehrbuch der Steindruckerei* was a textbook of lithography supplemented with original prints of works by well-known artists of the day. Although Senefelder himself was not a creative artist, his book proved that he had brought the technique of lithography to perfection, and to those that followed him he left a basically complete invention. The new method of printing spread with incredible speed to a number of European countries. Above all it was praised for its reproducability potential, which made easier and more perfect reproductions of works by old masters possible. But apart from that, many leading contemporary artists immediately grasped the immense possibilities inherent in the new technique. One of the first was Francisco Goya (1746—1828), who made his first lithographs as early as 1819 and three years before his death issued *Toros de Buerdos,* a series of chalk prints inspired by bullfights. Lithography was developed to its greatest perfection in France thanks to such painters as Jean-Auguste-Dominique Ingres (1780—1867), Théodore Géricault (1791—1824) and particularly the leading master of Romanticism Eugène Delacroix (1798—1863), with his cycles *Macbeth, Faust* and *Hamlet.*

Lithography became a truly popular, accessible and immediate art form; it was capable of spreading fast and thus helped create an intensive advance in the cultural sphere. It also became an effective tool in political struggles, in caricatures and in the critical work of Paul Gavarni (1804—1866), Honoré Daumier (1810—1879) and the Belgian Félicien Rops (1833—1898).

(75)
Rodolphe Bresdin (1822—1885)
The Holy Family
lithograph, 224 × 175

(76)
Honoré Daumier (1810—1879)
Under cobwebs (Attention), 1868
litho chalk drawing, lst state,
239 × 205

Simultaneously with its invasion into all spheres of public life, lithography frequently sank to a purely commercial level and there it accepted the character of a mainly reproductive technique and for a time lost its original high artistic standards. The production of colour prints, especially, yielded very much to popular taste. By then the way was open to photography, which made possible reproductions of even greater accuracy, speed and cheapness. It seemed that mass-produced reproductive photography would take over the field completely and that hand lithography would become extinct.

However, towards the end of the 19th century there was a new wave of interest in this technique, with its characteristic traits of softness of design and easy handling. Once more it was the French painters who set an example to others. A number of painters from the circle of the Impressionists and the Barbizon School such as Édouard Manet (1832—1883), Edgar Degas (1834—1917) and Auguste Renoir (1841—1919) raised the technique of lithography to new popularity and fame. It was also used brilliantly in the works of the Neo-impressionists Paul Signac (1863—1935) and Georges Seurat (1859—1891), in the works of the

so-called Intimists, Pierre Bonnard (1867—1947) and Édouard Vuillard (1868—1940) and the poet of the fantastic, Odilon Redon (1840—1916). The contribution of Henri de Toulouse-Lautrec (1864—1901) deserves special attention, especially for his creation of the lithographic poster in colour. In this he followed the founder of modern poster graphics, Jules Chéret (1836—1932), and brought new impetus to it. Under the influence of the growing Art Nouveau movement this genre soon found favour with many other artists.

The means of reproductive and commercial lithography were gradually perfected as a result of new discoveries in chemistry, photography and mechanical engineering, until it was replaced by the more rational offset process. But as a means of artistic expression lithography retains to this day many patrons among artists and art lovers.

The struggle for a new art style for the 20th century was reflected in lithography in the work of a number of important figures in modern painting and graphic art, such as Edvard Munch (1863—1944), Paul Gauguin (1848—1903), Paul Cézanne (1839—1906), Henri Matisse (1869—1954), Georges Braque (1882—1963), Pablo Picasso (1881—1973), Joan Miró (born 1893), Marc Chagall (born 1887), Jean Dubuffet (born 1901), Hans Hartung (born 1904), Antonio Tàpies (born 1923) and Robert Rauschenberg (born 1925). Whether they work with lithography consistently or only occasionally, all these artists prove that it is one of the most popular graphic techniques.

(77)
Edvard Munch (1863—1944)
Jealousy
lithograph — chalk and brush
technique, 655 × 450

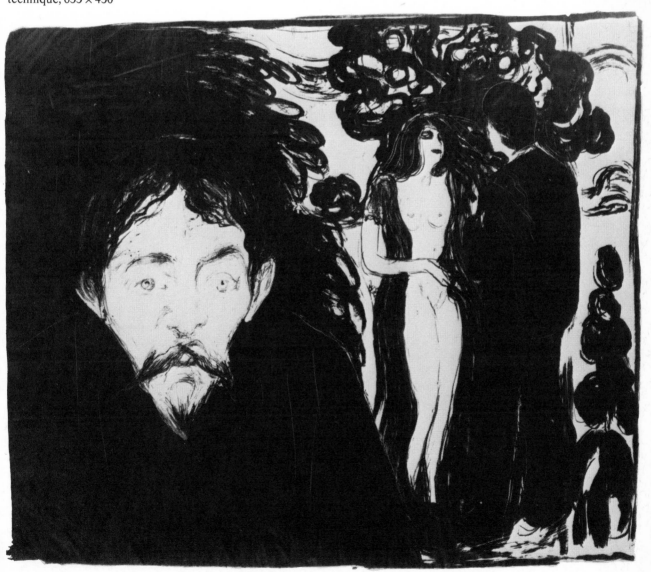

The technique of lithography

Lithographic stone

The light yellow, almost yellow-grey stones used for lithography are quarried in Bavaria (the best are from Solnhofen), the Rhineland and Saxony (Maxen), in France (in the vicinity of Verdun and in Les Euzes near Dijon), in Switzerland (Solothurn), Galicia, Croatia, England and New Caledonia. The stones are basically fine-grained calcareous carbonate of tertiary origin, and are supplied in various sizes with a thickness of 5—10 cm. They are quite expensive. The darker and greyer the stone, the harder it is.

Grinding the stone

Each stone, whether new or already used and drawn on, must be re-ground. In the larger speci-

alized workshops various types of grinding machines are usually installed for this purpose. For the purpose of this book only hand grinding, which can be done by oneself, is considered. Ideally it should be done on a special grinding table, which is positioned under a water tap and connected with the drainage system. The inner part of the table is covered with a sheet of zinc and the sloping surface has a lath or duckboard grid on which to place the stone. It is extremely useful to have strong shelves for storing the stones near the table.

Grinding sand is strewn onto the printing side of the stone after it has been sprinkled with water. The sand can be sieved river-bed quartz stone or pulverized porcelain or glass stone, used normally in glass works. Sieves of various sized mesh are used; the grinding is started with a coarser sand and gradually finer sand is added. Another slightly smaller stone is placed on the stone to be ground and moved in a circular motion. The smaller stone presses down onto the sand and in this way removes both the old design and the chemically disturbed layer of the stone. Occasionally fresh sand is added and if a thick paste has formed between the stones a little water is added. The grinding time cannot be determined exactly, for it depends on the age of the design which is being removed and on the softness of the stone. But it is important to remove even the slightest traces of earlier grease. At the same time the stone must not be ground too much in any place and the plane of the surface must be checked with a metal ruler for flatness.

Polishing

Any grain formed by grinding with sand is removed from the surface of the stone by smoothing it with *pumice-stone,* either the natural porous rock formed from hardened lava, or a small brick of artificial sandstone. This is applied, under slight pressure, with a circular motion over the damp stone. The paste which is created during this procedure is not removed as it helps create a smooth surface and at the same time prevents the stone from getting scratched.

A perfectly smoothed stone is rinsed well with water and left to dry in a vertical position. If necessary the drying process can be speeded up with a fan (see p. 173). Following this preparation the stone can be used for all the lithographic printing methods, except for the litho chalk technique.

Table for grinding stones

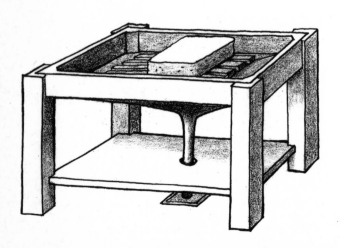

Litho pen drawing

The grain of the stone

To make the design with a lithographic chalk it is necessary to give the stone a grain. A dampened stone is strewn with quartz or glass sand, starting with a coarse one. The best results are obtained with *silicon carbide sand* Nos. 80—100 (the numbers denote grain size). A smaller lithographic stone is placed on top of the stone and, using only the weight of the rotated smaller stone, the surface is roughened. The coarser sand is then replaced with finer sand (Nos. 120—220, 250—300, and so on) until the required grain is obtained. In the final stages the sand must not be allowed to turn into a paste as this would produce a blunt grain. The grinding paste must therefore be rinsed off with water and fresh sand used.

The whole process of preparing the lithographic stone surface is quite demanding physically and it requires patience and practice. But the labour is worthwhile as this initial result substantially influences the success of the print.

Laying out the design

A preliminary sketch of the design on the clean stone should be made with soft natural charcoal, not with a pencil, as that leaves a greasy trace. Before the actual design is made the superfluous charcoal is dusted off. If working from a sketch on paper prepared in advance, the contours should be transferred onto transparent tracing paper and a mirror image copied with the help of a blunt needle through another paper, which is coloured with a ruddle or some other non-greasy material on the underneath — carbon paper cannot be used as it is greasy! These copied lines are a good guide for further work and at the same time they are easily distinguished from the black drawing.

The technique of drawing

Lithography provides an unlimited number of methods for composing an artistic image. It is up to the artist whether he chooses one of the pure techniques, or whether he combines them. It is up to his imagination and feeling for the material to choose the means best suited to his intentions. Therefore in the preparatory stage — in the sketches — it is necessary to test the suitability of the proposed technique by using similar materials.

For this technique a well-polished, medium hard stone is used. So that it will accept the drawing better it is advisable to wipe the stone with a cloth dipped in turpentine oil and to expose it for a short time to the effects of acetic acid. This increases its sensitivity to grease.

The design is made with a narrow *lithographic pen* dipped in greasy *lithographic ink* in the same way as when drawing with Indian ink on paper. The only condition is that the ink must have the correct viscosity. It must flow freely from the pen, so it is diluted with distilled water, but if too much is added it will lose its necessary greasiness and therefore its resistance to the etch. During the drawing the stone must not be touched with the hands. The best way to prevent this is to use a wooden drawing bridge or at least to place a sheet of paper over the stone so that there are no greasy stains which would show when the stone is inked up. It is difficult to remove such stains from the design. Try also not to breathe too closely on the stone, because a damp stone receives the greasiness of the ink badly. Do not be misled by the apparent softness of the design on the stone, as this is caused by the actual colouring of the stone. The resulting impression will always be a little harder. Incorrectly drawn parts should be carefully removed without scratching the printing surface. The edge of a scraper or an artificial pumice-stone pencil can be used. Smaller corrections can be made by pricking away the particular lines with an engraving needle.

Brush technique

A brush dipped in lithographic ink is used to obtain a more robust, relaxed or even quite flat design. The use of a brush makes for a more spontaneous drawing of a line than the movement of a pen. But to make use of this technique a light, practised hand is necessary.

If a broader scale of tones is preferred to a flat design. The use of a brush makes for a more stone and the tones are made by careful touching-up with a semi-dry brush.

Dotted technique

The actual linear design made by a pen or brush can be softened by allowing the individual lines or planes to turn, as highlights, into a row of points applied with a pen held at a right angle.

Alfred Kubín (1877—1959)
The stallion and the snake
litho pen drawing, 284 × 280

Dotting can be used to create whole unbroken tonal planes in the form of a sort of grid. In fact in some cases the entire design and its tonal shading can be made with the dotted technique.

The dotted method used to be very popular, especially in lithography in colour, as it produced a smooth transition between the individual colours in the register. As in its pure form, it is a technique which is very demanding especially in terms of time, and it is nowadays used mainly for small-format printing.

Splatter technique

A tone on a larger surface is achieved easily and quickly by splattering lithographic ink with a toothbrush; this is rubbed over the edge of a knife or a splatter sieve. It produces a distinctive, attractive grain, whose size and density is regulated by varying the amount of ink on the brush, by the mesh of the sieve, by the distance it is held from the stone and, of course, by the time spent splattering.

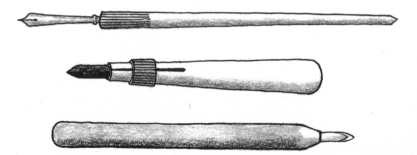

Instruments for lithographic work (pen, chalk in wooden holder and scraper)

146

(79)
Bohumil Kubišta (1884—1918)
The sea, 1916
litho wash drawing, 145 × 200

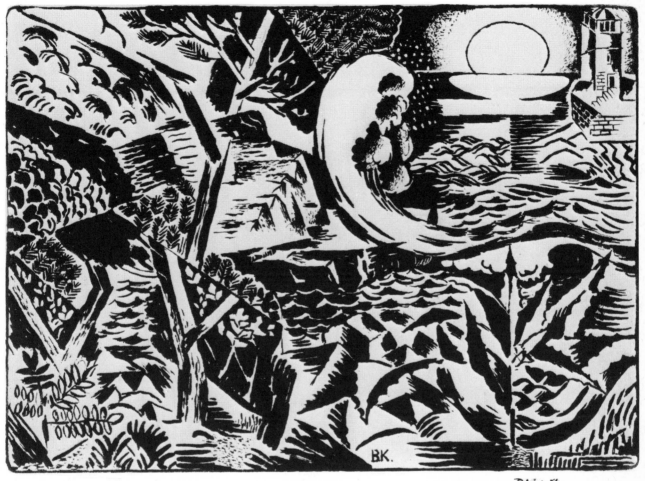

Bhubišta

White surfaces or surfaces already sufficiently toned are stopped up with a solution of gum Arabic or by covering with a paper stencil. For splattering large surfaces, for example in making posters or when a special vignetted effect in the design is required, a compressor spray gun can also be used.

Aquatint on stone

The principle of creating tones of varying texture by splattering lithographic ink, as described above, is also the basis for a relatively uncommon technique, whereby the whole of the tonal design is built up as in an aquatint on a metal plate. This technique can be used on its own, but it is better if combined with a linear pen design. This is made first, thus providing a sort of skeleton for laying down the surfaces. Those parts of the design that are to remain white and the edges of the stone outside the format of the design are covered with a solution of gum Arabic. When this has dried the entire surface is sprayed with the lightest tone. When the ink has dried, the parts which are to retain this tone are painted out with gum. In this way the stopping up and splattering are continued until the darkest parts are reached. Finally the corrections are made and the transition between the individual tones can be softened by dotting with a pen or by picking out with a needle.

The completed aquatint is set aside for a day, so

that the grease is drawn into the stone. Then the design is powdered with talc and the gum is washed away with water.

Lift ground lithography

To make a negative design, in white on a black background, it is most convenient to use the negative lift ground process.

The drawing is made with a pen or a brush dipped in a solution of gum Arabic, with a few drops of nitric or phosphoric acid added. The solution is coloured slightly with lamp soot or powdered red pigment. When the design is completed, the edges of the stone are covered with gum all the way to the perimeter of the final black surface and then the whole stone is left to dry properly.

After this, greasy lithographic ink is poured onto the stone and spread with a fine sable brush over the whole of the surface. The stone is left to stand for several hours so that the grease is drawn into all the places where it is not prevented from doing so by the design. When the stone is powdered with talc and the gum is washed away under running water, the negative design is exposed in all its details.

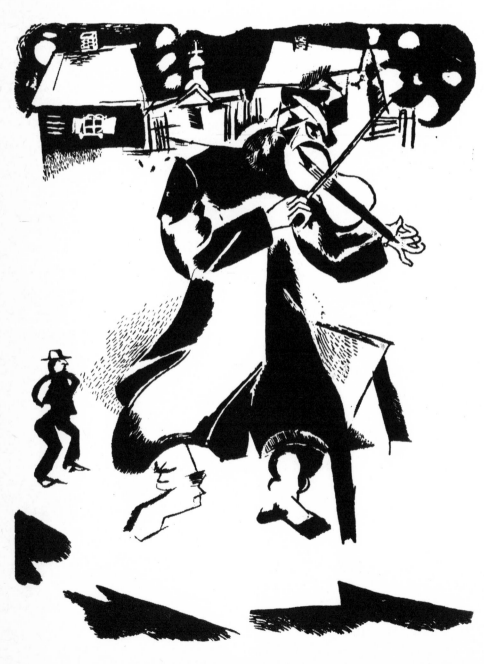

(80)
Marc Chagall (b. 1887)
The village violin player
lithograph — brush technique,
289 × 225

(81) ▷
Henri Matisse (1869—1954)
Woman after bath
litho chalk drawing

148

Litho chalk drawing

The tonal design made with a greasy *lithographic chalk* on a *stone with grain* is probably the most popular lithographic technique and it produces excellent artistic results. It is characterized by a wide scale of tones, from light silvery grey to rich deep black, which are always made up of a number of variously dense minute points formed by the movement of the black chalk over the surface of the grained stone. A hard grey lithographic stone is wiped with a clean cloth dipped in turpentine oil, to make it uniformly sensitive to the chalk. The drawing is done with lithographic chalks, either bought or home-made, of varying hardness. These are fixed in wooden or metal handles, marked with the degree of hard-

ness of the chalk. A hard chalk is used to obtain a light and airy tone; soft chalk is suitable for dark tones. The ends of the chalks are sharpened to a point with a razor blade.

Although it is best to do the whole of the design in one operation, it is only possible to learn from experience the right thickness of tone to use at the beginning without depending too much on subsequent darkening. This is the only way to ensure that the result will be fresh and direct. Energetic drawing is required, first of all with soft chalks in the dark parts, though it is important not to overdo their intensity. Gradually the harder chalks come into play until one gets to the lightest parts drawn. Here the colouring of the stone must be taken into account and the drawing line slightly strengthened, so that it does not come out too faintly in the printing. The parts which are too dark must be made lighter either by pricking out with an *engraving needle* — still maintaining the texture of the grain — or by scraping out with a scraper in the direction of the strokes. By applying a little more force in a similar way, it is possible at this point to make highlights which would have been difficult to leave out during the drawing.

The chalk drawing can be complemented and combined with a drawing by pen, brush, or the splatter process, for example. But its greatest charm is to be found in its pure form.

Poupée technique

To achieve the finest transparent tones, whether simply as part of chalk drawing or as a creative method in its own right, a paper poupée can be used for rubbing on a fine powder made of ground lithographic chalk.

Pencil technique

For especially fine work which is almost miniature in scale, it is possible to do the drawing on the stone with a very hard graphite pencil. But as this method is very sensitive to etching it is seldom used.

Litho wash drawing

Dabber technique

There is an analogous process to the aquatint on stone, whereby the tone is obtained not by spraying but by applying a special *dabber ink* with *a dabber*. A small amount of ink is prepared by heating:

8 parts wax	6 parts shellac
3 parts oil	3 parts soot
5 parts soap	8 parts printing ink

This is poured onto a glass mixing plate and patted onto the leather head of the dabber. The ink is applied lightly with the dabber onto the stone in a homogeneous tone. Once sufficiently toned, the surfaces are covered with a solution of gum Arabic. The method is suitable for large surfaces with a similar character to those in a painting.

To achieve special effects the dabber may be replaced by different fabrics or other materials which produce a variety of textures. Gelatine foils with a relief pattern of different textures (dots, lines, waves, hatching, etc) — called 'Tangiers screens' — can be printed onto the stone by cutting them into the appropriate shape, rolling them up with dabber ink and thus enlivening a simple pen design with a tone.

Just as a tonal design is made from a wash drawing on paper, so also diluted lithographic ink can be used on stone with a grain. But the stone must first of all be prepared with an emulsion made by *boiling:*

3 g beeswax
5 g soda crystals
1 litre of distilled water

The stone is carefully heated with a blow-lamp or torch over its entire surface and the filtered, still warm emulsion is poured onto it. Then the stone is set aside, standing at an angle, and left to dry and cool off.

The lithographic ink is diluted with distilled water to varying degrees of density in between three and five small bowls. The wash drawing is made with a brush, starting with the lightest parts where the thinnest ink is used, and so on to the darkest parts, where the ink is used undiluted. The complete design is built up in this way. However, it is also possible simply to use undiluted ink, and by dipping the brush alternately into clean water the required tone can be mixed directly on the stone.

The second, much simpler method, which does not require the stone to be prepared, is a *wash drawing with soapy water.* The soapy water is obtained by boiling a slab of normal soap in a quarter litre of water. The brush is alternately dipped in the soapy water and in the undiluted ink, and the tone required is created directly on the stone. The final result of the two procedures is basically the same.

(82)
Oskar Kokoschka (1886—1976)
Portrait of the mother
litho chalk drawing, 292 × 207

(83) ▷
Hans Hartung (b. 1904)
L 117
litho chalk drawing, 565 × 765

Litho
mezzotint

Superb results can be obtained with a technique which is based on lightening the design by scraping out a dark surface. A somewhat softer, sharply grained stone is rinsed with water, dried with a fan (see p. 173) and wiped with a cloth dipped in turpentine oil. The size of the design is marked out and the empty edges of the stone are covered with gum Arabic. When this has dried out, *asphalt ground* or *turpentine ink* (i.e. lithographic ink mixed with turpentine oil) is rolled on lightly in all directions with a smooth roller, until a thin unbroken layer which does not drown the grain has been obtained. If turpentine ink is used, it is worthwhile to increase its resistance to etching by powdering it with resin, which is burnt on with a blow torch. The stone is then set aside in a dust-free place for several hours.

The tonal design is made with a flat scraper, which is used for exposing the stone beneath the ground by scraping away the points of the grain. The weakest highlights of the design are done first. Those which are completely white are put in right at the end, as in these places the stone is left without any grain and a fault is difficult to correct. Larger light areas on asphalt ground can also be exposed with emery paper or with a steel wire brush.

Corrections of parts which are too light or sharp dark lines on a lighter background are made with lithographic chalk.

(84)
Adolf von Menzel (1815—1905)
Game with rings in the palace garden, 1851
litho mezzotint, 235 × 180

Lithography on paper (autography)

The most easily accessible lithographic technique, and therefore probably one of the most popular, is the autography method. The design is not made directly on the stone, but on *autographic paper,* and is subsequently transferred to the stone. Alois Senefelder, the inventor of lithography, considered this technique to be the most important part of his invention. It really does offer a number of advantages, for working on paper is, of course, much easier than drawing on heavy stone. Furthermore it is possible to draw without preliminary technical knowledge, in a studio or outdoors, and the rest of the work connected with the printing can be done in a well equipped lithographic workshop.

Preparation of autographic paper

For a chalk, Indian ink or autograph ink design, which is to be transferred to a stone within three days, any normal unprepared, thin, well sized paper can be used. Relatively good results are obtained with transparent transfer paper. The paper

(85)
Pablo Picasso (1881—1973)
David and Bathsheba, 1949
litho mezzotint, 760 × 560

must be prepared if the transfer is to be made later.

The preparation of size: a weak size solution is applied to a stretched, smooth or grainy paper and left to dry out. Two spoonfuls of fine wheat flour or rice are mixed with a quarter litre of boiling water. While stirring continually the mixture is brought to the boil, strained and, while still warm, is applied to the paper in a uniform layer with a broad sable brush. Then it is left to dry in a dust--free place.

Tempera preparation: a grained paper for a chalk design is given two coatings of white tempera paint, thinned to a consistency for painting ground. Tempera paint can also be used for making corrections in a faulty drawing on a dark background.

Senefelder's preparation solution:

1 part gum Arabic in glass of water
2 parts boiled glue
8 parts floated chalk
1 part slaked plaster
2 parts size

A well prepared autographic paper, which can be of varied character and surface texture, is used for drawing on directly, without making a mirror image of the design. The drawing is made either with *lithographic chalk* or with *autographic ink* applied with a pen or a brush. The front of the paper must be kept free of grease from the fingers. It is worthwhile to leave about 2 cm of free space between the design and the edge of the

(86)
Pablo Picasso (1881—1973)
Studio in Cannes, 1955
autograph, 185 × 150

(XXVII)
Georges Braque (1882—1963)
Helios VI, Mauve Héra, 1948
lithograph in colour, 470 × 411

paper, so that later on, during the transfer, the water does not reach the design. The design appears on the white background of the paper in a correct tone ratio. There is therefore no allowance to be made for the colouring of the stone. Apart from the possibility of making use of the actual texture of the paper used for a chalk drawing, special effects can also be obtained by placing the paper over various natural or artificial materials, for example wood, fabrics, embroidery, wallpaper, leaves and ornaments or *Tangier screens,* which produce a regular grid. This is called texture lithography. By cutting out and sticking together various designs in a different arrangement on another paper a *lithographic collage* can be obtained.

A combination of a positive and negative drawing can be used if a white gouache paint is drawn into surfaces and lines made with autographic ink or chalk. The white paint prevents the grease from adhering to the stone in these places during the transfer.

Transfer of an autographic design

Autographic paper with a completed design is placed on clean blotting paper and the reverse side is dampened until it becomes pliant. With prepared papers it is sufficient to use clean water, with unprepared paper the sponge is dipped in a mixture made of 1 part nitric acid and 10 parts water. The water must not reach the front of the paper with the design, as it would not connect with the stone. Thinner paper needs to be dampened only once before the transfer; thicker paper

must be left for as long as several hours weighed down under damp backing.

A perfectly dampened paper is laid face down on a fine grained or smooth stone which has been ground in a dry state with pumice-stone and slightly heated with a blow torch. The paper must not be allowed to wrinkle; it is covered with several moistened and several dry sheets of backing and all this is covered with greased cardboard. With heavy pressure from the scraper the stone is cranked several times through the lithographic press. The design is transferred to the stone, and this can be checked by lifting a corner of the autographic paper. If the transfer is insufficient, the paper should be moistened again and cranked once more through the press. When the design has been transferred, the paper is moistened thoroughly once more and carefully removed from the stone. Any remains of the paper preparation should be washed off with a sponge dipped in a weak solution of gum Arabic. The gummed stone is then left to stand for a day. The rest of the procedure is identical to that for drawing directly on the stone.

(XXIX)
Joan Miró (b. 1893)
The crazy pierrot, 1964
six-colour lithograph,
900 × 610

(XXX)
Frank Stella (b. 1935)
The star of Persia II, 1967
lithograph in colour, 787 × 660

Photolithography

Other forms of transfer

In addition to transferring autograph design, there are other ways of transferring a design which has been created by other means than by direct work on a stone. Although these methods are used mainly in reproductive practice, they may also be useful for purely creative reasons, therefore they are described here briefly. First of all the transfer to a larger stone of *a multiple number* of the original design can substantially speed up the printing process, if the size of the edition is large. Transfers can also be used to combine lithography with other techniques, such as letterpress or intaglio. For example lettepress proofs are transferred in this way if a text is to be printed together with the design. A linear or tonal design can be directly transferred onto a stone from a zinc block.

The *reversing method* is a way of making the second half of a symmetrical design without laboriously turning the first half over and repeating the same design.

The *anastatic transfer* makes it possible to reprint older prints by reviving the greasiness of the drawing. The old impression is prepared in a bath of hydrochloric acid, nitric acid and gum Arabic. The design is inked with a sponge dipped in transfer ink, which adheres only to the drawing. The principle of the transfer is in the printing of the drawing with transfer ink onto transfer paper. Then this is pulled several times through a lithographic press onto lithographic stone. The paper is then removed by moistening its reverse side with warm water. The process of fixing the design onto the stone is identical to that of a direct drawing.

The method of transferring the design onto stone using the photographic copying process is already an accepted part of reproductive techniques and is not therefore typical of the creative working of a printing form. But a photograph as such may sometimes become part of a graphic work as a whole and therefore the method of putting it onto stone is described here briefly.

The photolithography method was used for the first time by the French physicist and the inventor of photography Joseph-Nicéphore Niepce (1765—1833), who by 1812 was already copying photographic negatives onto lithographic stones which he had covered with a layer of bitumen dissolved in waterless benzine. He thus made use of the discovery made by Hagemann in 1782, i.e. that bitumen when subjected to light loses its original solubility. Later, a similar property was observed in bichromate salts, when these were homogenized by colloid matter.

A *line negative* is copied onto a smooth, dry, well cleaned stone, which has been coated, using a velvet dabber, with a uniformly thin *egg-white light-sensitive layer,* in dim daylight at a temperature of about 20° C. The drying out of the emulsion is speeded up with an electric dryer. The negative is placed in position and weighed down with a thick glass plate and the layer is subjected, for 5—7 minutes, to strong electric light from an arc lamp, or for 2—3 minutes to direct sunlight. The exposure time depends on the intensity of the light, the character of the negative and the thickness and sensitivity of the emulsion. The exposed stone is rolled up with transfer ink, the ink is dried out and powdered with talc. The copy is developed in warm water; to speed up the process a few drops of ammonia are added, using a piece of gauze. The emulsion is dissolved and washed off the unlighted parts. The stone is then washed well with water, gummed and left to stand for a day, so that the ink is drawn into the stone. The dried gum is dissolved with a thin solution of fresh gum and it is then ready for etching.

A sharp grained stone with *bitumen light-sensitive layer* can be used for copying *tone negatives* without using an autotypic screen. The bitumen is spread with a broad sable brush into a thin uniform layer and this is left to dry out. A mirror reversed negative is placed on the stone and weighed down with a thick glass slab. The exposure is done under direct sunlight or an arc lamp for 2—3 hours.

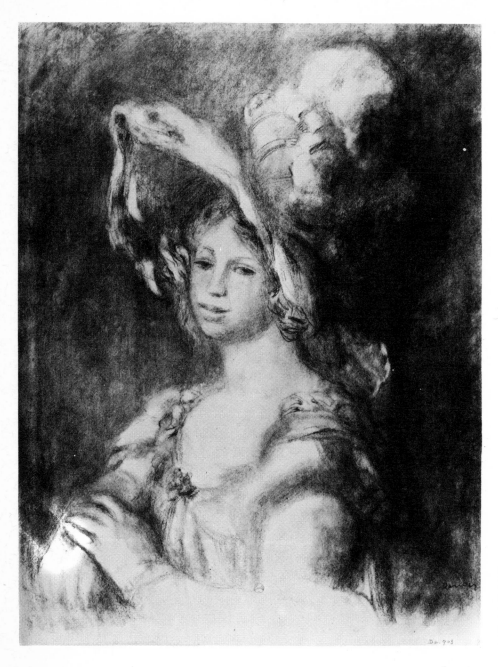

(87)
Pierre Auguste Renoir
(1841—1919)
*Portrait of a young lady —
Dieterle,* 1899, colour
lithograph, 530 × 400

The copy is developed with cotton wool dipped in turpentine oil, which washes away all the unexposed parts of the bitumen. The stone is then gummed and etched as with a chalk design.

A bitumen or egg-white copy can be corrected or added to with a lithographic ink or chalk drawing, when the surface of the stone has been deacidized with diluted acetic acid or a solution of alum.

In the same way multi-coloured photolithographs can be made if negatives of the individual colours, obtained from the colour diapositives, are copied onto the stone. This technique is called *photochrome* and it has been all but perfected by the Swiss firm Orell Füssli. Although the quality of the impressions, made from seven or more colours, is very good, they are always reproductions and imitations of an original lithograph.

Tools for working on stone

Ideally the design is made on a stone placed on a strong, well-built drawing table, with an upper surface that can be adjusted to a selected angle. A sliding drawing bridge is fixed to the plate. The bridge enables the work to be done without the hands touching the stone. If working according to a model, such as a previously prepared sketch, this must be reversed with a mirror. For this purpose there is a stand at the upper edge of the table, which can also be adjusted to the required angle.

Lithographic ink can be bought ready-made, in liquid or solid form, from shops which sell graphic art materials. For those who want to know more about this material and wish to prepare it themselves, several recipes used by different experts are given below:

Solid ink: (numbers indicate parts by weight)

(Senefelder)	*(Lemercier)*
12 beeswax	2 beeswax
1 ram's tallow	1.5 tallow
4 soap	6.5 soap
1 soot	3 shellac
	1 soot

(Desmafryel)	Liquid ink:
40 wax	*(Senefelder)*
10 mastic	4 shellac
28 shellac	1 borax
22 soap	16 water
9 soot	1 soot

(Kubas)
70 beeswax
18 soap
70 bitumen of Judea
10 ram's tallow
 5 paraffin
25 soot
350 cc turpentine essential oil

For diluting ink and for grinding solid ink in a porcelain bowl always use distilled water.

Lithographic chalk:

(Senefelder)	hard chalk
4 beeswax	*(Fritz)*
2 soap	12 wax
2 soot	8 soap
	10 shellac
	1 sodium solution
	2 tallow
	4 soot

medium chalk	soft chalk
(Kubas)	*(Engelmann)*
55 wax	32 wax
10 dried soap	24 Marseilles soap
60 bitumen	44 mutton suet
10 suet	1 nitric acid
10 soot	7 distilled water
	7 soot

Ink and chalk can be made at home by boiling. The substances are dissolved in a cast iron pot in the same sequence as given in the recipe. After prolonged boiling fumes start rising from the mixture, which is set alight and left to burn for several minutes. The longer the solution is boiled, or the longer its vapours burn and the faster it is cooled, the harder the resulting substance will be. The liquid is poured through a thick sieve onto a smooth moistened stone and while still semi-solid it is cut into sticks.

Lithographic pens were originally prepared by the lithographers themselves. They cut them with special scissors from a finely rolled steel sheet, hammered them out and ground them on an oil-stone. The pens were different in shape, with graded hardness and a varying flexibility of the tip. Nowadays commercially manufactured steel nibs, which can be bought in specialist shops, are used.

Brushes for lithographic work are no different from normal water-colour brushes and the best quality are made from sable.

Needles and scrapers are the same as used for the dry point technique. They come in various sections and are fixed in wooden handles. These instruments are extremely important when it comes to correcting the design and for litho mezzotint work.

Poupées for the poupée technique are made

from paper, usually blotting paper, which is rolled firmly into the shape of a pencil, with both ends sharpened.

Dabbers for the dabber technique are a sort of small leather bag tied at the top and filled with soft material, for example cotton wool.

The bitumen ground for the litho mezzotint is made beforehand from 350 g bitumen of Judea with 250—300 g turpentine oil, and stored in a glass bottle with a good, air-tight stopper.

Autographic ink, used for pen drawing on autographic paper, has a similar composition to that of lithographic ink, but a higher viscosity:

(Senefelder)	(Cruzel)
1 wax	8 wax
3 shellac	2 shellac
6 tallow	2 soap
5 mastic	3 soot
4 soap	
1 soot	

Boil the mixture, stirring continually. When the paste starts to harden it is formed into sticks, which can be mixed with distilled water to make fresh ink whenever it is needed.

Transfer ink, used for transferring a design onto a transfer paper and onto a lithographic stone is made as follows:

(Senefelder)	(Rambousek)
1 wax	4 wax
1 Venetian turpentine	15 suet
3 thick linseed oil	12 soap
4 soot	150 ink paint

The *transfer paper* is prepared with the following solution:

150	wheat starch
50	glue
80	floated chalk
15	gum resin
1500	water

After boiling, a little glycerine is added and the preparation is applied with a wide brush onto a thin fibreless paper.

Egg-white light-sensitive layer:
(Rambousek)
20 cc of fresh settled egg-white is dissolved in 100 cc of distilled water, mixed with 3 g of bichromate of ammonia dissolved in 100 cc of distilled water to which a few drops of ammonia have been added. This copying solution can be stored in a dark glass bottle kept in a cool place.

A bitumen light sensitive layer is made from powdered bitumen of Judea dissolved in chloroform and benzol.

The first two types of Senefelder's scraper press

Preparation
of a lithographic
design

The completed design, whether made with lithographic ink or chalk directly onto a stone, or transferred, must be fixed on the surface, i.e. prevented from disappearing.

At the same time the mutual antagonism between grease and water must be strengthened, so that the design does not get stronger when the printing ink is applied. For this reason the stone is prepared with an etch, i.e. a mixture of nitric acid with a solution of gum Arabic.

The gum contains arabin acid, which reacts with the nitric acid and changes to metaarabin acid; this acts on the surface of the stone and changes it from calcium carbonate to calcium nitrate, which is highly hygroscopic and repels grease. The etching dissolves the grease and the soap in the design and produces calcium metaarabinate, which is insoluble in water; this fixes the design. The surface of the stone which has not been drawn on, is at the same time slightly lowered.

The working procedure is as follows:

1) The design on the stone is dusted with powdered talc and this is rubbed in.
2) With a soft cloth an adequate amount of a clear solution of gum Arabic is applied and spread over the whole of the surface of the stone.
3) A *weaker etch,* which is tested beforehand on the edge of the stone (it should foam only a little), is applied with a sponge onto the still damp gum in a crosswise direction over the whole surface. Weak thin tones are etched only weakly, sometimes not at all, the action of gum Arabic alone is sufficient, for example, for a pencil design. Darker parts are etched several times. The overall strength of etching is dictated by the character of the design and also by the hardness and temperature of the stone. Hard, cold stones can take a stronger etching. The most important thing is to watch the design continually, so the fine parts are not destroyed. The less experienced will find it pays to make a trial etching on a small drawing on the edge of the stone, examine it thoroughly with a magnifying glass and subsequently grind it off.
4) The etch is removed with water, then a solution of gum Arabic is applied and smoothed by hand into a thin layer. The stone is then left to stand for a day.
5) A weak *tincture of liquid bitumen* is poured onto the gummed stone, and the drawing is washed out with a soft cloth. To make the washing out easier, a little turpentine oil is added.
6) A stiff printing ink is rolled with a rough soft roller onto the washed out design. Then the stone is moistened with a sponge and the surplus ink can be removed with another, clean roller.

At this stage the stone is ready for printing if the design is lighter or if only a small number of impressions are needed (for example, a proof impression). If the design has deep tones or if a large number of impressions are to be printed it is necessary to prevent the design from getting smudged by the printing ink, and this is done by continuing the procedure thus:

7) A small amount of pen ink mixed with the same amount of transfer ink is rolled onto the stone.
8) The design is dusted with talc.
9) An etching with an *etch of medium strength* is done for the second time.
10) Stages 4—6 of the working procedure are repeated.

For a large number of impressions or a litho wash drawing or litho mezzotint this procedure is inadequate. The design must be etched much more intensively, and first it must be protected against *burning.* Then at stage 8 an alternative course is followed:

8) *Powdered resin* is sprinkled over and wiped into the design with cotton wool. The powder adheres to the design.
9) The stone is dusted with talc and a broad sable brush is used to clean off the surplus resin.
10) A blow-lamp is used for burning the design so that the resin melts and combines with the ink to produce a hard ground. Care is taken not to let the design come in contact for too long with the flames, as it would burn. Furthermore, the stone might crack if it were heated for too long in one place.
11) The stone is gummed.
12) For the third time the damp gum is etched with a *strong solution.* The etch is spread with a sponge over the whole surface and a fresh dose is added about three times. The excess is removed with a wrung-out sponge and the stone is left for 12 hours.
13) Stages 4—6 of the procedure are repeated.

A design fixed in this way can withstand an almost unlimited number of impressions. If printing

Chemicals used
for the preparation
of the stone

is not to be done immediately the stone must be gummed — otherwise it loses the favourable properties obtained by the preparation. This also applies to long interruptions during printing.

Gum Arabic is the juice from the *Acacia vera* tree from the tropical zones of Africa and India which is dried into irregular round lumps. If it is crushed into a powder and dissolved in water (at the ratio of 1 : 2 and, as always, with distilled water), after about 12 hours it forms a sticky liquid with an acidic reaction, which protects the lithographic stone from the harmful effects of the atmosphere. Together with nitric acid it produces an etch which acts chemically and to a certain extent physically on the surface of the stone. As a conserving medium several drops of phenol acid or a piece of camphor are added.

Nitric acid (*acidum nitricum* — HNO_3) is a vaporous, colourless caustic prepared from aerial nitrogen or by the oxidation of synthetic ammonia. It is sold in the concentration of 35° —40° Bé. The acid is kept in a dark glass bottle with a double stopper.

The *etch* is prepared by diluting nitric acid to 8° —10° Bé (measured with Baumé's hydrometer in a glass cylinder) and by mixing it with a solution of gum Arabic in the following volume ratios:

Senefelder's cylinder lithographic press

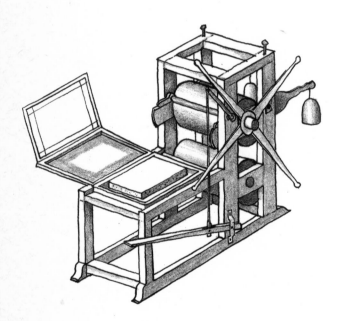

The lithographer's drawing table (with adjustable board, drawing bridge and stand for model and mirror)

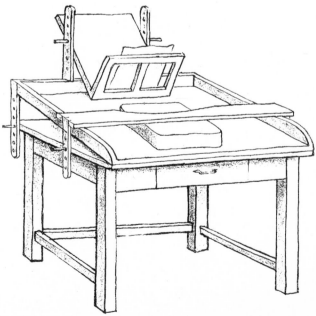

1 : 30 weak etch
1 : 14 medium etch
1 : 8 strong etch

Talc, an acid metasilicate of magnesia, is a fine powder of greyish colour which is used for removing surface greasiness from a design on a stone. It is also used for dusting fresh prints, to avoid the smudging of wet ink.

Resin is a by-product of the distillation of turpentine essence; it is yellow-brown in colour and has a vitreous refraction. It melts at a temperature of 80° − 120° C, dissolving in turpentine, alcohol, petrol and benzene. It resists acids well, and so it is used during the burning and etching of a design.

Tincture of bitumen is used for washing out the design on a stone, while greasing it at the same time, thus increasing its durability and its capacity to receive the ink during inking. It is bought either ready-made or can be prepared according to the following recipes, either in a cold state or by boiling in a steam bath.

In a cold state:
 100 bitumen
 80 turpentine oil
 20 linseed oil
 20 machine oil

In a steam bath:
 (Kappstein)
 60 bitumen
 300 turpentine oil
 40 wax
 30 tallow
 40 Venetian turpentine
 20 filtered tar
 10 oil of lavender
 (Held)
 2 raw oil
 5 tallow
 1 oil of lavender
 100 turpentine oil
A stabilized solution is filtered and kept in a tin.

Turpentine oil (volatile oil), sometimes also called French turpentine, is made by the distillation of resin obtained from fir trees, particularly pine trees. It is a clear liquid with a pleasant aroma, and with unwanted substances removed by purification; if a drop of turpentine oil falls on a piece of paper it should not leave any trace of grease.

A *deoxidizer* for lithographic stone is easily obtained by strongly diluting acetic acid or, if necessary, from ordinary table vinegar or a solution of alum.

The etching ground for the etching in stone technique is prepared by boiling the following substances:
 1 wax
 2 bitumen of Judea
 3 resin
 1 mastic
 1 lamp soot
The cooled off mass is cut into sticks and these are mixed with turpentine oil before using.

Correcting the design after the preparation of the stone

The lithographic design can be judged during the work on the stone. But if later (for example, after a proof impression made after the 6th stage) the design needs to be added to, it is necessary first to deoxidize the stone so that it accepts grease. The stone, with the excess ink rolled off, is dried and dusted with talc. This prevents the ink smudging when making the additions. The stone is dampened with water and the *deoxidizer* is poured over it and spread out with clean cotton wool. After a while the spent deoxidizer is washed off and replaced with fresh. The stone is sprayed with water, left to drip and dried with a fan.

Corrections made with a scraper must be sufficiently deep to remove the greased layer of stone and must be thoroughly etched with a brush.

THE COMBINATION OF PLANOGRAPHIC AND INTAGLIO PRINTING

Lithographic engraving

In lithography there are two, now seldom used, techniques where the exact line design is engraved or etched into a smoothly ground surface of a hard lithographic stone. They could therefore also be placed among the intaglio techniques. But because the chemical properties of the stone also play a part, the result is a combination of intaglio and planographic printing. Apart from the fact that the plate is produced differently, all the rest is identical to the other planographic techniques.

A perfectly ground hard stone, without blemishes or traces of scratches on the printing surface, is moistened, sprinkled with powdered salt of sorrel and polished by the circular movement of a felt dabber. The white grease which is formed is not removed and, if necessary, salt and water are added. The polishing can take up to two hours and the surface of the stone should have a light mirror finish. The acidic potassium oxalate together with water when in contact with the stone produce a calcareous oxalate, which, in the form of a glaze — insoluble either in water or grease — protects the stone later on when the ink is rolled into the engraving.

A fresh solution of gum Arabic, coloured with lamp soot or black pigment, is spread with a brush into a uniformly thin layer and left to dry. The design is engraved, under relatively strong pres-

Starwheel lithographic press — French model

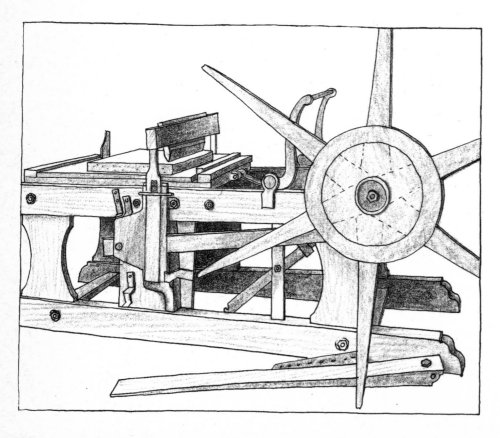

Lithographic etching

sure, with a sharp needle or diamond, all the way through the glaze into the mass of the stone. But the depth of the incision should not be exaggerated; deep lines make the subsequent removal of ink difficult. Where necessary the lines can be widened with a triple-edged scraper. The depth of the lines can be judged by the amount of white stone powder which is removed during work with a soft brush. The line drawing can be enriched by using, in addition to the scraper and needle, a sharp dotting wheel or dotting mallet.

A lithographic engraving permits one to build up a design from the finest lines with a maximum density and it is therefore suitable for producing miniature prints. In such cases the work is done with the help of a magnifying glass. Linseed oil is wiped with a soft cloth into the engraved lines of the completed engraving and its greasiness is allowed to act on the stone for several hours. The rest of the surface is protected against the effects of the oil by the previous preparation. Then the whole of the surface is washed with a damp cloth. The engraving is inked out with a flannel dabber with weak boiled oil, diluted with printing ink, on a moistened and thinnly gummed stone.

The impression is made onto a moistened paper, which is covered with blotting paper and cardboard. The paper is forced under heavy pressure in a hand press, into the grooves of the design, from which it receives the ink.

Dabbing the lithographic engraving and its printing is a relatively lengthy process, therefore the design is usually transferred onto another smooth stone if a large number of impressions is to be printed. The stone is prepared, burnt and printed as for a litho pen drawing.

Another method by which to replace the laborious inking of an engraving with a dabber inking method, is as follows: the design is inked thoroughly with transfer ink, dusted with resin and burnt. The medium etch is used for etching until the surface of the stone is the same level as the engraved design. Then the stone is gummed, washed out over the gum with turpentine, greased with tincture of bitumen, inked with pen ink, and rolled out with a smooth roller. The design is then printed as a pen lithograph.

It need hardly be said that these auxiliary techniques do not increase the quality of the design, on the contrary, the lithographic engraving is in this case deprived of the characteristic ink relief on the impression and thus a part of the charm which should be intrinsic in any engraved print.

A thin uniform layer of *etching ground* is applied with a leather roller to a hard, smoothly ground stone, which has been polished with oxalic acid as in the case of engraving, and warmed slightly. When it has cooled off the design can be made with a blunt needle. The incision is made only in the ground, not in the surface of the stone. Incorrectly drawn parts are covered once more with ground and repaired. The etching can be made either with strongly diluted hydrochloric acid or nitric acid, diluted with water at a ratio 1 : 20. This is poured over the centre of the printing surface, which has been surrounded with a barrier of soft wax.

However, it is more practical to use a thick mordant, made up of 1 part nitric acid and 15 parts of gum Arabic; this mordant does not disperse over the stone and therefore can be used for etching with a brush or a sponge. In this way a richly graded line can be created as when etching on metal. The etching time depends on the hardness of the stone, the concentration of the acid and the character of the design. When the design has been sufficiently etched it is rinsed with water, deoxidized with a solution of alum or acetic acid, rinsed with water once more and dried. Then it is greased with tincture and left for several hours. Finally the wax ground is washed off with turpentine, the stone is moistened and the etching is inked with a felt dabber. The printing is made onto dampened paper in the same way as with an engraving.

The scraper with a strip of cardboard or leather

Background

To lessen the contrasts of a black-and-white ink or chalk design or lithographic engraving on white paper and to give it a more finished appearance, a light transparent tone is sometimes added as a background. The best results are achieved with warm shades of yellow, ochre and brown — there are a number of possibilities and the choice is largely subjective.

The perimeter of the basic design is transferred together with the loading marks onto a clean smooth or finely grained stone. The marks and the perimeter of the surface are drawn with a pen and the whole surface of the background is coated with stiff lithographic ink applied with a brush. The surface is fixed in the same way as in any other design. The whole procedure is completed by rolling up with black litho ink. When this has been washed out with turpentine oil it is possible to roll up the bright colour with a rubber or smooth leather roller. The ink is prepared by mixing it with a small amount of white paint.

The background surface can be prepared very quickly — without preparing the stone — by drawing with an alcohol or acetone varnish in a smooth thin layer. When the stone is dampened the chosen colour can be rolled up immediately.

Chiaroscuro lithography

This technique, which was once very popular, provides an intermediate technique between black-and-white lithography and lithography in colour, and in its effect even surpasses the similar method of the chiaroscuro woodcut. It is a combination of several different lithographic procedures whereby the basic colour (most frequently yellow-grey) is developed in various tones, varying from the lightest background to the darkest colour which is used for drawing in the contours. If the individual components of the design are correctly harmonized and if each colour hue has been chosen correctly it is possible to attain great spatial depth and a softness of shading.

It is up to the artist to choose the number of tones to be used for building up the resulting design, probably with the aid of preparatory sketches. The classic procedure is described here; possible variations depend on the character of the intended design and on the artist's imagination. Usually the design is composed of six tones: six lithographic stones are prepared and the respective contours transferred onto each stone. The first two stones are prepared and worked with the litho mezzotint method. The first stone is used for making the light background, with only the most intense highlights and reflexes, by scraping through the bitumen ground. On the second stone the slightly weaker and broader highlights are marked in. The next two stones are made as a wash drawing with a diluted lithographic chalk and they are used for the weaker and stronger tones. On the fifth stone the darker parts are drawn in with a lithographic chalk, and on the sixth only the darkest and deepest tones, if necessary, using a pen or brush dipped in undiluted ink.

The etching of the individual stones corresponds to the technique used for making the design. The respective tones are printed from each stone, starting from the lightest one. Their precise register is obtained in the same way as in lithographic colour printing.

If the drawing of a particular tone includes a part of the basic framework of the whole design it is a good idea to do it first and then to make a rich impression from this stone onto a smooth paper. This paper is then dusted with a red or blue pigment and transferred onto the other stones. This method gives greater accuracy without the need for laborious copying.

◁ (88)
Cyril Bouda (b. 1901)
Masks, 1943
lithographic engraving in colour,
315×250

Lithography
in colour

Nowadays lithography is second only to the silk screen process in popularity for creating prints in colour. Everything described so far in the part devoted to print-making in colour is particularly applicable here. In addition to this, a necessary condition for obtaining good results is the perfect mastery of lithographic procedures in their black-and-white form.

Lithographs in colour can be made either by drawing directly with lithographic ink or chalk on stone or by working with autographic paper. A colour sketch made with watercolours, gouache or coloured chalks, is copied onto translucent paper and the loading marks are drawn in on the shorter side. The same number of stones are used, with a grain prepared beforehand, as there are colours to be printed. The contours and the boundaries of the individual colour tones are copied onto the stones.

If the basic design has a firm contour, it is possible to use the previously described method of reprinting it onto the other stones. The individual colour parts are worked out on the respective stones with chalk or ink, either with a brush or a pen. Some parts may be made by dotting or by splattering or with the litho wash technique.

Here the most important factor is the correct estimation of the intensity of the tone to be applied, in relation to its resulting colour value. Higher tones, especially yellow and ochre, are ultimately weak when drawn in and must therefore be drawn much darker than would be expected from their appearance on the stone.

All the stones with the finished design are then prepared in the usual way, first by being rolled up with black ink and then by gumming. The bright printing colours are rolled on immediately before printing only after the design has been washed out with turpentine oil. Usually the darkest contour is painted first. The impressions are left to dry freely for about two days, so that they do not tone the next colour during the next printing. It is not advisable to powder the fresh impressions with magnesia or talc as this speeds up the drying-up process but lowers the intensity of the colour.

Loading the paper

An exact register of individual colours can be obtained in one of three ways: by loading on to marks in diagonally opposed corners of the paper (if the paper is a regular format) or with the help of pins on two points in the design, made on each stone (if using hand-made paper with irregular edges), or with loading crosses, to be cut away later from the impression (if the edges of the paper are to be trimmed).

Drying flag

The loading of paper for lithography in colour

(89)
Robert Rauschenberg (b. 1925)
The accident, 1963
lithograph, 960 × 690

THE TECHNOLOGY OF LITHOGRAPHIC PRINTING

The lithographic workshop

The graphic artist who wants to try his hand at lithography once in a while will not need to establish his own lithographic workshop and will probably leave all the work connected with the preparation and printing of the stone to a specialized professional workshop. He can then concentrate fully on the execution of the actual design, whether it is made directly on the stone or on autographic paper.

But for someone who wants to devote himself to lithography, the building of a workshop is worthwhile, as the character of the design and its quality can be influenced by other factors than the drawing itself. A complete knowledge of all the techniques can provide inspiration for the creative work.

In addition to the equipment already mentioned (a *table for the grinding of stones,* the necessary number of *lithographic stones, shelves* for storing these and a *drawing table*), some other equipment is necessary for a lithographic workshop.

The most important item is, of course, the *litho-*

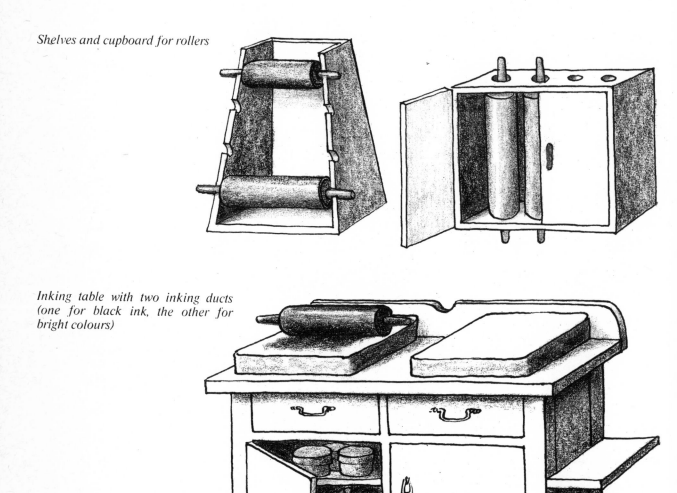

Shelves and cupboard for rollers

Inking table with two inking ducts (one for black ink, the other for bright colours)

graphic press. This has been made since 1878 in a practically unchanged form and it is basically a perfect development of Senefelder's scraper press construction of 1789. The base of the machine is formed by two massive cast-iron stands with rails connected by a revolving steel cylinder which is fitted on each end with a toothed wheel and a crank. A heavy wooden bed, covered with felt and a nailed-on zinc sheet — onto which the stone is laid — is moved over the cylinder by cranking the handle. In the upper part of the press is a metal frame with a spring mechanism and a large lever which makes it possible to apply heavy pressure to the scraper. This pressure can be regulated by a screw.

The *scraper* is an easily exchangeable piece of hardwood, with its lower edge cut in the shape of the letter V. A strip of shiny cardboard or leather is stretched over the scraper. Scrapers of various sizes are used, depending on the size of the stone. The scraper should not be so short that the stone cracks under the pressure, nor should it be too long, as that results in damage to the edge of the scraper and a poor-quality impression.

Lithographic *inking hand-rollers* are made with a wooden core, which is similar to a kitchen roller. This core is enclosed in a layer of felt. A roller for inking a chalk design has a seamless cover of fine calf leather with a coarse surface. A new leather roller must be impregnated with weak boiled oil before it is used. A roller for printing pen drawings has a smooth shellac-treated skin and a roller for bright colours has a surface of smooth rubber. To make sure that the handles turn well in the palms of the hands loose leather grips are used. The rollers need constant careful maintenance and it is essential that no ink is left to dry on them. The ink must always be scraped off and the rollers washed in turpentine. As the rollers would get damaged by lying horizontally they are stored in a special cupboard or hung on a hanger, suspended over the inking table. An inking stone has a permanent place on the table. This stone is a normal smoothly ground lithographic stone, prepared with oxalic acid so that it repels grease. It serves for rolling out the printing ink before it is rolled up on the printing stone. Two such stones are needed — one for black ink and one for bright colours.

The necessary chemicals and inks are stored under the table. A revolving fan made of hard cardboard is a good aid for drying the stones.

Also useful is a *table with drawers* for storing clean paper and prints if necessary. It should not be smaller than 75×105 cm so as to accommodate all the different sizes of printing paper.

Printing

The stone with its completed design, which has been fixed on it by preparing it as previously described is placed on the moveable bed of the lithographic press — it is now ready for printing and at this stage the *lithographic ink* is prepared. This is done by rubbing high-quality fine gas soot into boiled linseed oil of varying thicknesses. The thickest is called chalk black, while pen black is of the medium density and dabber black, for printing engraved lithographs, is the thinnest. The ink is diluted with weak non-adhesive boiled oil or, if necessary, thickened with talc. The tin with the ink is opened carefully so that the edges are not damaged. The ink is scooped with a spatula from across the whole surface, keeping it level until the tin is empty. In this way contact with air is limited as much as possible. The tin is always kept closed and the bottom edge of the lid sealed with adhesive tape. The surface of the ink can also be covered with a circle of greased cardboard.

The printing stone is dampened with water, or if it has been gummed, washed down with gum. The scooped out ink is spread onto an *inking stone* with a spatula and rolled out evenly with a *leather inking roller.* The ink is rolled onto the printing stone in all directions. Pressure is applied only at first, then it is rolled lightly until the ink covers it evenly.

The moveable head of the lithographic press, with the stone placed in the middle, is slid under the scraper so that the scraper is immediately over the edge but does not slip off when pressure is applied.

The printing paper is placed on the loading marks of the inked design. Usually a wood-free offset paper is used, but if a hand-made paper is required it must be of the soft fine-grained sort. The paper is covered with a layer of dry clean backing which is covered in turn with a shiny compressed sheet of cardboard, greased on the surface with tallow.

When the pressure has been adjusted correctly, the lever is pulled down and the stone is cranked through under the scraper. Then the lever is released, the moveable bed is returned to the starting position, the cardboard and backing are removed and the impression is carefully lifted off.

If the impression is satisfactory, the procedure is repeated for the next printing. The stone must be sufficiently damp before inking; if it is not, the design may come out too strongly or it may smudge. On the other hand, an excessive amount of water on the stone prevents it from being inked cleanly. It is best to use clean, preferably soft water and a clean sponge, kept in a bucket under the press.

Printing faults

The *strengthening of the design* during the printing can also be caused by the following: a stone

has been wrongly prepared, or after a lengthy interruption of the work has not been gummed; the stone is too soft or has been insufficiently ground; the ink is too thin or of low quality or too much has been used; ink has been allowed to dry

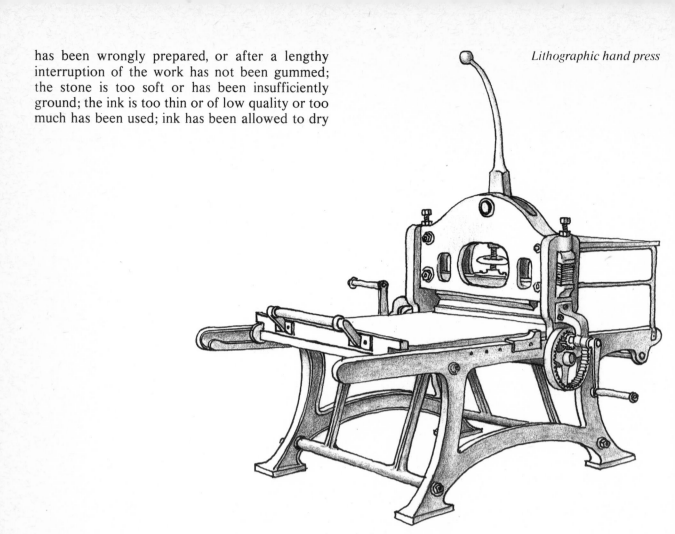

Lithographic hand press

on the roller; the printing has been made with too much pressure applied to the scraper; the temperature of the room or workshop or of the stone is too high. If it has not been possible to avoid these faults, it is best to wash out the design with turpentine over gum, ink it once more and re-etch in slightly.

A *weak design* is usually caused either by the incorrect execution of the design, or by media which are not greasy enough; it can also be caused by the stone not being rinsed properly with water after graining, or by overetching the design during its preparation. The cause may also be in the tincture used for washing out the stone, too hard a roller or too stiff an ink (during inking), unsuitable paper or too low a temperature of the room or the stone.

Faults in the impression may also be caused by

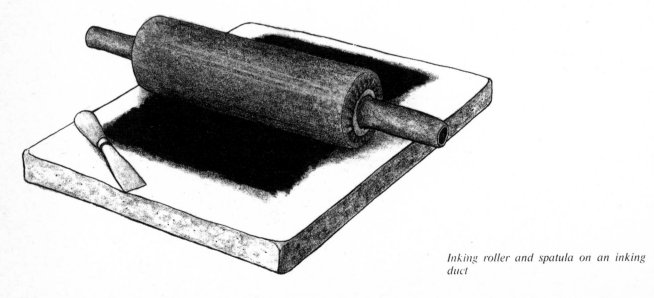

Inking roller and spatula on an inking duct

174

the scraper or the leather which covers it having a damaged edge, by damaged cardboard or badly smoothed out backing, or even by unevenness of the stone. It is possible to increase the greasiness of the design by washing it out with tincture over gum and by inking it with transfer ink. If this does not help, the design is powdered with talc, the stone deoxidized, left to dry out and corrections are made in the design.

(XXXI)
Andy Warhol (b. 1928)
Marilyn, 1967
silk screen process in colour, 900 × 900

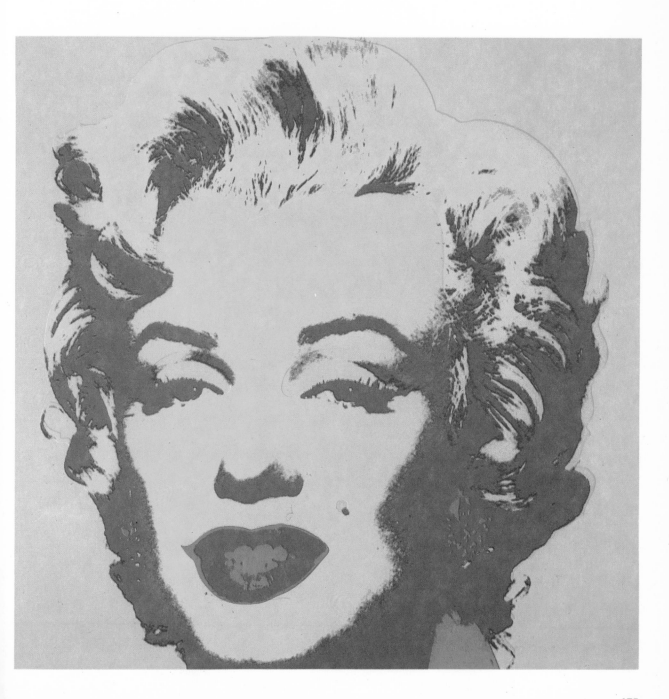

Algraphs

This technique, which is similar to and a development of the lithographic technique and forms a sort of intermediate step between lithography and offset printing, was invented towards the end of the last century by the Mainz lithographer Scholz.

As opposed to lithography, an algraph is not made from a stone printing form but from an *aluminium plate* grained with steel or glass marbles and deoxidized with a 10% solution of sulphuric acid. The light weight of the plate makes it suitable for open air work.

The design is made with a lithographic chalk or ink in the same way as when drawing on a grained stone. Aluminium is very sensitive to grease and its grey tone causes the design to appear lacking in contrast — therefore the whole design must be made slightly lighter. It is again important that the surface of the design is not made greasy by contact with the fingers.

The complete design is prepared with a mixture of phosphoric acid and an aqueous solution of gum Arabic.

Corrections of the design made by scraping are unsuitable as the grain is low. To make additions it is necessary to deoxidize the plate again.

The printing is done on the lithographic hand press with the aluminium plate placed on a stone. It is important to adjust the pressure of the scraper correctly, as with heavier pressure the design on the plate can easily be damaged.

Offset proofing process

Replacing the aluminium plate used for algraphs with a zinc plate with a thickness of 0.5—0.7 mm, such as used in offset printing, brings the process almost within the confines of modern reproduction processes. But even this can be considered an original print-making technique if the artist has made the design himself, directly onto the plate, with lithographic chalk or ink, without recourse to photomechanical copying.

Offset may therefore be considered a further step in perfecting the principles of lithography; the heavy fragile printing stone is replaced by a light, easily manipulated and easily stored *zinc plate*. The development of this printing method itself has been even more marked. The horizontal movement of the stone and the direct printing onto paper has been replaced by the rotary movement of a rubber-covered cylinder. The ink is transferred from the design on the plate to the cylinder and then from the cylinder to the paper. This principle made more effective and economical production possible with the rapid development of printing machines and therefore gave the offset process a prominent place in the printing industry.

A perfectly smooth offset plate, with all traces of old ink removed with a lye solution, is ground and grained with the horizontal rotary movement of a grinding machine which uses small glass marbles and damp carborundum sand. It is then deoxidized with a saturated solution of crystallic alum and a few drops of nitric acid. After some ten minutes the plate is removed from the deoxidizer, rinsed thoroughly with water and dried quickly to prevent unwanted oxides forming.

Hand driven offset proofing press

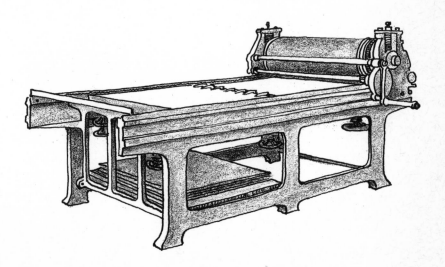

◁ (XXXII)
Josef Istler (b. 1919)
Head, 1968
monotype in colour, 265 × 235

The design is made on the offset plate, as on a grained lithographic stone, with chalk or ink as it is meant to be printed, i.e. without drawing it the wrong way round. It is easy to be misled by the colouring of the plate and as a result to make the design too dark — all the more so as the chalk drawing on a zinc plate tends to become stronger during printing. Corrections of the design by scraping are not recommended as the metal in the part where the grain has been removed repels water and therefore attracts the ink.

The preparation of the design

To make sure that the design is fixed sufficiently and at the same time to increase the mutual affinity between the metal and water, the offset plate is prepared and wiped with a solution made of 30 g of Strecker salt dissolved in 500 cc of distilled water, and thickened with a solution of gum Arabic.

The design is dusted with talc, brushed with a mordant and after about five minutes rinsed with water. The following process is the same as in the preparation of the stone: the plate is gummed slightly and left to dry; the design is washed out with a tincture of bitumen mixed with turpentine oil: ink is rolled on; the gum and surplus ink are washed off with water and the plate is cleanly inked up the with printing ink once more.

Kašpar Hermann (1871—1934), a lithographer from Bohemia, originated the idea of printing lithographs by transferring the design with the help of a rubber-covered cylinder. The first offset machine was made according to his design in 1907 in Germany. Two years later he invented a machine to print simultaneously on both sides of the paper. The stone was soon replaced by a zinc plate. The incredible speed of offset printing was soon exploited in a number of new types of machines. The flat-bed printing machine was in most cases replaced by the much faster rotary printing machine. This was made possible by using zinc plates for the design which could be fastened around the rotating cylinder with the ink being transferred to another rubber-covered cylinder. Modern industrialized offset printing uses multi-colour rotary offset machines with a high output. These have improved the quality of printing quite remarkably and at the same time have made it much cheaper. However, apart from a great number of advantages, there is one disadvantage when compared with other printing methods, namely the need to dampen the zinc plate during printing.

The *offset proofing process* can either be a hand press or power-driven, and there are various types (for example Druckmakont and Mailänder) some of which have an automatic damping and inking system. The press is supported by two massive cast-iron stands. Between the cog rails on the upper part of the machine there are two massive fixed steel beds with adjustable height — one for fixing the offset plate and one for the printing paper. A heavy steel roller covered with rubber moves along the rails collecting the ink from the design on the plate and transferring it to the paper. If the bed for the plate is lowered the offset proofing press can be used for printing from stone; but in this case the design must be drawn in reverse as for a lithograph.

Collotype

Collotype is a reproductive technique which makes an unsually high quality of prints possible; it can be used for printing the finest tones without the need for any kind of screen. The printing elements are carried by a film of gelatine. The fast drying of the layer produces a puckered grain. But as this printing method is slow it is seldom used, and then almost solely for making reproductions of outstanding works of art.

The principle of collotype was discovered in 1852 by William Henry Fox Talbot (1800—1877), who found that a layer of gelatine, which includes potassium or ammonium bichromate, ceases to be soluble in warm water or to swell in cold water in places which have been light-sensitized and exposed; and this happens in direct proportion to the strength of the light. The swollen parts of the low gelatine relief retain their dampness and repel the greasy ink. On the other hand the light-sensitized and hardened parts repel water but retain the greasy printing ink.

This discovery was developed successfully by the Munich court photographer Josef Albert (1825—1886), who was the first to use a glass plate as a base for the gelatine. In 1869 he bought the invention for fixing the gelatine layer from the Czech painter Jakub Husník (1837—1916) and then patented the technique, from which the term *Albertotype* originates.

A glass plate 12 mm thick with cut edges is given a matt surface on one side by etching with hydrofluoric acid. Older used plates are cleaned with a lye solution, re-ground with fine pumice-stone powder and wiped with a solution of ammonia. This side is then spread with a thin film of the following solution:

300 cc water
60 g gelatine
15 cc chromic alum (1 : 10)
15 cc soluble glass

This preparation layer ensures that the light-sensitive layer adheres perfectly; it is prepared in a warm state from the following materials:

240 cc water
30 g gelatine
3 drops of saturated chromic alum
120 cc potassium bichromate

This recipe is used if a tone negative is to be copied. For a line drawing 60 cc of the potassium bichromate is replaced with the same amount of ammonium bichromate.

The plate with the gelatine film is dried in a horizontal position for 1—2 hours increasing the temperature gradually from 40° to 60° C. This produces the typical puckered collotype grain and the plate acquires a uniform matt appearance.

When the plate has dried and cooled off a photographic negative (or a negative drawing, for example made with a litho chalk on astrafoil) can be exposed, preferably in sunlight. The plate is then immediately submerged in cold water for 3—4 hours, thus washing away all the chromium salts that have not been hardened during the exposure. Afterward the plate is set at an angle and left to dry.

The plate is prepared for printing with a glycerine dampener:

(strong dampener)
700 cc glycerine
350 cc water
 12 g sodium thiosulphate
 50 cc ammonia

(weak dampener)
1 part glycerine
2 parts water

The dampener effects the required swelling of the gelatine relief; it is then wiped off with a sponge and dried lightly with a soft cloth. The plate is then inked with a leather roller carrying a stiff printing ink.

Printing is done on machines similar to the litho press. The plate will not withstand a very large edition — no more than 2,000 good quality impressions.

IV. SILK SCREEN PRINTING

The most modern printing technique, and one which has spread rapidly during recent years in various fields of industry, in advertising and in the arts, is the method of reproducing a design with the help of a stencil.

The printing form is a stencil made in various ways. This is supported by a very fine gauze made of textile, metal or synthetic fibre, stretched over a solid wooden or metal frame. The printing principle is very simple — a squeegee is used to force a viscose ink through the porous parts of the stencil.

The uses of the silk screen process in industry are extensive for this technique makes it possible to print on almost all types of material (paper, textile, leather, glass, metal, plastic, wood, etc.), on flat and three-dimensional objects and on extremely large formats. Silk screen inks may also be applied in very thick layers. With various additives wetting power, elasticity and even electrical conductivity can be obtained.

In the textile industry this technique is called *screen printing* and it is used for printing on most decorative fabrics.

In the printing industry the silk screen process is the fourth group of printing techniques. Compared to the other printing techniques, the cost of the printing form is quite low. But the low speed of printing (except when using the highly efficient automatic silk screen machines) makes the whole manufacturing process more expensive and therefore limits the economic viability of this technique to small editions.

The development of the silk screen process

The direct predecessors of the silk screen process in its current form were the methods for reproducing patterns on cloth using stencils which were used in the Far East, especially in Japan, long before the Christian era. There the knowledge of manufacturing fine silk, which is an important part of the stencil, played a major role.

The western world became interested in this screen printing technique only towards the end of the 19th century, at the time of the large-scale development of the textile industry. The first attempts to use screen printing were made in textile manufacturing plants in the USA and soon afterwards in Great Britain and France. A major step came when, in 1907, Samuel Simon from Manchester was granted a patent for a new manufacturing process: the colour was forced through the textile gauze by two felt rollers and the stencil on the gauze was not made of paper but of lacquer.

Between the two world wars the silk screen process began to be used in other countries, and for other purposes than for printing textiles. It was in advertising, in particular, that the possibilities of a speedy and cheap method for reproducing posters and for printing wrappers was appreciated.

Although in the past screens had been made experimentally out of various unusual materials (even human hair), for a long time natural silk was the only accessible and satisfactory material. Re-

Diagram of the silk screen process

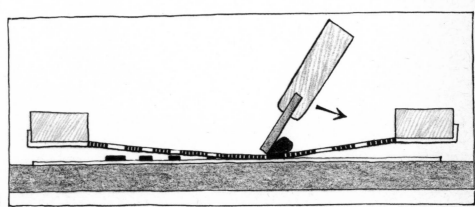

(90)
Jean Arp (1887—1966)
Büste des Nabels
silk screen process, 420 × 295

Serigraphy

cently, however, the first experiments have been made with the far more resistant metal gauze. The development of a suitable technology for applying a gelatine light-sensitive layer onto gauze has given rise to a perfect reproduction technique, which makes the reproduction of almost any pictorial image possible.

The greatest development of the silk screen process took part mainly after the Second World War. The American Army used it to print on paper, mark weapons, signposts, and so on. For this purpose special units were formed and equipped with mobile printing equipment. Thus the apparatus and technique of silk screen printing spread throughout Western Europe, especially West Germany. Attempts to perfect and modernize the method were made in the rapidly expanding new silk screen works. New, very fine gauzes made of plastics, special light-sensitive solutions, stencil papers and films, fast-drying inks and so on, began to be used. The printing process was also speeded up with the construction of highly efficient semi- and fully-automated machines and production lines.

Although the use of silk screen in the field of art is fairly recent, the advantages of the technique have gained it a number of followers among print-makers, who have found it enabled them, with a minimum of equipment, to produce impressions of a new quality, which differed from the results obtained with classical techniques. In this field the term *serigraphy* (from the Latin *sericum* meaning silk) has also come into use. This term is sometimes used to describe the technique for reproducing original prints for which the artist prepares the printing forms himself without the use of photomechanical processes for copying the image. He uses various specific procedures for preparing the stencil and may achieve special artistic effects by printing with opaque matt colours combined sometimes with glossy or transparent colours.

The silk screen print is characterized by the uniform layer of colour, which is in slight relief and is produced on the surface of the paper without the application of pressure. The thickness of the ink deposit can be regulated. It can be very thin or as thick as paste and it is even possible to cover dark tones with light colours.

The silk screen process is an ideal technique for designs with flat surfaces without much fine detail and for large formats, but the present technical level (and development continues) makes it adaptable for almost any purpose.

(91) ▷
Vieira da Silva (b. 1908)
The Labyrinth, 1959
silk screen process, 330 × 410

Simple silk screen process printing equipment (the frame is held by a vertically adjustable lath)

THE TECHNIQUES
OF PREPARING AND PROCESSING
A SILK SCREEN PRINTING STENCIL

The techniques for making silk screen stencils are: the covering stencil technique, the wash-out stencil technique, the cut-out stencil technique and the photo stencil technique.

The basic elements of a silk screen printing form are the gauze which supports the design and the frame on which the gauze is stretching.

The construction of the frame

The frame is usually rectangular and its dimensions are adapted to the expected size of the impression. The frame must be perfectly right-angled, sufficiently strong and absolutely flat. The most frequently used material for making it is laths of dried seasoned wood, usually pine, with sections of 30 × 40 mm to 40 × 70 mm (according to the size), firmly joined at the corners, preferably with metal angles. A frame cut from plywood 15—20 mm thick is very strong and at the same time light. The surface and the edges of frame must be perfectly smooth, so as not to tear the gauze, and impregnated against water with a multiple coating of hot boiled linseed oil.

The double, self-tightening frame is slightly more complicated but very practical. The gauze is stuck to the narrower frame. The second, larger and more robust L-shaped frame is pressed against the gauze from the inner side by tightening a number of screws, in this way stretching it uniformly. This arrangement provides the tension in the gauze that is required during printing, and loosening the screen during storage prevents loss of elasticity and reduces the risk of tearing it.

Serigraphers also like to use metal frames made

from stainless steel or duralumin tubes, because of their strength, lightness and resistance to water. These are suitable mainly for machine printing and for stretching a metal gauze, which is glued or soldered to the frame. Large-scale production also makes use of various types of pneumatic self-tightening frames which are factory produced.

Types of gauze

To ensure a high-quality impression, the gauze must have the following characteristics: it must be sufficiently elastic, but it must not change shape; it must allow the ink to pass through freely; it must be resistant to abrasion and chemicals.

In the early stages of the silk screen process only one type of gauze was known — natural silk. Even today it is the type used most frequently in studio work. Silk fulfils the above requirements relatively well — the ink is pressed through easily, it resists abrasion and it can be stretched without acquiring permanent deformation. But its perviousness decreases and after repeated coating the fibres fray.

Metal gauzes made of phosphor bronze or stainless steel are the most frequently used for screen printing in the ceramic and glassmaking industries. Because of their properties of resistance they are also used for printing large editions in cases where an accurate register or a high relief of ink is required. These gauzes are also very suitable for original silk screen process work, but they are rather costly. They are very resistant if handled carefully, but can be easily and irreparably damaged.

Synthetic textile-fibre gauzes have the best qualities, and as a result are the most widely used in screen process workshops. These materials are either *polyamides* (nylon, perlon etc.) or *polyesters* (terylene, dacron etc.). They are very strong and elastic and resist chemicals. After being submerged in hot water they can easily be stretched on a frame. As the fibres have a smooth surface the perviousness is excellent.

For less demanding work, with a smaller number of impressions, it is sometimes possible to use gauzes of lower quality and which are much cheaper, such as *cotton organdie* or *synthetic silk* (i.e. rayon). These save time by making the laborious process of removing the stencil unnecessary and the gauze can be discarded after use.

The density of the cloth count is usually chosen according to the character of the design; it is approximately in the range of 40—150 fibres per cm.

Stretching and fixing the gauze

The correct stretching of the gauze is very important for the success of the entire job. There are a number of procedures, aids and apparatuses used to achieve this, but here only the method of stretching by hand on a simple wooden frame will be described.

The oldest and simplest method, which can be used for stretching silk, is that used by painters for stretching canvas. The fabric is cut about 2—3 cm larger than the outer dimension of the frame and laid so that the mesh of the gauze is absolutely parallel with the wooden frame. With the help of a wire stapling machine the gauze is fixed to the bottom or outer side of the laths at relatively frequent intervals, preferably placed in a diagonal direction. Starting from the centres of the laths, proceed towards the corners with as uniform a tension as possible. In the case of larger sizes the gauze is dampened inside the frame with a sponge dipped in cold clean water. After fixing the staples, the gauze on the laths is brushed with fast-drying adhesive varnish or a shellac solution, which helps to prevent the fibres tearing out. It is useful to stick adhesive textile tape or to nail a narrow wooden slat 3—10 mm thick (depending on the size of the frame) over the row of staples.

A well-tried system is to stretch the gauze using

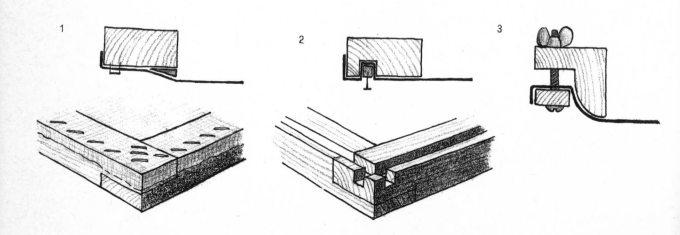

press-in laths. In this case the frame is provided with a slot around the outer edge about 6 × 6 mm in section. The gauze is stretched only lightly over the outer sides of the frame (drawing pins are sufficient to hold it) and the hard wood laths are pressed into the groove accurately over the gauze. The laths are then nailed or screwed down.

A synthetic gauze is stretched to about double tension; this is quite difficult to achieve with larger sizes. In this case, wedge-shaped slats can be inserted between the frame and the gauze. These are also used when the gauze slackens during printing.

There is also a simple mechanical method for stretching the gauze which is done simultaneously with the gluing. The gauze is stretched on a flat wooden surface and fixed with drawing pins on three sides. The frame is inserted under the fourth, loose side. Thin flat blocks of wood are pushed under the frame until the gauze is sufficiently stretched. Then the fourth side is fixed to the wooden base and the frame is coated with a water-resistant glue, for example PVC-based. This forms a thermoplastic adhesive layer. When it is dry the surplus gauze is cut away; with this method, however, there is rather a lot of waste.

A polyamide gauze should be wiped, after stretching out, with an 8% solution of formic acid. The acid effects the fibres slightly, welding them together where they cross and preventing them from shifting.

When the gauze has been stretched, and each time the screen is to be used, all traces of dirt and grease must be removed. For this purpose either a cleaning solution made up of spirit and acetone at a ratio of 1 : 1, or one of the common detergents can be used. From metal gauzes grease is removed with an alkaline preparation (soda) and the gauze is then treated with weak acid (vinegar) and finally dried quickly.

Making the silk screen stencil

The printing form is the base for the silk screen stencil, i.e. the design-forming layer on the surface of, or within, the gauze. The ink is prevented by the stencil from passing through the non-printing areas.

There are a number of ways of making the design stencil. There is a basic distinction, however, between *direct stencils,* which are made directly on the gauze, and *indirect stencils,* which are prepared separately from the gauze and subsequently transferred to its surface. There is a further distinction between hand-made stencils, which are used mainly in graphic art work, and stencils obtained by one of the photomechanical processes, which are more often used for reproductive screen process printing.

Various types of silk screen frames: 1 — the gauze is held by wire clips from a stapling machine and stretched out with a wedge-shaped slat, 2 — a frame with grooves for press-in slats, 3 — two part self-stretching frame)

The grinding of the squeegee edge on emery paper

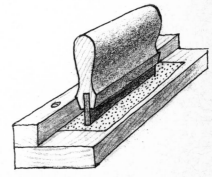

The silk screen
stencils

The covering stencil technique

The least time-consuming and simplest way of making a pen drawing stencil is by the application by hand of a solution which forms an impervious film on the gauze after hardening. The preparatory ink sketch on the paper is placed directly under the gauze. The sketch is protected by a transparent foil placed on top of it.

If the number of impressions is to be small it is possible to work on the inner, squeegee side of the screen; for a larger number of impressions the covering layer must be applied to the outer (bottom) side of the screen, so as to prevent it from getting damaged later with the squeegee. In this case the design must be turned over as in a mirror.

Usually an aqueous solution of methylcellulose, known as size, with several drops of glycerine and slightly coloured with aniline dye is used with a pen or brush to cover the non-printing areas — the gauze which is to remain pervious is left out.

When the design has been completed it is checked by looking through it at a light to see if all the non-printing parts have been enclosed sufficiently. Then the gap between the gauze and the frame is closed up on the inner (upper) side with adhesive paper or textile tape. The stencil is then ready for printing.

To correct faulty parts, or when the printing has been completed, the covering layer is washed off with warm water with soda or lye added. Instead of the water-soluble size, a solution of shellac in spirit or enamel paint can also be used (this is suitable when printing with water-soluble poster colours).

The wash-out stencil technique

This lift ground silk screen process produces a more relaxed, flowing design, using either a pen or chalks (with graded tones).

The inner (squeegee) side of the gauze, which has had all traces of grease removed, is drawn on either directly or over an underlaid sketch, with a greasy lithographic chalk or ink. The design is drawn in the positive, the right way round. To obtain a more pronounced grain, glasspaper cardboard with a roughly structured surface is placed under the gauze. When the design has been completed the whole surface of the gauze is coated with a uniform layer of water-soluble size applied with a broad brush. This layer is then left to dry in

a horizontal position. The greasy drawing is then washed out with turpentine essence. This also releases the layer which had adhered to the drawing, thus exposing the screen where the ink should pass through.

For an ink drawing a pigmented solution of gum Arabic with a little glycerine is used. In this case the surface of the gauze is coated with diluted enamel paint and the design is washed out with water when the enamel has dried.

The cut-out stencil techniques

Hand-made indirect stencils for simple flat shapes can be cut out of paper or stencil film. The contours of the design are drawn with drawing ink onto transparent paper which is slightly larger than the frame. The reverse of the paper is given a thin coating of size and the sheet is stretched out on a clean glass plate. When it is dry the paper is given two or three coatings of thinned transparent varnish. The printing parts are cut out with a sharp blade and removed. All traces of grease are then removed from the fabric in the frame and the screen is placed on the cut-out stencil. The inner side of the screen is then wiped with a cloth dipped in solvent; at the same time the gauze is pressed into the dissolving layer of varnish. After it has been left to dry, the paper is firmly stuck to the gauze. The paper is then cut off around the frame and removed carefully from the glass plate. The gap around the frame is taped down and the form is ready for printing.

In place of this simple, easily accessible material, it is possible to use one of the factory produced stencil films (Stenplex, Nu-film, McGraw, etc.). These are usually made of two layers; the printing parts are cut out of the upper sheet and removed from the lower, bearing sheet. The surface of these sheets is covered with a layer, which, after being dissolved with the right kind of solvent, provides a firm bond with the gauze. With some types of sheeting this layer is thermoplastic and is welded on with a warm iron. When the stencil has been transferred the bearing sheet is pulled off and the screen can used for printing.

The photo stencil techniques

A number of photo stencil techniques for preparing printing forms are used by screen process workshops. The majority of these are only impor-

(92)
Victor Vasarely (b. 1908)
Pleionne
silk screen process, 420 × 393

tant for reproduction purposes, but some of the ways of using a light-sensitive layer can also be used by the graphic artist.

The design (in its final form) can be made separately from the printing form on transparent material. The design is then transferred to the gauze using a light-sensitive layer. The design can be drawn on tracing paper, on normal drawing paper (which is made transparent by wiping it with glycerine or paraffin oil), on clean, greaseless film or on a matt surface astrafoil. The drawing is made with Indian ink (which is made more opaque by adding 1% of potassium bichromate) or with retouching opaque red ink or special ink for drawing on foil. A tonal design can also be made with black wax chalk or lithographic chalk on transparent foil or on transparent paper placed for example over a sheet of glasspaper.

The transparency obtained with one of these methods is copied in the same way as a transfer onto the light-sensitive layer which covers the gauze.

Gelatine light-sensitive layer

Stock solutions:
A) 100 g of gelatine added, while stirring continually, to 900 ml of cold water, is left to swell for about 3 hours. 10 g of glycerine is warmed in a bowl placed in water heated to a temperature of 50°C and mixed in.
B) 10 g potassium bichromate dissolved in 100 ml of water.

Before using, the two solutions (A and B) are placed in containers in warm water and heated to 40°C, and then mixed together; 0.1% of spirit is added as a conserving agent. To make the developing process easier to control, approximately 1% of a water-soluble alkaline pigment can be added.

The application is made rapidly with a broad, soft brush, so that the gelatine does not gel prematurely. The work is done in dim daylight or by the light from a weak electric bulb. The drying is done in a dark, dry and warm room — with the screen in a horizontal position, squeegee (inner) side upwards.

Polyvinylalcohol (PVA) light-sensitive layer

Stock solutions:
A) 100 g of polyvinylalcohol bichromate added, while stirring continually, to 800 ml of water and brought to the boil; the mixture is left to swell overnight.
B) 20 g of ammonium bichromate dissolved in 200 ml of water; 30 ml of a 5% wetting agent is added to the water beforehand.

Before using, the container with solution A is placed in water and heated to 70°C. Then it is mixed thoroughly with solution B. The mixture is filtered and left to stand for 24 hours. The light-sensitive layer is applied with rapid strokes of a brush to the inner side of the gauze. While still wet the coating is smoothed out and the surplus removed with a strip of celluloid. The screen is left to dry for 2—3 hours in a dark place.

Copying

The photographic negative or a transparency with the design is placed on the light-sensitized gauze, weighed with a glass plate 5—7 mm thick and copied by subjecting it to direct sunlight or light from an arc lamp, a mercury vapour lamp or a special incandesent bulb (HPR — Philips 125 W).

The exposure time depends on the type of light source, its distance from the negative, on the transmissiveness and opacity of the design and the light-sensitivity of the layer — it may be roughly between 3 to 30 minutes. The length of the exposure time must be tested with a series of preliminary trials.

If the copying is made with the help of sources which give out a large amount of heat, one must be careful that the light-sensitive layer does not overheat and also that the gauze does not get damaged.

Developing

When the exposure has been completed the gauze screen is submerged in a tray filled with water (with a temperature of about 20°C for a PVA layer, and a temperature of 40°—50°C for a gelatine layer), where it is left for about 6 minutes. During this period the screen is moved a few times. If the exposure has been made correctly, all the unexposed parts dissolve and are washed away; the exposed parts swell, but do not dissolve.

This completes the developing process. The stencil is rinsed under a shower and dried with chamois leather or a sponge. Then it is dampened with spirit on both sides and left to dry naturally.

THE TECHNOLOGY OF SILK SCREEN PRINTING

Printing equipment

No great pressure is required for transferring the ink from the screen onto the paper — the viscous ink needs only to be expressed through the pervious parts of the stencil — and demands on the printing equipment are also minimal. It is true that screen process workshops use a number of highly efficient machines, but for the printmaker the simplest hand operated equipment suffices. This equipment can easily be home-made.

It consists of a flat base plate and the printing screen already described. The longer side of the screen is fixed with two hinges to a batten which can be vertically adjusted with two screws. A moveable wooden bar fixed to one side of the frame supports the frame in an open position.

The silk screen squeegee

The squeegee is an important printing instrument which is used for spreading the ink within the silk screen frame while simultaneously pressing it through the pervious parts of the stencil onto the paper. It is a strip of flexible synthetic rubber or soft PVC screwed or bolted into a wooden or metal handle.

The strip is 5—8 mm thick and extrudes from the handle by 10—20 mm. Its scraping edges are either right-angled or rounded (a rounded profile permits a larger amount of ink to be deposited). If the edges of the squeegee have become uneven through long use, they must be cut straight with emery paper glued to a flat support, otherwise a uniform layer of ink cannot be achieved. When the work is finished the squeegee is set aside so that nothing touches the rubber strip.

Silk screen process inks

As the silk screen printing procedure differs from other printing techniques it was necessary to develop inks with slightly different physical properties. Special silk screen inks for printing on paper are sold in several basic shades — these can be either matt or glossy.

Matt inks have a pleasant appearance similar to a tempera or pastel layer. Their surface dries in about 15 minutes and they dry completely in 48 hours. *Glossy* inks retain their glossiness even on absorbent paper, although it is best to use sized paper. Glossy inks dry in 12—24 hours.

Usually the ink cannot be used without adapting its viscosity. Special turpentine, paraffin or benzine solvents are used for this purpose.

Various shapes of the scraping edge of the squeegee (1 — universal, 2 — for fine designs with a thin layer of transparent ink, 3 — for a thicker covering layer, 4 — for a strip of stiff material, 5 — for a very thick ink relief)

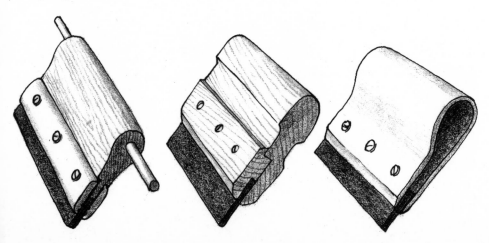

The silk screen process scraper, called the squeegee

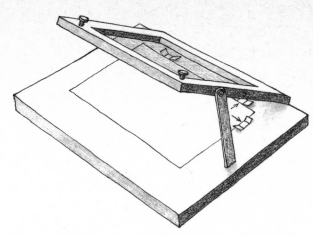

The loading of the paper between three loading marks

Printing procedure

The printing paper is placed on the base table. Position markers are stuck onto the table in three places — these help to place the design correctly and to achieve a perfect register when printing in colour. The frame with the stencil is laid down. At the edge of the gauze, along one of the shorter sides of the frame and outside the design, a strip about a centimetre thick of a correctly prepared printing ink is applied with a palette knife. The length of this strip corresponds to the width of the picture. A squeegee is placed behind the strip of ink and pushed in one uninterrupted continuous movement to the other side of the frame; at the same time slight pressure is applied. All the ink must be wiped from the surface of the fabric. The squeegee is held at an angle of about 45° — 60° to the printing surface. The smaller the angle the larger the amount of ink pressed through the stencil. The screen is lifted and fixed in the upper position and the completed impression is removed. The prints are laid loosely next to each other to dry.

For the next impression the ink is drawn over to the starting side or alternatively it can be moved over with the squeegee held at a right angle and without pressure. In this case the ink is expressed through the gauze, which is only filled with the ink, and the impression is made with the next stroke of the inclined squeegee.

During short breaks in the printing procedure it is necessary to make sure the ink does not dry in the holes in the fabric. Two suitably large sheets of newspaper are saturated with oil and applied to both sides of the stencil. If the printing process is interrupted for a longer time the ink must be removed and the gauze must be washed out properly with the prescribed solvent.

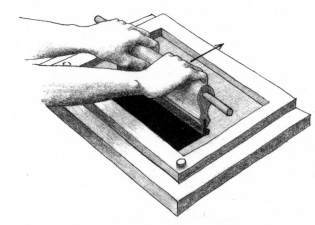

Filling the stencil with a squeegee held at a right angle

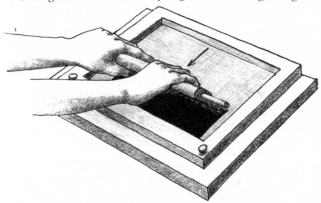

Printing by pulling the squeegee towards oneself with the necessary pressure and at the correct angle

Removing the stencil

Once the required number of impressions has been printed the stencil is usually washed off the gauze. The means depend on the technique being used. Varnish is washed off with solvent, a gelatine layer with warm water (50° — 70° C) to which, if necessary, a 10 — 20% solution of sodium lye is added. A PVA layer is removed with a solution of oxalic acid or sodium chlorate. The layer melts in five minutes and is washed away with water.

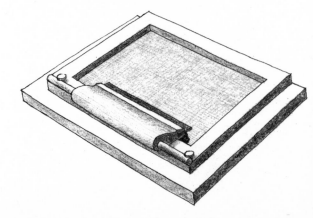

Putting the squeegee aside over the inking system

THE BOUNDARIES OF PRINT-MAKING

Pochoir

The elements of painting in print-making

The relationship between print-making and painting, although the two are formally separated, has undoubtedly remained very close. The history of both these fields is filled with the quest for new themes and the best way to express them. Although these means differ slightly, the influence exerted by one on the other is unavoidable, and, in fact, it was painters who created the most important prints and who advanced the development of print-making.

In a formal sense, the use of elements of painting in the field of original graphic art printing basically means the free application of ink to the printing form in those places which are not outlined as printing elements in any way. By this, for example, one means the inking of one printing plate with several colours which intermingle slightly, as e.g. in Japanese wood engravings and coloured engravings, etchings or the imperfect wiping off of ink in the dry point technique or etching, which adds half-tone effect to the linear design.

Pochoir, a technique used in France in the mid-19th century, is included here for the sake of completeness. It was used for the mass production of gouache paintings and the only thing it had in common with print-making was that the basic drawing was preprinted in collotype. The individual colour parts were subsequently applied through a stencil with a brush. The quality of the paintings made in this way can sometimes approach that of a silk screen process print. However, the difference is usually revealed by the brush traces.

(93)
Giovanni Benedetto Castiglione
(1610—1665)
The visitation of the shepherds
monotype, 373 × 247

Monotype

The monotype is difficult to classify as an accepted print, for it could also be described as a method of painting. It consists of printing a painting on a metal plate with oil paints.

This technique works with a smooth, silver- or nickel-plated plate — so that the colours do not lose their brightness through the action of oxidized metal. The painting on the plate is made with standard undiluted tube oil paints, applied with brushes in a very thin layer. These can be further worked with a brush or with the fingers. The highlights are either left out or wiped out with a cloth or with a piece of leather. The completed painting is printed in a copperplate press onto a low-size content, preferably Japanese, hand-made paper, which is dampened beforehand. Before the plate is pulled through the press it is warmed slightly.

The finished print has an inimitable charm which comes from the smooth flowing colours. These acquire a translucent watercolour appearance on the paper. However, the impression can be made only once and to repeat it the whole painting must be done again. For this purpose the main contours of the design can be etched slightly, but then each print is inevitably different from the others.

Photography in print-making

Since its inception photography (apart from its various roles as a means of documentation, information or as a creative art form) has had the role of a perfect reproductive technique. Involved as it is in all fields of printing, it has substantially helped to develop them into the industrialized forms of today. Long before this level had been achieved photography enabled originals to be transferred accurately onto a printing plate. The original design, sometimes also a text or a photograph, was copied with the help of a light-sensitive layer onto a wood engraving block (photoxylography), a lithographic stone (photolithography), a glass plate with a gelatine layer (collotype) or a silk screen (photo stencils).

These methods lie on the boundary between original and reproductive print-making; at one point they even caused a certain decline in the artistic standard of graphic art productions. As in other art fields, print-making stopped competing with photography in the attempt to register visible reality accurately. The free manual preparation of the plate was taken as the basis for defining the originality of print — i.e. without using photomechanical means for transferring the design.

These techniques have, however, been included in this handbook to provide a complete picture of the level reached in the development of classic printing techniques. Sometimes even a photograph can become an integral part of a larger graphic composition, as in a collage, or the photochemical properties of a light-sensitive layer can be used for fixing a drawing made by hand directly on a plate, as in etching on light-sensitive bitumen.

Photographic prints

Towards the end of the 19th century a number of techniques for the direct contact copying in daylight of a photographic picture from a paper negative (made translucent by grease) were developed. These sometimes included the subsequent application of printing ink. These techniques are known as photographic printing. They have played their role in the history of photography, but have influenced printing processes only as a supplementary means of transferring the design onto the printing form.

The *carbon print process* (a pigment process, invented by A. L. Poitevin in 1855), the *oil print process* (E. Mariot, 1866, G. E. H. Rawlins, 1904). the *gum print process* (J. Buncy, 1958) and the *bromoil print process* (C. Wilborbe-Piper, 1907) are all techniques based on the properties of gelatine (or gum Arabic) which has been light-sensitized with chromium salts: it hardens in exposed places, whereas in unexposed places it is washed away in hot water or swells in cold water. This makes it possible to use the mutual antagonism of water and printing ink: swollen gelatine combines with moisture and repels the ink while hardened gelatine combines well with the ink. The ink is applied with a roller or brush and the plate is drawn through a press; in this way it can be printed on any kind of paper or printing plate.

These methods are therefore more in the nature of copying techniques than the printing processes which their names imply.

The glass print (Cliché verre)

The French painter Corot (1796—1875) invented this process which is not in fact a printing technique but a method of photographic copying of an original design. Nowadays it is seldom used.

Lines are engraved with an engraving needle into the exposed and developed light-sensitive layer of a photographic glass plate. In this way a negative transparent design is obtained in the black surface and this is contact copied onto contrasting photographic paper. This is developed and stabilized like a normal positive print, producing a fine black pen design of unusual character.

(94)
Jean Baptiste Camille Corot
(1796—1875)
Death and the maiden, 1854
glass print

SOME ADVICE
FOR COLLECTORS

Apart from official state and national collections and graphic art departments, where the best works created in the field of print-making are systematically gathered and preserved, there are a number of private collectors throughout the world. Their collections are of varying quality and range, from chance acquisitions numbering only a few prints to large-scale print collections. Some concentrate on progressive contemporary works, others prefer old masters or various themes. Thanks to their enthusiasm a number of graphic art masterpieces have been preserved. But as always, care must be taken with the storage of graphic prints so that irreparable damage and loss is avoided.

The arrangement of a print collection

Single prints are usually mounted in folded mounts made of very tough cardboard. The front sheet of the mount has an opening which is slightly larger than the format of the printed plate. The placement of the opening is an aesthetic point — ideally the upper and side margins should be of equal width, with the bottom margin up to twice as wide. The print is placed in the mount in such a way that the whole impression, including the signature, is visible. The print is carefully taped down by the upper corners in the reverse side of the paper to the rear fold of the mount. To prevent dust from reaching the print it is worth covering it (beneath the front of the mount) with thin plastic.

If a large number of prints are to be stored, it is a good idea to have the mounts made in two or three uniform formats, for example 34 × 42 cm, 42 × 68 cm, 68 × 84 cm; then it is possible to order cardboard boxes for 100 — 200 prints with an inner dimension exactly corresponding to the format of the mounts. In this way the prints are protected not only against physical damage, but also against atmospheric, chemical or biological influences.

Inside each mount a card should be glued with all the necessary data concerning the origin, technique, date and so on. When giving the size of the print it is the dimensions of the printed plate that are important, the size of the printing paper is given only in exceptional cases. The first dimension denotes the height; thus a print with a format of 30 × 40 cm is wider than it is deep.

Very large prints with broad margins can be placed in a stiff portfolio interleaved with thin clean paper.

In some large public and private print collections, special stamps or blind block marks are printed on the edge of the reverse of the print to denote the collection to which the prints belong.

If it is necessary to transport prints, it is best to use firm folders for this purpose (preferably large ones). The individual prints should be interleaved with fine paper. Large-scale works are transported (rolled from the reverse side) in cardboard tubes.

Framing prints

The print is used more and more frequently nowadays as an element in interior decorating. Prints used for this purpose are placed in glazed frames made of simple thin single-coloured mouldings. A thick cardboard, with an obliquely cut opening, is used for mounting as this prevents the glass from touching the print. A covering cardboard sheet is placed over the reverse side and this is fixed to the frame and sealed with adhesive tape. This prevents fine dust from reaching the print and making it dirty. Recently a system of mounting which omits the wooden frame has come into use — the mount is hung on the wall, framed only with adhesive textile tape.

A print should not be placed on a wall where the sun shines intensely, because this will cause the paper to turn yellow and a coloured print to fade.

Identification and classification of prints

A collector often comes across a graphic print, which lacks all data concerning by whom, when and with what technique it was created. The determination of these three factors is usually interrelated.

The identification of the artist is a rather complex matter, requiring considerable art-historical and technical knowledge.

The determination of the age of the work is based mainly on the identification of the artist and sometimes on the correct placement of it within the context of his entire life's work.

Sometimes, especially with older prints, an estimate of the age of the paper, based on an analysis of the *watermark* is useful. These watermarks are made in the form of simple linear designs or lettering. They are produced by a wire entwined in the mesh of the paper mill form; the paper pulp

which is poured onto the mesh is thinner in these places and the paper becomes translucent. Every manufacturer of hand drawn (and sometimes even machine drawn) paper always used his own watermark, thus providing a guarantee of the quality of the product and nowadays also historical authenticity. Even if one accepts that such a paper may have been used some time after it was made, its age is an important guide for judging the age of a print.

The identification of print-making techniques

The identification of the technique used for creating a print is of great importance and is not always easy. A good magnifying glass is used for examining the print and in doubtful cases a photographic enlargement of a detail can be made. These facts are then compared with the characteristics of the different techniques already described.

The first thing to be established is whether, or not, it really is a print. An original drawing will give itself away by the instability of the materials used, by ink or paint that has run or soaked through, by a paint layer with brush traces, and so on. A certain disorder of the design expression or design elements is a clue, being a characteristic which does not occur when using printing techniques.

It is of equal importance to distinguish whether the print is an original impression or a reproduction. Often it is sufficient to find that a design is broken up into a half-tone or gravure screen grid and it is then obvious that a photomechanical process has been used. In other cases the character of the grain, the marks of the facet, or of the edge of the stone, the texture of the printed wood and similar ponts are examined.

The next thing is to identify the printing technique used and finally the method of working the printing plate. Some techniques give very similar results and it can be quite difficult to distinguish between them. Therefore a summary of the techniques which are easily confused is given below:

litho engraving — woodcut, linocut
woodcut — linocut, metal cut
wood engraving — lino engraving, Mässer plate, litho engraving
original pen zincography — wood engraving
original chalk or sprayed zincography — litho chalk drawing

copperplate engraving — etching, litho engraving, steel engraving
dotted engraving — etching or lithography in the dotted manner
mezzotint — litho mezzotint
engraving or etching in the crayon manner — litho chalk drawing
line etching — engraving in metal or on lithographic stone
soft ground — litho chalk drawing
brush etching — brush drawing on stone
lithograph — algraph, offset
silk screen process — linocut, litho pen or chalk drawing, pochoir

In addition to these, all relief printing techniques can be mistaken for a pen zincography block, intaglio techniques for reproductive photogravure and planographic techniques confused with offset or collotype.

BIBLIOGRAPHY

Arms, J. T. Handbook of Print and Printmakers *New York 1934.*

Bachner and Dümubier Bruckmann's Handbuch der modernen Druckgraphik *Munich 1973.*

Beckert, F. Die neuen Lehrbriefe der Siebdrucktechnik *Ulm 1962.*

Bersier, J. La lithographie originale en France *Paris 1943.*

Bersier, J. La gravure *Paris 1940.*

Biegeleisen, J. L. The Complete Book of Silk Screen Printing Production *New York 1963.*

Billoux, R. Encyclopédie chronologique des arts graphiques *Paris 1943.*

Blau, F. K. Holzschnitt-Technik *Strasbourg 1912.*

Bliss, D. P. A History of Wood Engraving *New York 1928.*

Blum, A. The Origins of Printing and Engraving *New York 1940.*

Boch, E. Geschichte der graphischen Kunst *Berlin 1950.*

Bosse, A. Traité des manières de graver la taille-douce etc. *Paris 1645.*

Brundson, J. The Technique of Etching and Engraving *London 1965.*

Brunner, F. Handbuch der Druckgraphik *Teufen 1962*

Buckland-Wright, J. Etching and Engraving. Techniques and the Modern Trend *London 1953.*

Calabi, A. Saggio sulla litografia *Milan 1958.*

Carrington, F. Engravers and Etchers *Chicago 1917.*

Cleaver, J. A History of Graphic Art *London 1963.*

Cliffe, H. Lithography *London 1965.*

Colapinto, E. Elementi di serigrafia *Milan 1959.*

Curwen, H. Processes of Graphic Reproduction *London 1963.*

Dictionnaire di l'imprimerie et des arts graphiques en général *Paris 1912.*

Ditrich, H. and Hofstätter, H. 'Holzschnitt, Kupferstich, Lithographie und Serigraphie'. In Geschichte der Kunst und künstlerischer Techniken *Munich 1965.*

Dutmit, E. Manuel de l'amateur d'estampe *Paris — London 1888.*

Ehlers, K. F. Siebdruck *Munich 1962.*

Engelmann, G. Traité théoretique et pratique de la lithographie *Mulhouse 1940.*

Faithorne, W. The Art of Graving and Etching *London 1702.*

Fikari, M. A Survey of Graphic Art Techniques *Prague 1955.*

Fišer, K. Original Graphic Art *Prague 1915.*

Flocon, A. Traité du burin *Geneva 1954.*

Friedländer, M. J. Der Holzschnitt *Berlin 1917.*

Friedländer, M. J. Die Lithographie *Berlin 1922.*

Fritz, G. Handbuch der Lithographie *Halle 1898.*

Fünf Jahrhunderte europäischer Graphik. Austellungskatalog *Munich 1965.*

Furst, H. Original Engraving and Etching *1931.*

Gaza, M. Les techniques de la sérigraphie *Paris 1963.*

Gross, H. Etching, Engraving and Intaglio Printing *London 1970.*

Guberti-Helfrich, M. Serigrafia per Artisti *Milan 1957.*

Gusman, P. La gravure sur bois *Paris 1916.*

Hayter, W. S. About Prints *London 1962.*

Hayter, W. S. New Ways of Gravure *London 1966.*

Herberts, K. The Complete Book of Artistic Techniques *New York 1958.*

Hiett, H. L. and Middleton, H. K. Silk Screen Process Production *London 1950.*

Hind, A. M. A History of Engraving and Etching *London 1923.*

Hind, A. M. A Guide to Processes and Schools of Engraving *London 1952.*

Hoberg, R. Die graphischen Techniken und ihre Druckverfahren *Berlin 1922.*

Hollenberg, F. Radierung, Ätzkunst und Kupfertiefdruck *Eitorf 1976.*

Holman, L. The Graphic Processes *Boston 1929.*

Janssen, D. Siebdruck, das ideale Druckverfahren *Oldenburg 1954.*

Jones, S. Lithography for Artists *London 1967.*

Juna, Z. Etching and Related Techniques *Prague 1954.*

Knigin, M. and Zimiles, M. The Technique of Fine Art Lithography *New York 1970.*

Konow, J. von Om Grafik *Malmö 1955.*

Kopta, F. Intaglio Printing *Prague 1950.*

Kořínek, O. The Silk Screen Process *Prague 1971.*

Kritsteller, P. Kupferstich und Holzschnitt in vier Jahrhunderten *Berlin 1905.*

Kroger, O. Die lithographischen Verfahren und der Offsetdruck *Leipzig 1949.*

Kruck, C. Technik und Druck der künstlerischen Lithographie *Frankfurt 1962.*

Kubas, J. Graphic Art Techniques *Bratislava 1959.*

Lainer, A. Anleitung zur Ausübung der Photoxylographie *Halle 1894.*

Laran, J. L'Estampe *Paris 1959.*

Leisching, J. Schabkunst *Vienna 1910.*

Leisching, J. Die graphischen Künste *Vienna 1926.*

Lieure, J. La lithographie artistique et ses diverses techniques *Paris 1939.*

Lipmann, F. Der Kupferstich *Berlin* and *Leipzig 1926.*

Loche, R. Lithography *New York 1974.*

Lumsden, E. S. The Art of Etching *New York 1924, London 1925.*

Lützow, C. v. Der Holzschnitt der Gegenwart *1887.*

Mayer, R. Die Lithographie *Dresden 1955.*

Mayer, R. The Artistic Handbook of Materials and Techniques, *New York 1940.*

Meder, J. Die technische Entwicklung der Graphik *Vienna 1908.*

Melleris, A. La lithographie artistique et ses diverses techniques *Paris 1898.*

Melleris, A. La lithographie en couleurs *Paris 1898.*

Mock, H. Einführung in die Techniken der graphischen Künste. In Der Graphiksammler *Munich 1965.*

Müller, H. How I Make Woodcuts and Wood-engravings *New York 1945.*

Novák, A. A Key to Graphic Art *Prague 1946.*

Papillon, J. M. Traité historique et pratique de la gravure en bois *Paris 1766.*

Papillon, J. M. Woodcuts by Thomas Bewick and his School, *New York 1800.*

Peterdi, G. Printmaking — Methods Old and New *New York 1959.*

Platte, H. Artists' Prints in colour *London 1961.*

Poortenaar, J. The Technique of Print and Art Reproduction Processes *London 1933.*

Prideaux, S. T. Aquatint Engraving *London 1909.*

Rambousek, J. Lithography and Offset *Prague 1948.*

Rambousek, J. Dictionary and Recipes for the Painter and Graphic Artist *Prague 1954.*

Rambousek, J. The Woodcut, Wood Engraving and Related Techniques *Prague 1954.*

Reiner, I. Holzschnitt — Holzstich *St Gallen 1947.*

Rhein, E. Die Kunst des manuellen Bilddrucks *Ravensburg 1975.*

Rothe, R. Der Linolschnitt, sein Wesen und seine Technik *Prague 1917.*

Rothenstein, M. Linocuts and Woodcuts *London 1962.*

Sachs, P. J. Modern Prints and Drawings *New York 1954.*

Schasler, M. Die Schule der Holzschneidekunst. Geschichte, Technik und Ästhetik *Leipzig 1866.*

Schreiber, W. L. Manuel de l'amateur de la gravure sur bois et sur métal au XVᵉ siècle *vols 1-5, Berlin 1890—1911.*

Schürmeyer, W. Holzschnitt und Linolschnitt *Ravensburg 1964.*

Senefelder, A. A Complete Course of Lithography *London 1819.*

Senefelder, A. Vollständiges Lehrbuch der Stein-druckerei *Munich 1818.*

Singer, H. W. and Straug, W. Etching and Engraving and Other Methods of Printing Pictures *London 1897.*

Singer, H. W. Der Kupferstich *Leipzig 1907.*

Sotriffer, K. Die Druckgraphik. Entwicklung, Technik, Eigenart *Vienna — Munich 1966.*

Stiebner, E. D. Bruckmann's Handbuch der Druckgraphik *Munich 1976.*

Stinger, H. W. Der Kupferstich *Leipzig 1904.*

Struck, H. Die Kunst des Radierens *Berlin 1908.*

Stubbe, W. Graphic Art in the Twentieth Century *New York 1963.*

Syrovátko, J. and Raatz, J. The Lithograph *Prague 1951.*

Trevelyan, J. Etching *London 1963.*

Weaver, P. The Technique of Lithography *London — Norwich 1964.*

Wilder, F. L. How to Identify Old Prints *London 1969.*

Woods, G. The Craft of Etching and Lithography *London 1965.*

Ziegler, W. Die manuellen graphischen Techniken *Halle 1901.*

PRINTS ILLUSTRATED IN THE TEXT

ACKNOWLEDGEMENTS

We should like to give particular thanks to the following museums which kindly gave permission to reproduce some of their artefacts for this book:

Ill. Nos. 42, XVII, 65, 70, 81
Dresden, Staatliche Kunstsammlungen, Kupferstichkabinett
Ill. No 4
London, Tate Gallery
Ill. Nos. XXII, XXXI
Paris, Bibliothèque Nationale, Cabinet des Estampes
Ill. Nos. VII, 38, 44, 49, 55, 87, XXVII
Prague, Památník národního písemnictví
Ill. Nos. V, 31, 32, 34
Prague, Národní galerie
Ill. Nos. 6, 7, 8, 9, 10, 11, 14, 15, 17, 18, 19, 20, 22, 23, 24, 26, 29, 30, 37, 39, 43, 45, 47, 50, 53, 57, 58, 59, 61, 62, 63, 64, 68, 69, 71, 74, 75, 77, 79, 80, 82, 83, 88, 95, II, IV, VIII, IX, X, XI, XII, XIII, XIV, XVIII, XXI, XXIV, XXV, XXVI
Private collections
Ill. Nos. I, III, 33, XVI, 67, XXIII, XXXII
Wien, Graphische Sammlung Albertina
Ill. Nos. 21, 41, 48, 56, 78, 84, 93

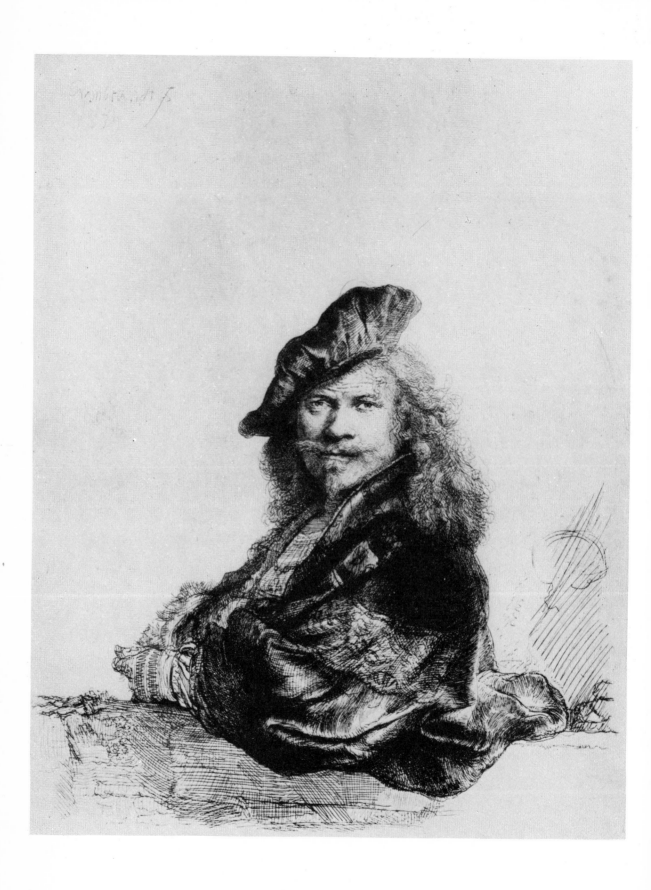